VERSIFIED PRINTS:
A LITERARY AND CULTURAL PHENOMENON
IN EIGHTEENTH-CENTURY FRANCE

W. McALLISTER JOHNSON

Versified Prints

A Literary and Cultural Phenomenon in Eighteenth-Century France

UNIVERSITY OF TORONTO PRESS
Toronto Buffalo London

ISBN 978-1-4426-4285-0

Printed on acid-free, 100% post-consumer recycled paper with vegetable-based inks.

Library and Archives Canada Cataloguing in Publication

Johnson, W. McAllister (William McAllister), 1939–
Versified prints : a literary and cultural phenomenon in eighteenth-century France / W. McAllister Johnson.

Includes bibliographical references and index.
ISBN 978-1-4426-4285-0

1. Prints, French – 18th century. 2. French poetry – 18th century – History and criticism. 3. Art and literature – France – History – 18th century. I. Title.

NE647.6.V47J65 2012 769.944'09033 C2011-906206-2

This book has been published with the help of a grant from the Canadian Federation for the Humanities and Social Sciences, through the Aid to Scholarly Publications Program, using funds provided by the Social Sciences and Humanities Research Council of Canada.

University of Toronto Press acknowledges the financial assistance to its publishing program of the Canada Council for the Arts and the Ontario Arts Council.

 Canada Council Conseil des Arts ONTARIO ARTS COUNCIL
for the Arts du Canada CONSEIL DES ARTS DE L'ONTARIO

University of Toronto Press acknowledges the financial support of the Government of Canada through the Canada Book Fund for its publishing activities.

For Millie

Contents

Preface

Tous les hommes peuvent juger des Vers & des Tableaux, parce que tous
les hommes sont sensibles, & que l'effet des Vers & des Tableaux tombe sous
le sentiment.

(Charles Du Bos, *Reflexions critiques sur la Poësie & sur la Peinture*)·

The engraver and author Bernard-François Lépicié uses Dubos's citation
in an entry for the second volume of his *Catalogue raisonné des tableaux du
Roi* (1754), adding that one is always affected when one sees a painting
of Nature rendered with truth and choice – such as Annibale Carracci's
Assumption of the Virgin engraved by Guillaume Chasteau. Where, how-
ever, versified *prints* are concerned, the possible relationships between
painting and poetry become more subjective than factual.

What the people of the Ancien Régime brought to such prints as a
result of breeding or education is a matter of conjecture, but the print
letters found in the margins make most, if not all, of the decisions as to
how the mind's eye 'sees' the image. Accordingly, versified prints involve
a different level of attraction and different levels of engagement than do
unaccompanied images. For reproductive prints, verse rapidly orients
and channels the viewer's reception and interpretation of situations left
unresolved in the model. For direct-to-print models – contemporary art
that did not 'pass' through the intermediary of painting – text and image
were conceived more or less in tandem rather than being retroactively
applied, as they were with historical paintings. All this reduces to the
query as to whether verse supports or extends an image.

Whatever the causes, the effects are beyond dispute. Once put together
on a sheet of paper, print image and verse cannot be put asunder – the

consummate *Ut pictura poesis* together at last and for all time. We may (and should) sniff out authors and sources, separating mere citations from original circumstantial poetry, but this is not the point – at least, not the main point. Versified prints represent a peculiar creative effort whose fabrication involves many crafts – an *art à plusieurs mains*, an amalgam where poetry is the unexpected final element to be thrown into the crucible. They are known throughout eighteenth-century France. They evolved over many years. They exist at both high and low levels and effortlessly pass back and forth between them.

Most important of all, the replacement of inscriptions by verse is a reminder of how essential this form of expression was for a period where people were used to reading between the lines. It is just that these verses have come down to us in a particular way, on prints. Visible and accessible to all, they once explicated paintings and the occasional drawing for their contemporaries and for history. Versified prints are no respecters of the pictorial genres and underlying theory. They are an effort of the imagination that can intervene – and change assumptions – at any stage in a print's genesis. Where theatre and opera are concerned, their libretti can be the very origin of a print that neither possesses nor requires versification.

This little book began as lectures at the Société historique et archéologique 'Le Vieux Papier' (Paris 1984) and the Zentralinstitut für Kunstgeschichte (Munich 1999). Its topics are virtually inexhaustible, lending themselves to myriad differential studies that others are perhaps better qualified to carry out than I am. I have accordingly restricted myself to a closely reasoned outline of issues and methodology, illustrated with the best and most telling examples I could find.

Unless otherwise indicated, all photographs are reprinted by permission of the Bibliothèque nationale de France (Photo B.n.F.). Prints shown at the Salon were, with few exceptions, definitive and commercialized states. When catalogued or calculable, mention is made of progressive states as an indication of the late date at which poetry appears on prints of the period even if other undescribed intermediate states continue to surface. The passage from Diderot's Salon of 1765 appears by permission of Oxford University Press.

For their superb collections and their unfailing interest and encouragement over many years, I should like to thank successive directors of the Département des Estampes et de la Photographie of the Bibliothèque nationale de France and their staff. And for their comments and insights at critical moments, Arsène Bonafous-Murat (†), Sean

J. Taylor, and François Rouget. As this text evolved, the spectre of completeness occasionally haunted my dreams but remains as illusory as are all spectres. Not all versified prints are iconographically and historically significant; the truth is not in the details but in the larger picture encompassing them. Prints lending themselves to rich research outcomes will be recognized by those who can, and I trust will, do the proper work.

VERSIFIED PRINTS

1 The Phenomenon Defined

Every so often one runs across a phenomenon so daunting in prospect that it seems impossible to work through it in the short term. Versified prints fall into this category. They attract notice, and finding where they lead requires more than passing curiosity. The more one finds, the more the concept appears diffuse, even impenetrable since the quality is so uneven. Even when the phenomenon was remarked, often it was, as with Nicolas IV de Larmessin's *Quatre Heures du Jour* after Lancret, by particular type or context only: 'Il était d'usage de mettre alors au bas des estampes un quatrain, pour en élucider le sens.'[1] Their number is so considerable that this phenomenon must be worth investigating. But how?

We can, of course, draw analogies with poetic theory and see where it leads, but little tradition exists for the study of versified prints. In fact, this 'genre' is largely absent from the discussion and evaluation of eighteenth-century French poetry, while much of the verse at issue is unsigned, unattributed, or identified only by initials. Given the number of versified prints throughout the century whose incipits serve as de facto titles (fig. 1), the phenomenon itself is inescapable.[2] Precedents in print versification were likely built up as prints were issued. If so, chance observations may lead to theory, the alternative being that each poetic application is unique, owing nothing to history or example. Indeed, there may be elements of truth in both postulates. Significant advances in understanding this phenomenon may be made by the study

Note: This study crosses the boundaries of several disciplines, each with an extensive cast of characters. Readers desiring supplementary information concerning the names of artists and authors may consult the index.

of striking and highly characterized examples – by working outwards from simple typology to the issues. This means being interested in things that no one else is, or that no one has noticed – prints that are 'unknown, unloved, forgotten, or unused' by modern scholars and neglected or spurned by modern curators.

Even the repertory is problematic. Early catalogues are full of tantalizing references to prints by known engravers such as 'deux vers françois' or 'avec quatre [six, huit] vers françois au bas' – an oblique way of indicating a distinctive *type* of print often found under the heading 'Sujets d'histoire et de genre.'[3] Unless one lives in a print cabinet or frequents print dealers, such prints are noted as they are seen, but the criteria for their acquisition or study are likely to be different, prescriptive, or exclusionary. Curiosity is aroused but not easily satisfied. Whether one works from literature or from the works to hand, it is difficult to sense, much less to appreciate, the extent and chronology of such prints. Yet it has been noted that 'neglected sources such as print verse may turn out to reveal hierarchies of quality and innovation in their own right, which makes their comparative use at once more fascinating and more difficult.'[4] There the case has remained.

There is little interest in the study of such curiosities and, as a result, little fear of distorting the print market. In contrast, versified prints were everywhere in vogue throughout the eighteenth century. Most people lived with them.[5] Some, such as Colalto of the Comédie Italienne, are said to have died with them, surrounded by their children, in scenes paralleling those of Greuze:

> Il est mort d'une maladie fort lente et fort douloureuse. Ses enfans, qui n'ont point quitté son chevet, l'ont vu s'éteindre dans leurs bras. Il a senti tous leurs soins, et ses derniers mots ont été l'expression de sa reconnoissance. Ses yeux étaient arrêtés sur l'estampe du *Paralytique servi par ses enfans.* On lit ces vers au bas de la gravure:
>
> Si la verité d'une image
> Est la verité de l'objet,
> Que le sage artiste a bien fait
> De mettre la scène au village!
>
> «Mes enfants, leur dit le mourant d'une voix faible, l'auteur de ces vers ne vous connoissait pas.»[6]

Yet Flipart's great 1767 print after Greuze, presumably indicated by the print title given, has no verse (fig. 2).[7] Instead, reference is being made to a reversed repetition, severely truncated on the top and sides and of more usable dimensions,[8] published by Le Pere et Avaulez as *La Piété Filiale* (fig. 3). Full verse citation from what was a lesser print in quality and price not only confirms the conceit but extends its context – from paint to life and from country to city:

> D'un amour tendre et filial
> Des sentimens de la nature,
> Vous voyez ici la peinture:
> Mais où trouver l'original?
>
> Si le mérite d'une image,
> Est la verité de l'objet;
> Que le sage Artiste a bien fait
> De mettre la scène au village!

Did we not know both prints, we might think Colalto's pointed reference to be but one of the many examples of the power of poetic thought in society. However, whilst the quality of print verse must be evaluated as literature, and literature applied to an image, such prints were not rarities – quite the opposite. Important in their day, they were regularly advertised, discussed in the periodic press and in correspondence,[9] and commented on in private newspapers that circulated in manuscript by subscription. They often gave rise to poetry, whether or not it was committed to paper, much less published. They provide a crash course in the types of things that occur in the fabrication of prints in general if one follows through their successive states of development. They assist in the reconstruction of artistic and cultural circles – and of a distinct 'culture' of prints and their production. In exceptional cases (Joseph Vernet's shipwrecks) they transmit public emotions to the *subjects* of painting:

> Au magique effet de ton art,
> Je sens toute l'horreur que chaque personnage
> Eprouve au moment du naufrage.
> *Balechou* revit dans *Flipart*.[10]

Literary historians know little of their riches, while print historians attend to other matters. Yet no less an artistic force for his period than

Pierre-Jean Mariette considered Netscher's *Mort de Cléopatre* as his most *noble* painting, remarking five years after the fact that 'la gravure qu'en a fait M. Wille & les vers de M. Piron, font qu'il est aujourd'hui connu de tout l'Europe.'[11] In his eyes, verse need not be part of the print itself (fig. 4), but it could, on occasion, draw attention to a work that had been as finely engraved as it had been painted.

Versified prints are singular in this respect – and an interdisciplinary dream, or perhaps nightmare – since there is neither methodology nor repertory for their use. This was put forcefully to me in 1984 when I was lecturing at the annual dinner of the Société 'Le Vieux Papier.'[12] Normally a show-and-tell, with items passed about after the table is cleared, it became a happening: one associate went as a marquise Watteau (half-suffocated by her stays, which were laced too tightly), another as a Cossack (cloth of gold trousers are at very least translucent), while I appeared in full regalia as Cardinal Richelieu (crimson damask and a three-metre train are heavy and do not breathe). We declaimed the verses on the prints chosen and created a minor sensation. Significantly, members of a great Parisian print house in attendance confessed that they never bothered to *read* such verses, merely noting their presence. Translated: the full print letter simply defines the definitive (commercial) state of a print; it is deemed a *cataloguing* problem, not a historical or interpretive one.

Yet we are usually no better off in the study of versified prints when consulting existing catalogues. Mentioning a print's state in labels and exhibition catalogues today often means that its accompanying verse need not be fully transcribed or printed since it is displayed on the walls, described in the literature, and most likely illustrated. We may not be much further advanced when addressing repertories, given their partial transcriptions (often only the incipit). This represents a regression from the norms set out by Robert Hecquet in 1751: 'J'en donnerai les titres en entier, & quand il y aura des vers, j'en transcrirai les deux premiers, en conservant même les fautes d'ortographe qui s'y recontreront, comme dans les titres.'[13] He makes no mention of the source of the accompanying verse. Rarely do we have shorthand of the precision and elegance of Dacier and Vuaflart's *Watteau* of 1922, when describing a print such as *Voulez-vous triompher des Belles?* whose conventional title is derived from its poetry.[14] Their notation 'Suivent 10 vers sur 2 col. de 5, de part & d'autre des armoiries, et signées: par C. Moraine,' followed by the first and last lines, gives something to work with as well as a hint of its disposition within the print letter. *A contrario*, Bocher's typographical reconstitutions of actual print letters, in his catalogues of extensively versified painters

such as Baudouin, Chardin, and Lancret, remain a standard that was possible in his day but virtually unattainable in ours, where illustration has become the descriptive norm.

What is the point here? The final and generally known state of a print *conceals* all the earlier stages and decisions of its maker(s) while revealing larger changes in print culture itself. Once published, it may undergo still more changes as the copperplate is retouched, reworked, or restruck and passes through the hands of successive editors. In this, the 'Watteau tradition' is pivotal – witness the second and fourth states of Dacier and Vuaflart 4,[15] first announced chez François Chéreau in December 1727. Beyond the signatures of the artists and his own address, Gersaint's earlier issue (fig. 6) has only the following verses

> Au foible Efort [*sic*] que fait Iris pour se défendre,
> De son dessein on peut avoir Soupçon:
> La belle adroitement cherche a se faire entendre,
> Et Sans parler donne cette leçon.
>
> Un jaloux de ses Soins tire un triste Salaire,
> Un Curieux sans fruit passe son tems;
> Mais celui qui n'a point d'autre but que de plaire,
> Doit esperer d'agreables momens.

while the third state effaces them entirely, completely reworks that portion of the plate, and substitutes Chéreau's address and privilège. A concise and 'impersonal' print letter now appears, with its dismally symmetrical bilingualism and a title – 'Le Compteur,' corrected to 'Le Conteur' in Chéreau's fourth and final state (fig. 7). The direct confrontation of image and verse originally intended is no longer possible. Nor can the image be 'read' from its verse, as with slightly earlier prints after Jacques Courtin and Jean-Baptiste Santerre. The print's title, derived from the expression *conter fleurette* (to murmur sweet nothings), still leaves much to the imagination by reinforcing the presumed impenetrability of Watteau's subject matter. Poetry after contemporary subjects first sets a context for its image, then seems to emanate from it, as with paintings by Chardin and Lancret. Image, title, and verse are here fused into cautionary notes (*moralités*) or badinage. Lancret's and Pater's prints venture into literature (La Fontaine, Scarron), while those after Baudouin adapt this process to music, as those after Watteau had for theatre.

Whether the verse itself is created or derived, the decision to versify a print is a *choice*. It is one of the many practical decisions to be made in the working up of a copper plate, each of which cannot be changed except through burnishing (resurfacing) and reworking prior work. Since the image constitutes the major portion of the workable surface, the print letter itself comes rather late in the process. This can be illustrated by an unfinished 'before letter' preparation and its definitive state (figs. 8 and 9). Seeing it for the first time, what might this print be titled? What (and how much) verse should be placed in the allotted space at bottom? How could it be agreeably and effectively distributed in the print letter (one or two columns)? Does this choice depend upon a horizontal or a vertical print format? After all, a print *requires* neither title nor verse, and many prints have neither. Would poetic inferences be misleading? *Le Joli Dormir* (also called *Le Doux Sommeil, ou l'Aimable Repos*) could refer to a maiden but does refer to a matron (and to sexual commerce). Its advertisement betrays similar ambivalence as to its subject even as it falls back on the appended verse for an interpretation:

> Puisque d'un cher Epoux vous regrétés l'absence,
> Ce Sommeil ne sçauroit venir d'indifférence,
> Sans doute qu'en dormant pour calmer vos soupirs,
>
> Un rêve officieux le rend a vos desirs,
> Ah! dirés vous bientôt, je n'ai vu qu'un mensonge,
> Mais le plaisir est-il autre chose qu'un songe.[16]

While no one ignorant of its two states could have noticed the refinement of facial expression into a faint smile denoting a pleasant dream, this iconographically significant detail begs the question. Would the image be somehow better or stronger if left to itself? What happens when one *grafts* a text onto an image, often an existing painting, as was commonly done with Watteau and Chardin? (What if it were a Greuze or a David?) More to the point, what if an image of a somnolent female some sixty years earlier (fig. 10) gets its title from its poetic incipit and relies on that poetry to make a related point?

> Ne reveilléz point cette Belle
> Marchéz doucement parlez bas;
> Epouse encor toute nouvelle
> Le repos nourrit ses apas,

Fidelle au Dieu de L'hymenée
Elle veut en avoir vn fruit;
Et ne dort pendant la journée
Q'uafin [*sic*] de mieux veiller la nuit.[17]

What if one simply relies on a title such as *Le Repos* (fig. 11)?[18] One might conclude (correctly, I believe) that apparently 'subjectless' scenes have a longer, richer tradition than we think possible. As paintings, they call up no specific associations beyond a general mood or action; as prints, they are meaningless – and commercially pointless – unless somehow *invested* with meaning. The later Ancien Régime knew but three means of implying content in prints: (1) a title alone, (2) title and verse, and (3) verse alone. Collectors of before-letter states went resolutely in another direction.[19] For them, what mattered was the beauty of a print fresh off the press and/or its presumed rarity (fabricated rarities were rapidly integrated into the commerce, and just as rapidly deplored). Most of the public, however, appreciated the unity of an image and its letter or verse. The increasingly popular cabinet pieces – *petits sujets* in subject as well as size – mitigated differences in class or education by intimating attitudes and motives as well as actions and reactions in given situations. As Montaigne noted in philosophy, everyone understands when 'inductions and similarities are drawn from the commonest and most familiar actions of man.'[20] Whatever their quality, and even unto satire, individual and group interaction lent themselves more naturally to versified prints than did other artistic genres.

We take all of these as givens, which they are. Choosing among them was one of the most important decisions taken by printmakers in respect of their own œuvre and that of others. The raising of 'neutral' images to meaning is a value-added process that also requires different things of the viewer. A print title may be trivial unless based on proverbial expressions; it tends to suppress psychological dimensions in favour of a label. Print titles and verse complement each other rather like a chapter heading and its text do; they must first be related to one another and then to their image.[21] Verse alone, however, is experienced *alternately* with its image, rather like a label for a work on exhibition. It matters little whether one begins with one or the other; moving back and forth between them builds meaning and, with it, insight. How quickly this relationship becomes apparent depends on how much of the one is in the other, that is, situations, prompts, and key words in what is in effect a poetic novella. Depending upon its size and the relative proportion

allocated to image and print letter, the copperplate itself affects this dynamic. Large horizontal plates better integrate while subordinating verse, since the image not only prevails but dominates. The smaller vertical plates with extensive verse from the early part of the century mean that their texts assume material and intellectual primacy. The question then becomes how easily and effectively this process – evocation and allusion – can be applied to images that possess meaning at first glance, as mythology and history, or to genres that naturally invite comment, as portraits and street scenes.

All this is peculiar to the print that (unlike a drawing or painting) carries its own textual descriptors everywhere with it in the lower margin or print letter. Contemporary terminology referring to a print's 'author' is also a literary analogy. Significantly, it applies indifferently to either the printmaker or the painter, but especially to the former. This perceived dichotomy led to two systems of classification – by artist or by engraver – each with a different emphasis. Both systems are still with us today, so prints are studied and used in two different ways: in and of themselves and as iconographical surrogates for what they depict.

2 Methodological Issues

The study of versified prints is fortunately not dependent on archives. These may not exist, have been preserved, or be accessible. Study emanates from the prints themselves, which is to say that it is purely object oriented in its early stages. Publishing the history of the Paris Print Cabinet in 1988 afforded me insights that situated further research and study there.[1] The traditional thrusts of print study can, however, be extended when dealing with versified prints to include the following:

1 Gestation of a print, normally paid for in three stages or states (*eauforte*; *terminé*, yet before-letter; *fini*). The final state has the print letter and verse. It was – and remains – known to all. This state is the most historically informative about all aspects of print culture and conventions. This may be why it is the least appreciated, for it is the least amenable to aesthetic or technical study (connoisseurship), albeit most suited to thematic usage (art; literary and pure history). Early collections naturally referred to the definitive state, then listing preliminary states as they were (or became) known.

2 Location and study of progressive print states – each potentially completing and enriching individual catalogues raisonnés or entries for given prints.[2] In theory this leads to myriads of addenda and corrigenda to existing publications, yet makes sense only within the context of individual prints. The problem remains as to how best to integrate such chance discoveries within the literature.

3 Assemblage of artist's proofs, retouched proof states, and 'annotated states' related to the aforementioned developmental stages. Inked or penned inscriptions – usually considered an act of unenlightened or well-intentioned vandalism by modern curators – actually testify to

the *historical* sense or interest of the writer, rather like marginalia in manuscripts. Printmakers' annotations tend to concern issues of fabrication.[3] Those of collectors go in all directions.

One can conclude that versified prints are expressions of art criticism in general and in particular.[4] They give synchronic development in types of images and treatments rather than focusing on a single painter, engraver, or type of subject matter. Present findings represent roughly one-tenth of a sampling of 11,000 prints, surely resulting in an acceptable initial typology. Even this statistic is misleading in as much as the sample includes prints reported but not seen or fully described, some of which are known to be versified, while excluding portrait series. Inclusion of the superabundance of versified portraits, many of which are very small or not of great interest, would defeat the purpose of this study. Yet portraits by well-known engravers can be among the most difficult to elucidate. Verse could also be suppressed; witness Miger's portrait of Madame Geoffrin (fig. 12). His *Memoirs* give the quatrain intended for the print shown at the Salon of 1779, no. 277, although it was issued with only her name, dates of birth and death, and an epitaph of sorts ('Son Eloge est dans le Cœur de tous ceux qui l'ont connue'):

Tout concourut pour elle au bonheur de la vie;
Des grands, même des rois, elle se vit l'amie,
Mérita sa fortune en sachant l'annoblir.
Et des lettres, des arts fit son plus grand plaisir.[5]

None of this is surprising. Of all print genres, portraits and allegories are most subject to external forces and timeliness. Public figures – artists, *comédiens,* and literati on the one hand, officialdom on the other – provided an outlet for focused public sentiment in verse. Whilst the *act* of versification was so fundamental in French society that 'chaque nouveauté doit avoir sa chanson ou son épigramme, bonne ou mauvaise,'[6] the *perpetuation* of that act in typography and with an image was far more delicate since its authors could be more easily traced. Métra notes that an author could be sent to the Bicêtre prison for 'impertinence' in a print hemistich.[7] The intervention of censors may have been effective in the short term for a given print (Augustin de Saint-Aubin's *Benjamin Franklin* after Cochin fils) whose message was construed as potentially dangerous lese-majesty. It did not prevent the rejected verse from appearing on other prints.[8] In such cases, however, it was reduced to an

epigraph, as with F.-D. Née's otherwise untitled *Franklin* after Carmontelle.[9] When it corresponded to public sentiment, pre-existing verse could only be used prescriptively, that is, for the personality for which it was originally intended. Such, in 1778, was the impromptu of the Marquis de Saint-Marc for Voltaire:

> Aux yeux de Paris enchanté
> Reçois cet hommage
> Que confirmera d'âge en âge
> La sévère Postérité.
> Non tu n'as pas besoin d'ateindre au noir rivage,
>
> Pour jouir de l'honneur de l'immortalité;
> Voltaire reçois la couronne
> Que l'on vient de présenter:
> Il est beau de la mériter,
> Quand c'est la France qui la donne.

Grimm notes that 'il s'en est répandu mille copies dans un instant.'[10] Although absent from the authoritative Gaucher print of 1782, which correctly depicts the coronation of Voltaire's bust after the sixth representation of *Irène* at the Théâtre-Français on 30 March 1778,[11] the verse itself appears on all sorts of variant scenes relating to that event, including Nicolas Dupin's *Habillement de Voltaire Modes Françaises, en 1778* (fig. 15).[12] More significantly, some print letters retain only the final quatrain – the peroration of Mme Vestris's declamation – or just the last two lines.[13] By what logic and with what effect?

The body of evidence suggests that the quatrain, whether emanating from the general public or from the producers or consumers of prints, is the most natural and sustainable verse scheme – the one most likely to fully integrate image and text. (In some *vues d'optique* it complements or replaces the second identification of the subject in the lower margin.) Easily tossed off by amateurs and professionals alike, its cadence is scanned as readily by eye as by voice, while its rapid rise and fall is equally satisfactory for narratives and encomia. This was not something new, merely part of a steadily evolving tradition in French *estampes de modes, mœurs et de société* as early as the 1660s to the 1690s. In works by Nicolas and Henri Bonnart and Nicolas Arnoult inter alia, the quatrain extends the print title in various ways, including amorous equivocation. This unsigned verse adds an extra dimension, rapidly taken in and digested, to

print margins accompanying depictions of trades, occupations, activities, or situations. What the eighteenth century adds through its choice and presentation of subject matter is the artistic and psychological complexity of the real world. Even when a person, a portrait, and circumstances are entirely fabricated, as in Johann-Elias Haid's print of a poet presumably imprisoned in the Bastille for forty years (fig. 18), the social context of the quatrain is proclaimed in its two final lines (italics added),

> Eh! quel crime? d'avoir, dit on, en quatre vers,
> Osé parler d'un fait *connu de l'univers.*[14]

which alludes to the power of a quatrain's witty conclusion. This suggests why, in an unscientific sample of some 1,250 versified prints, roughly 50 per cent have four lines, and 23 per cent have eight, while only 12 per cent have six. Line increments naturally rise by twos, but their total number falls off dramatically after eight lines (essentially two quatrains, one to create and one to resolve a situation, generally disposed in parallel columns). One portrait, that of Edme Sébastien Jeaurat by Louise Jacquinot (fig. 13), even features two quatrains alluding to his career as an astronomer, each signed by a different author.[15] The rise in elegance of prints graced with text also led some *graveurs en lettres* to sign their work, previously an anonymous if necessary craft.[16] And if we follow Courboin's clever analogy with the *cul-de-lampe* in books, poetry may have had *aesthetic* purpose as well.[17] Its absence, particularly when portraits were concerned, must have led to the many known suggestions and alternatives for specific print letters. For example, Chardin was widely known and loved for engravings made after his work, between 1723 and 1757. His likeness was issued by Laurent Cars with the customary print letter (name and titles) of the 'Cochins' (fig. 17). However, when the print was announced prior to exhibition in the Salon of 1755, no. 166, Chardin was praised as the La Fontaine of painting, and his printed portrait deemed worthy of being graced with the following epigram:

> De quoi pourrait ici s'étonner la nature?
> C'est le portrait naïf de l'un de ses rivaux.
> S'il respire en cette gravure
> Elle parle dans ses tableaux.[18]

Simple biographical data in print letters were often deemed insufficient to characterize someone's life and achievements, much less to reveal

his human traits to succeeding generations. Epigrams naturally differed in emphasis for the living and the dead. When these form part of a portrait collection, such as Desrochers's *l'Europe Illustre* (Suite Odieuvre),[19] they are a recognizably serialized product.[20] Not so the 'Cochins,' the wonderful *portraits en médaillon* repertoried by Charles-Antoine Jombert in 1770, a genre whose vogue stretches from the early 1750s to the death of Cochin fils in 1790.[21] These reveal a different creative attitude, being issued and passing more as isolated prints of contemporaries than as elements of a historical compendium. When Jombert advises that 'il faut en avoir une épreuve avec le nom gravé au-dessus du portrait, avant les quatre vers de Voltaire qui y ont été ajoutés après coup' with regard to Flipart's *J. Du Ronceray epouse de M. Favart*,[22] he addresses the print's overall quality, not its information or poetic embellishment, as would someone studying these matters. Dealing, as they did, with contemporaries, still more Cochins appeared until the artist's death two decades later. Having been cleverly farmed out to many talented engravers, they avoid the constraints inherent in a single, if exceptional, draughtsman or printmaker. Their miniature-like format was adapted through differences in technique, accessories, and the use of both factual and poetic print letters.[23] One of these, Augustin de Saint-Aubin's *Piron*, suggests, as did Miger's *Mme Geoffrin*, that the urge to versify could be resisted even when a poet was concerned. In its second state (fig. 5, an advanced preparation or underlayment, whose effigy and marbled backdrop were completed only in the third state), an etched distich below the signatures sums up the essence of the epigram in general, and of Alexis Piron's work in particular:

Soutient [*sic* for Soutien] du Vrai Comique il se rit de nos Drames,
Il sait se faire Aimer Malgré ses Epigrammes.

The distich disappeared in favour of birth and death dates in its fifth and final state.[24] This change also poses the essential but oft-neglected question of timelines in print creation, for Piron died at eighty-four years of age on 21 January 1773, and this commemorative print, dated 1773, was completed in time to figure in the Salon *livret* along with three other Cochins (1773, no. 286). We know that Cochin's 'sitters' were unposed, often conversing, seen and drawn in social situations – hence their animated profiles – so Piron's effigy already existed (but for how long and in whose hands?) before being turned over to Saint-Aubin for execution.

Everything from concept to realization in a portrait print is potentially a variable, with size and complexity most affecting the engraver's task

once the model has been selected. These factors may well have played a role in the choice between epitaph and epigram types of print letters, one of the best mixes of which is seen in another post-Jombert Cochin, its unsigned verse commemorating the print dealer and entrepreneur Pierre-François Basan (fig. 16):

> P. FR. BASAN, Né à Paris, en 1723
> De l'Art de la gravure il étendit le goût,
> Au chemin de l'honneur il trouva la fortune,
> Et joignant au talent une ardeur peu commune,
> Toujours avant l'aurore, on le trouva debout.[25]

Portrait verse stating more intimate knowledge of personal traits can be found in less formal and presumably less commercial prints such as Boilly's 1794 *Grimod de la Reynière* –

> Gai, vif, original et même un peu bizarre,
> Il censura nos mœurs dans ses piquants ecrits,
> Et de ses soins jamais son Cœur ne fut avare
> Pour sauver l'innocence, et servir ses amis.
> Par M. ****

– while the use of suspension points or asterisks that reduce authors to simple male or female entities is seen throughout eighteenth-century France. This convention serves as a reminder that unsigned verse on portraits of family and friends – and other works intended for limited if not private circulation by *amateur* engravers – is likely to be their own.

Yet, possibly the most eloquent versified print of the era was printed with no verse at all – Cochin fils' 1764 Eclipse allegory (fig. 20).[26] This cartel was created between the solar eclipse of 1 April 1764 and the sudden death of Madame de Pompadour on the fifteenth following. Charles-Simon Favart's intended verse on her convalescence and the plate itself were suppressed, indicating the celerity with which such prints were created (or sacrificed) in the face of changing circumstance:

> *Du premier avril 1764.*[27]

> Le soleil est malade,
> Et Pompadour aussi.
> Ce n'est qu'une passade;

L'un et l'autre est guéri.
Le bon Dieu qui seconde
Nos vœux & notre amour,
Pour le bonheur du monde,
Nous a rendu le jour
Avec Pompadour.

Votum populi laus ejus.

Artists had become more accustomed than others to quantities of adu-
latory verse inspired by works seen in their atelier or at the Salon du Lou-
vre, although some, such as the sculptor Houdon, took what measure
they could to see that these remained in their own hands, unpublished.[28]
Public figures resigned themselves to the circulation of all manner of
scurrilous or satiric verse on their actions or portraits.[29] Others doubtless
counted on the respect due their rank or gender. Mme Lingée's print
of the Marquise de Villette after the miniaturist Pujos (fig. 14) was an-
nounced with the verse

Elle eut Voltaire pour Parrain,
Belle & Bonne, est le nom que lui donna Voltaire.
Et ce nom mieux que le burin,
Peint sa grace & son caractere.[30]

Two days later, Pujos published a double disclaimer on behalf of both sit-
ter and poet (her husband): 'C'est sans le consentement de cette Dame
que ce prétendu Portrait a été gravé & annoncé, & l'Auteur du quatrain
n'a jamais eu l'intention qu'il soit rendu public, ni par l'impression, ni
par la gravure.'[31] He did so with reason, for within the week commenta-
tors had already seized upon the unhappily mixed metaphor: 'Jusqu'ici
l'on pensoit que le burin ne peignoit, puisque peindre y a, que les traits
de la figure.'[32] What also seems at question is *intent* to publish, not the
fact of a (presumed) life portrait and its verse. Pujos specialized in what
Karl-Heinrich von Heinecken called 'Gens, qui se sont acquis quelque
réputation' but who did not fall within the traditional portrait classes.[33]
There seems to have been no question of withdrawing the print itself
from circulation, so appearances were preserved by the insertion.[34]

Taken together, prints link phenomena that would otherwise be
seen as separate issues, fit only for discrete repertories. Had I not been
interested in versified prints I should not have remarked one by Hor-

ban after Mme Vigée-Lebrun that was 'dessiné et gravé de mémoire' after a painting from the Salon of 1787 – opening up another, quite fascinating, research parenthesis (fig. 19).[35] Or the portrait of the author Jean-Antoine Roucher, done the night before he was guillotined, later printed and circulated to family and friends with his own verse (fig. 21).[36] Three days after Leroy's portrait drawing of 6 Thermidor, for the artist was similarly incarcerated rather than being brought in to do his work,[37] the Thermidorian Reaction set in. Robespierre was guillotined and the Terror was over.

Lest we forget, familiarity with versified prints permits *by analogy* the identification and better titling of contemporary paintings and drawings, such as a Greuze in the National Gallery of Canada (fig. 23). Formerly considered *Le Paralitique* (most unlikely, given the clothes, walking stick, and gaiters), in 1988 it was retitled *Le Retour du voyageur* by unspoken reference to Vidal's 1772 *L'Heureux Retour* (fig. 22), a print after Johann Eleazar Schenau, who worked in the shadow of both Greuze and Jean-Georges Wille (whose son Pierre-Alexandre was also apprenticed to Greuze). Although such layered artistic influence is uncommon, the action and supporting verse are not: 'Le Ciel enfin te rend à ma vive tendresse, / Qu'il soit beni cent fois de ton heureux retour. / Cher Epoux, Chers Enfans, que ce jour d'allégresse / Dans nos Cœurs réunis, fasse briller l'Amour.' Anecdotes are necessary and unavoidable in the writing of print history. So is narration.

The 'ideal' versified print, such as Larmessin's 1736 *Les Amours du Bocage* after Lancret (fig. 25),[38] is immediately accessible to the reader and perfectly aligned in text and image:

> Que cet heureux Oiseau, que votre main caresse,
> Est bien recompensé de sa Captivité:
>
> Le Berger qui vous sert avec tant de tendresse
> Est moins libre et moins bien traitté.
> <div align="right">Roy.</div>

Its problem is similar to that of suitable label lengths for art exhibitions: the longer they are and the more they say about what is actually seen, the more one loses interest in them because of the effort one spends; in other words, the more one is drawn to the text from the image, the less the two can be taken in concurrently. For example, both the Chardin and the Allou females seen here are portraits, but the former, as in

L'Instant de la Méditation (fig. 26), remains generalized, important more for what *surrounds* her than for *who* she is, while the latter's incarnation as *L'Optique* (fig. 27) specifically refers to the artist's wife, here seen in the complex process of drawing an anamorphosis.[39] Hence the extended reference to her learned qualities.

Much print verse is signed. A repertory of authors and incipits would prove useful and be datable in part thanks to the prints themselves and/or to print announcements in the newspapers, which identify, albeit rarely, the author of unsigned verse.[40] Many early *annonces* even cite the correspondence between text and image as a commercial ploy, as did the aforementioned 1736 Lancret: 'On lit ces vers au bas.'[41] Transcribed verbatim from the print letter, texts for many new prints in *Mercures* of the 1730s and 1740s conclude with verse as an informational element describing the print itself. The dilemma arising between the interaction of title, verse, and subject comes when attempts were made to describe the composition rather than give the subject of the print. Verse almost invariably concludes such annonces, so we must also conclude that it was thought to adequately describe the image, even as the painting inspired the verse. It is doubtful, in viewing a print, that it would be bought for the verse alone; however, in *reading* about a new print, the citation of its verse surely had great force for a society more accustomed to words than images. Even so, one begins to find wordings during the same period that affirm their complementary nature: 'Ces vers sont de M. Lépicié, ils expriment très-bien le Sujet du Tableau [his *La Mère laborieuse* after Chardin].'[42] Or, for Balechou's *L'Opérateur Barri* after Jeaurat: 'On lit au bas, la dixiéme Epigramme de feu M. [Jean-Baptiste] ROUSSEAU, qui exprime très-heureusement le sujet.'[43] Balechou also employs Rousseau for *La Naissance* and *L'Enfance* after Dandré-Bardon,[44] illustrating an early stage of development – an age of innocence where subject matter was easily paralleled and matched, even posthumously so, in the existing works of authors.

In time, however, come affirmations that verse dispenses with the need to describe the image: 'Comme les vers qui sont au bas des Estampes en expliquent mieux le sujet que tout ce que nous pourrions dire, nous allons les rapporter.'[45] These prints by Claude II Duflos after Boucher – *La Toilette Pastorale* and *Les Confidences Pastorales*[46] – have titles that are more allusive than descriptive, less readily conjuring up an image or situation than does the work of the generation of 1699/1700.[47] Duflos (1700–80) was one of Boucher's principal interpreters until 1755, and his verse is signed by a half-dozen poets who had to respond to the new

art of Boucher, with its endless variations and repetitions.[48] The pasto-
rale is, however, more a category or type than a subject (little wonder
that the *Mercure de France* defers to the poetry to explain the image).
What cannot be said by those of literary profession is anything concern-
ing the style or complexity of the work reproduced unless its subject can
be readily reduced to a line or so, its stylistic particulars being carried by
the name of the painter. The next complication in advertising versified
prints comes when the freedom of action inherent in single prints is
tempered by the rise of pendants.

In the early years of the century most people understandably never
saw the paintings or drawings in private collections that served as models
for prints. This was true, as well, for works shown at the Salon, intended
as it was to arouse comment and emulation and to direct taste. It is not
by accident that the annonce for Bernard-François Lépicié's *Le Bénédicité*
situates its historical and artistic importance by stating:

> Ce Tableau est placé dans le Cabinet du Roi, & n'est pas un des moindres
> Ouvrages de M. Chardin, qui en a fait plusieurs excellens. Il a été exposé au
> Salon du Louvre [1740, no. 61], où il a réuni les suffrages de tous les Con-
> noisseurs. Le sujet du Tableau est exposé dans quatre vers de M. Lépicié,
> qui sont au bas de l'Estampe.
>
> La Sœur en tapinois se rit d'un [*sic* for *du*] petit Frere,
> Qui bégaye son Oraison.
> Lui sans s'inquiéter dépêche sa Priere;
> Son apétit fait sa raison.[49]

It is not that verse is merely being appended to an image; it is clearly in-
tended as a means of revealing and interpreting content, as a narrative.
It becomes an ecphrasis of sorts that permits readers to ponder subject
matter, visualizing it as they will in the absence of a human situation that
will be fully revealed once the print has been purchased. The poetry
both describes – *and sells* – an image that remains unseen and unde-
scribed, particularly so when it is sold by correspondence rather than vis-
its to the studio or shop. A curiosity factor is at play here. In contrast, the
compression required in early sales and collection catalogues generally
precludes full citation, merely alluding to the number of verses present
on individual prints or suites.

The one thing that the poetry cannot tell us is what changes were
made to the composition being engraved. A rare example – where we

know exactly what happened and roughly when – concerns the pendants *Le Chant* and *La Tourterelle*.[50] We likely know this only because their owner, Lalive de Jully, was known for his collection of contemporary French painting and sculpture[51] and because his catalogue was established by Mariette prior to its sale. Their entry notes that 'Les deux femmes ont été peintes à Rome, & les figures accessoires ont été faites à Paris plusieurs années après. Ces deux tableaux sont gravées par FESSARD, comme ils étoient en arrivant d'Italie avant les augmentations que l'Auteur y a fait.'[52] These changes were introduced by Lagrenée the Elder prior to their description in the Salon livret (1755, no. 126). Six years later, Étienne Fessard engraved them with verse by Pelletier, who applies a common topos on the amorous nature of doves (fig. 24):

Objet de tous vos soins, dans vôtre plus bel age,
Cet Oiseau, jeune Iris, a l'art de vous charmer:
Vous le verez un jour, par son tendre langage,
Apprendre à vôtre Cœur qu'il est fait pour aimer.

Exceptional as this case may be in documenting changes in paintings that were engraved, it is proof positive that versifiers worked from what they saw. The result depended upon their culture and imagination. Purchasers only noted that the print title and verse matched the image.

Like other prints, versified portraits presume intent, written or oral exchange, and, if not a contract, at least an understanding. Unlike versified subjects, however, highly personal variables come into play when determining a likeness and its accompanying message. Whether sollicited by engravers or as a result of commissions, portraits imply a measure of control by the patron that we are rarely able to document. When we can, as with Per Gustave Floding's work for the Count and Countess Tessin, the dossier gives a tissue of issues and responses that might be applicable elsewhere.[53]

For the print of his countess (fig. 28), Tessin himself signs the 'Vers pour mettre au bas du portrait de Mad.ᵉ de Tessin et au dessous de son nom' even before the model was forwarded for graphic reduction and engraving.[54] A flurry of correspondence comes seven months later, when Floding broaches retouching the proofs for better effect.[55] He is advised against this since 'lorsqu'on est arrivé à un certain poinct, le mieux qu'on cherche est un pas vers la degradation, et les retouches deviennent des grimaces'; yet, one of the models was chosen, and the missive ends with a pressing request to get the print letter done.[56] Upon

receipt, Floding submits this proof state to the painter Gustave Lundberg for his opinion as to its effect as a print.[57] Early in 1768, as he finishes printing and needs to know the quantity of impressions desired, Floding confesses his problems in achieving the requisite effect, harmony, and resemblance, saying that he will return the drawing after Lundberg's model.[58] Tessin offers to pay whatever Floding wishes and to let him retain the copperplate (which he avers will not be melted down after its brief appearance, as are so many others), assuring him that the work is so faithful a likeness of his wife that her dog has just licked the work.[59] While accepting Tessin's praise, Floding expresses reserves, noting that the countess is only his third portrait – a difficult genre – and, rather than fixing a price, requests permission to do the count, his long-time protector.[60] Tessin's encouraging but terse reply leaves this decision to Floding, again dictating the content of the print letter: 'Si vous prennés, Monsieur, la peine de le graver, ce ne sera, s'il vous plait, qu'à condition de n'y pas mettre mon nom, mais simplement les vers suivans' (Voltaire's *Henriade*, Chant VII).[61] Most likely after Lundberg's pendant pastel,[62] the project seems to have been abandoned.

 This rare instance shows the care with which appended poetry, whether freshly composed or merely borrowed, was, on occasion, chosen. In its opposition of Virtue and Fortune, that of the countess contrasts with the philosophical and existential lines for the count, reflecting the divide between personal merit and accomplishment generally found in portrait prints regardless of gender. In the end, however, the choice and the gestation of the image dominate the correspondence although the entire print letter was determined ahead of time. Even this unusual case confirms the ultimate precedence of image over poetry.

3 Poetry as Cultural Expression in Prints

We often forget that poetry was so popular a means of expression that eighteenth-century France may be called the Golden Age of the Epigram. For a fortunate few, amateur verse was paralleled by etching since 'la manie de signer un paysage, une *bergerotterie*, était devenue à la mode, comme celle de signer un sonnet.'[1] The newspapers are full of verse for *this* person or *that* rumour or event.[2] So is the better correspondence of personal nature.[3] Improvised verse even became an entertainment at the Musée de Paris for an entrance fee of six livres.[4] That everyone 'tournoit tout en spectacle, s'amusoit de tout, même dans ses calamités' was noted when verse in honour of Louis XVI and Marie-Antoinette was placed on the 'Obélisques de neige' raised in the capital during the winter of 1784.[5] Or when the departure of a waterproof aerostat approved by the Royal Academy of Sciences, but unexpectedly 'orné d'une Figure allégorique, d'un Médaillon & de Vers à la gloire de M. Mongolfier,' was announced.[6]

Verse celebrating a painting, sculpture, or monument whether permanent or transitory is straightforward enough, as are events. Yet great caution is required in interpreting isolated 'Vers pour le portrait de ...' that appear in the gazettes lest they be confused with the true *literary* portrait genre.[7] Similar distinctions must also be made between verse penned by the public at large and that penned by those within a sitter's circle, as when a person

... attachée à M. Monmartel et qui a joui jusqu'à sa mort de sa confiance, nous a envoyé les quatre vers suivans pour mettre au bas de l'estampe [fig. 29]:

Les traits qu'avec plaisir chacun ici contemple
Offrent ceux d'un vrai citoyen:

Cher à son Roi qu'il servit bien,
Français, il vous invite à suivre son exemple.[8]

The point, of course, is that such effusions appear *upon* or *after* the publication of a print. In either case, the print letter itself remains unchanged.

Given their rapid diffusion and ubiquity, prints provided universal points of reference for the discussion of personalities and issues. They are *instruments* of culture, not just its documentary by-product. Expressions of poetic gratitude appeared in the newspapers, ostensibly for the gift of a print but equally as an indication of privileged relations with some personality.[9] Public discussion in the 1780s as to the most suitable inscriptions for the statues of the *Grands Hommes* seen at recent Salons prompted musings on the most successful types of verse to accompany portraits in general and the suggestion that, for a writer, 'on peut lui emprunter le vers, la phrase ou la pensée qui lui ont servi à se peindre lui-même.'[10] Poetry was often found pinned to works shown at the Salon du Louvre whether or not they were listed in the livret.[11] This practice continues into the nineteenth century – witness Pierre Lélu's etched *Monument à Desaix* (fig. 30) with its 'Vers anonimes qui furent attachées au bas du tableau historique de la mort de ce général peint par Renaud [J.-B. Regnault] et exposé au Salon l'an 10.'[12] At the other end of the scale lie far more utilitarian and ephemeral objects such as fans giving principal scenes from a comic opera, each with its ornaments and appropriate verse – the fans themselves giving rise to Moraine's flattering *A LA REINE, Pour lui présenter des Ecrans.*[13] And while Gabriel de Saint-Aubin seems not to have versified his own etchings, he seems to have frequented Sedaine and to have filled the latter's *Recueil de poésies* (second edition, 1760) not only with his *croquis* but with all sorts of topical verse.[14] Since they concretize art and social issues, prints become control factors for other documentation.

Prints also relate to literary tradition through verse pertinent to pastorales, bergeries, and generally any scene relating to amorous dalliance and offering some moralizing or cautionary note. This, not unexpectedly, is built around stock female characters such as Iris and Philis (on the order of two to one); its effect depends largely upon whether they are addressed directly or spoken about and whether second, third, or fourth characters are given by name to complicate the situation. Signed or not, these particular literary constructs span the century with supreme indifference to artistic tendency although they are

concentrated in its first half.[15] Other versified prints make little use of literary tradition while propagating a topos – the effects of love – which stands out as definably French in the print production of its day.

Once tabulated, the types of published or circulated verse relating to prints are ten in number in three classes: poetry on prints, about prints, and inspired by print subjects. These types include the following.

Congratulatory Verse to Painters and Engravers

In this type, congratulatory verse was normally signed and addressed to painters and/or engravers by members of the public upon the appearance of a print.[16] This contrasts with P.-A. Danzel's letter to the *Mercure de France* upon issuing his *Voltaire* (fig. 33), nominally to warn against any *mauvaise copie* that might result from his work.[17] To underscore its 'perfect resemblance,' he then inserts Voltaire's letter of 11 December 1765 to the Marquis de Villette, author of the print verse, which alludes to the artist's *belle main*:

Je me souviens très-bien que,

Ce *Danzel*, beau comme le jour,
Soutien de l'amoureux empire,
A dans mon champêtre séjour
Dessiné le maigre contour
D'un vieux visage à faire rire.
En verité c'étoit l'amour,
S'amusant à peindre un Satyre
Avec les crayons de *La Tour*.

Il est vrai que dans l'estampe on me fait terriblement montrer les dents; cela feroit soupçonner que j'en ai encore.[18]

Danzel's clever ploy was not easily transferable to others and would probably not have been published were it not for the sitter's notoriety. Whether Voltaire's subtle criticism sank in is not recorded and may not have mattered in the rush for any Voltaire likeness taken at Ferney.

Congratulatory Verse Addressed Privately to an Engraver

Congratulatory verse was addressed privately to an engraver and referred to his œuvre as well as given prints. The engraver Wille considered the

ode sent to him in Paris by Stürtz of Darmstadt to be 'bien faite et mag-
nifiquement *imprimée*' (italics added).[19]

Impromptus Inspired by the Gift of a Print

Impromptus were inspired by the gift or receipt of an easily identi-
fied print[20] or of an unnamed print whose identification is equivocal.[21]
Both show how easy it was to create the equivalent of print letter verse
upon seeing an image. Impromptus might also include the rare open
letter to a print collector with a detailed description and a poetic *post-
scriptum* inspired by, for example, 'cette Estampe, & le nom dont elle est
décorée' – Jacques-Philippe Le Bas's *4e Fête Flamande* after David Teniers,
dedicated to Mme de Pompadour.[22] The cultivated public habitually cre-
ated equivalents of print letter verse without preparation or premedi-
tation, although it was more meaningful if one knew or possessed the
print. Actual print versification, however, remained the preserve of a
select few.

'Vers pour Mettre au Bas d'une Estampe'

'Vers pour mettre au bas d'une estampe' were reactions prompted by an
existing or forthcoming print. These may be signed or unsigned, imply-
ing that a print might have a different or better print letter by having
a *poetic* one.[23] Some are published at the moment of subscription for a
commemorative print – well in advance of final decisions as to its de-
sign.[24] In the Suite Desrochers, the portrait of the Abbé Desfontaines
was anomalous in lacking a versified cartouche until the engraver (Petit,
successor of Desrochers) included two lines 'qui lui ont été envoyés par
un inconnu'![25] Verse published in the *Mercure de France* did replace a bio-
graphical text for another small-format portrait in its second state.[26] Yet
there is little evidence that such suggestions were taken seriously, at least
on a regular basis. There was little reason to do so when, as we shall see,
printmakers could (and did) obtain the services of eminent poets for
this purpose. Indeed, the lead-in to a quatrain submitted to the *Mercure*
by 'Le Désintéressé' makes it abundantly clear that it was never intended
to appear elsewhere.[27] The concision of amateur versifiers was suitable
for prints, but this type of published work is really a pastime gone public.
As personal effusions they are but one of many types of documents relat-
ing to people or events under discussion.

'Vers Proposés pour Mettre au Bas d'une Estampe'

'Vers proposés pour mettre au bas d'une estampe' were usually published anonymously – more properly, laudatory verse concerning the sitter for a portrait, or even 'vers fait sur ce personnage.'[28] Posthumous encomia also appeared, such as the 'VERS Pour être mis au bas de l'Estampe de feu M. Languet, Archevêque de Sens,'[29] a pious wish quite unable to be satisfied two years after its issuance.

These types of verse – external but related to prints – are similar to and often assume the form of Letters to the Editor as well as simple insertions. Signed or not, they have deeper cultural meaning and resonance since they reflect societal habit. With regard to portraits, as many as possible differing redactions of annonces must be consulted. This may result in attributing the verse or otherwise corroborating the identity of the versifier, many of whom belong to the category of 'beloved or illustrious friends or relations, or notables.'[30]

Such passing references can be expected. Fuller records can occasionally be compiled for artist portraits that illuminate print design and display, even the model itself. Working backwards in time, a certain Laffichard thanks in verse the celebrated pastellist Maurice-Quentin de Latour (1704–88) for the gift of a print by Georg-Friedrich Schmidt shown at the Salon three months earlier (fig. 32).[31] Now the Salon of 1743 is the last of five annual Salons whose abbreviated handlist (without descriptions or dimensions) was printed in the *Mercure de France*, often with cursory reportage of public reaction to the work of each exhibitor. Schmidt's entry unexpectedly concludes thus:

> Voici des Vers qui nous sont tombés entre les mains, destinés à mettre sous ce Portrait, où l'habile Peintre est représenté en négligé d'une maniére pittoresque, & tel qu'il est ordinairement dans son Cabinet:

> Pour bien exprimer l'art que cette tête loge,
> Faut-il implorer Apollon?
> Mon cher *la Tour*, je crois que non:
> Au bas de ton Portrait, pour faire ton Eloge,
> Il suffit de mettre ton nom.[32]

This reported verse, its origins veiled by a locution, could only have been intended for placement *under* the print on display at the Louvre, as will

be the case for Pierre Lélu's *Monument à Desaix* some sixty years later (fig. 30). What is important is the commentary identifying for Salon-goers the artist's garb and activity, if not his expression or gesture. When Crayen publishes his catalogue raisonné of Schmidt's prints forty-six years later, Latour's playful expression and theatrical gesture are attributed to being interrupted in his work to the point of locking the door. Upon the arrival of an importunate abbot friend just as he is doing his own portrait, 'Il semble se dire en lui même: voilà l'abbé, il n'a qu'à frapper il n'entrera pas.'[33] The pastel itself occupies only a fraction of the worked print surface, no provision being made for a lower margin beyond that for a discreet publication line. This runs counter to the design of most versified prints, in which poetry is isolated in the lower margin where it is most convenient and legible. Crayen notes that before-letter states of this Schmidt were rare (only definitive states of prints appeared in the Salon in any case), so his print was seen as it has come down to us, both authors being identified by a highly personal inscription – '*Peint par De La Tour / & Gravé / Par son Ami Schmidt / en 1742*' – that falls within a restricted number of print dedications commemorating relations between artists.[34] Exceptional in every way, this portrait within a decorative stone surround serves as reminder that when poetry becomes part and parcel of the image, it is less easily deciphered and becomes either a distraction or an irritation.

'Vers à un Jeune Graveur'

'Vers à M. Danzel, jeune graveur, pour l'engager à faire paroître deux de ses ouvrages dont le Sujet de l'un est Vénus & Adonis, l'autre Vénus & Énée,' by a Mme Guibert de F.,[35] is a peculiar and excessively rare use of poetry which suggests that going public and commercial was not taken lightly by emerging engravers.

Verse Appearing in Newspapers and Alluding to Given Prints

In this type, verse appeared in newspapers, alluding to given prints. Separate insertions may be cross-referenced to earlier numbers, as, for example, a March 1739 poem referring to a *Martir de S.ᵗ Pierre* after Matteo Preti that had been announced six months previous and published without verse (fig. 34):

Cur Capite inverso plantas ad Sydera tollit,
Suspensus Dominâ Petrus in urbe Cruci,

Ut Caput in terris summum sub principe Christo,
Seque piis rectum monstrat ad Astra Ducem.
J. Coullon, de Paris.[36]

At the opposite pole is the six-page ode published in 1752 in praise of Dr Daviel's cataract procedure, the first lines of which, along with their source, appear in 1760 under a rather abstruse allegory by the painter Devosge as public thanks for a successful cataract operation (fig. 31).[37] Unfortunately, not all verse of this type actually appeared. Having lauded Lépicié's *La Gouvernante* after Chardin's recent Salon picture (fig. 35),[38] the *Mercure de France* confesses that its appended verses were 'peu de tems après, traduits fort heureusement en Vers Latins, par un Auteur Anonyme, & ils étoient destinés à paroître dans le Mercure. Mais on ne sçait par quel accident ils se trouvent égarés, en sorte qu'il nous a été impossible de les retrouver; sur quoi l'Auteur est prié de vouloir nous les renvoyer, pour remplir leur destination.'[39] What intrigues is not so much the event as the intent – composition of a Latin equivalent of Lepicié's own print quatrain that the *Mercure* obligingly republishes:

Malgré le Minois hipocrite
Et l'Air soumis de cet Enfant,

Je gagerois qu'il prémédite
De retourner à son Volant.

Poetry Concerning Printed Portraits or Allegories

Poetry concerning printed portraits or allegories such as that arising from Carle Vanloo's *Mlle Clairon en Medée*[40] seems prompted more by the notoriety or social position of the recipient. This is rather different from the verse, attributed by Grimm to the abbé de Voisenon, printed below *Mlle Favart en Bastienne*, also by Carle Vanloo (fig. 36),[41] and relating directly to her innovation in theatrical costume, dressing in rough fabrics and sabots rather than appearing as the traditional Boucher shepherdess clad in silk and taffetta known from the Foire Saint-Germain, the theatre district of Paris during Lent. And it differs even more from Gravelot's allegory with its retroactive epigram by David Garrick: 'J'ai prédit que Clairon illustreroit la Scène . . .'[42]

This sector is by far the most unpredictable given its reliance upon public opinion. Of all the verse inspired by the Medea role (fig. 37), by

far the most endearing (and appropriate) in print context is the follow-
ing 'VERS mis, par un Amateur, au bas d'une estampe de Mlle Clairon':

> Cette divinité, que la France idolâtre,
> N'étaloit qu'à Paris ses talens précieux,
> Il falloit à Clairon un plus vaste théatre;
> Par l'effet du burin elle brille en tous lieux.[43]

While this could refer to annotating a before-letter state, it may indi-
cate that the owner annotated an unframed impression below the image
(figs. 51 and 52), the plate-mark, or a mounting sheet (figs. 104 and
105). At any event, some such cases permit us to assign a response time
required for the distribution of a print and the printing of verse relating
to it (here, between September 1764 and April 1765).

Published Verse Referring to Unidentifiable Prints

In this type, published verse referred to prints that are not immediately
identifiable.Personal reminiscences of verse alluding to prints whose ex-
istence is unsure are also included in this category.[44]

Unpublished Verse Circulated to Subscribers

Nominally unpublished verse was circulated to subscribers in privately
published newspapers. Generally of satiric nature, often settling scores
when public figures or events are concerned, such verse has a print
repertory that is an iconographer's dream in deviations from what was
intended, as, for example, in a commentary on Voltaire's *Henriade*. Au-
gustin de Saint-Aubin's print placed Voltaire's portrait medallion above
those of his editors, and the *Mémoires secrets* note that 'un partisan de ce
grand homme a fait le quatrain suivant, où le madrigal est si finement
enveloppé dans l'épigramme qu'on a peine à l'y trouver. L'idée est prise
du parallèle naturel que l'estampe présente avec la figure de Jésus-Christ
au milieu des deux larrons: Entre La Beaumelle et Fréron / Un graveur
a placé Voltaire. / S'il s'y trouvait un bon larron, / Ce serait sans faute un
calvaire.'[45]

The range and purpose of the aforementioned quatrain is impressive
in itself. So is the fact that it appeared in journals of record that anyone
could have accessed at the time. These instances are, however, so widely

scattered that their importance is historical and cumulative even if their intent was circumstantial and momentary. Unlike many poetic insertions in public papers, they have one thing in common. They add up to something unimagined then, something as unexpected as it is valuable to us now: they define through verse the contemporary attitudes towards prints in general as well as documenting a variety of individual prints.

4 Case Studies of Text versus Image

Perhaps the easiest way to understand distinctions and subtleties in versified prints is to give paired prints – identical or categorized images that are differently presented – with a cursory discussion of the issues surrounding the iconography, all of which have to do, albeit in different ways, with the authority of the image. Whoever the author and whatever the rhyme scheme, the verse tends to fall into three modes: declarative (factual or descriptive), speculative (scenes or situations), and vocative (direct address of a protagonist).

Created and Cited Verse

By verse is meant occasional poetry created for a print as opposed to the citation of existing verse followed by its source. The first is represented by Danchet's verse for Cochin père's *L'Amant sans gêne* after Jean-François Detroy (fig. 38):

> Fuyez, Iris, fuyez: ce Sejour est à craindre.
> Tandis que de ces eaux vous cherchez la fraîcheur.
>
> Des discours d'un amant déffendez vôtre coeur.
> Ils allument un feu difficile à S'éteindre.[1]

The second can be seen in Jean-Antoine Pierron's *Le Retour trop précipité* after Lavreince (fig. 39):

> Il profita de son premier tribut,
> Trop bien peut-être, et mieux qu'il ne fallut.
> <div align="right">(La Fontaine, Contes)[2]</div>

The work of some artists seems to lend itself naturally to *original* versification, yet we must always ask how much of this was dependent on changing taste and times. Prints after Baudouin are rarely versified, compared to about half after Chardin and virtually all after Lancret – even those of literary inspiration. Moreover, the creation of verse for subjects and for portraits implies two very different mindsets. That for portraits, whether of historical or contemporary figures, is a distillation of what is known, said, or felt. Poetry for subjects proceeds from the analysis of what can – or could – be made of the image that it is to accompany. Given its impromptu nature and the expectation of wide diffusion, this is a particular challenge even if the actual steps in the process remain unclear. It is possible that versifiers worked from before-letter states, in which case the composition is complete in essentials, and the space available for the print letter is clearly defined, the components of which are variable in number and in length. Process and protocol would likewise vary were the versifier to be rather more 'resident or familiar' than 'invited' – certainly so when his name appears under his work. All this, while logical, remains conjectural until it is documented.

Once Painted, Twice Engraved

Most paintings or esquisses (which can include drawings) were engraved only once. If they were engraved twice (figs. 40 and 41), could a difference in engraver and verse (or a slight change in title) have made one think differently about the composition or subject – particularly since both Claude II Duflos and Jean Daullé were among B oucher's preferred engravers? Hence Duflos's 1748 *La N'aissance* [*sic*] *de Vénus*:

Le liquide Elément est Fécond en n'aufrages [*sic*],
Les Aquillons souvent y montrent leurs fureurs.
Mais jamais sur les flots on ne voit tant d'Orages,
Que les yeux de Venus en causent dans les cœurs.

Cette divinité que la Mer mit au Monde,
Aux Dieux comme aux mortels sçait imposer des fers,
Elle à prit [*sic*] dans le sein de l'onde
De quoy mettre en feu l'univers.
<div style="text-align:center">Panard.[3]</div>

may be compared with Daullé's 1750 *Naissance et triomphe de Vénus*:

> Quelle Divinité sort du Gouffre des Mers?
> Que d'Amours autour d'elle elancés dans les Airs!
> Tritons, accourez tous de vos grottes profondes;
> Nymphes, presentez lui l'hommage de vos ondes.
>
> Déja tout reconnoit l'empire de ses yeux;
> Leurs regards vont plus loin que les traits du Tonnerre:
> Si les Dieux regnent sur la Terre;
> Souveraine des Cœurs tu regnes sur les Dieux.
> par M.^r le Brun[4]

Yet cursory examination reveals that these two images do not really correspond to each other. Whether, in the cataloguing language of the day, one considers them *changements* or *augmentations*, such differences could be due the painter or (less likely for such an important living artist) the engraver. Only upon remarking that Daullé's print letter reads '. . . d'après l'Esquisse peint par F. Boucher' does it become clear how the works are related. The Duflos, previously shown as a painting at the Salon of 1743, no. 7, has a pendant, the Daullé none, perhaps because the esquisses were separated. It is rare for both a painting and its oil sketch to be engraved; that the one should wind up competing with the other, explicated by much the same verse conceit, gives pause.

Print Letter Modifications

When the same copperplate is concerned – for example, Pierre Filloeul's 1734 *La Courtisanne amoureuse* (figs. 42 and 43) – we must ask how differently one would have reacted if the verse were in Latin or French only, or in both languages (the Watteau print tradition). In the long term the trend was towards the vernacular. Two years later, announcing four new prints for what became the *Suite Larmessin*, Filloeul, with his predilection for engraving Pater, noted that the first four of the series – *Le Baiser donné*, *Le Baiser rendu*, *La Courtisanne amoureuse*, and *Les Aveux indiscrets* – originally had French verse with Latin translation, thereafter effaced in favour of new, more extensive French verse to avoid repetition on the one hand and to enhance æsthetics or

comprehension on the other.[5] In any event, once Fillœul's prints were distributed by the editor de Larmessin, French was required to harmonize the entire suite for commercial purposes. Thereupon, sixteen lines of entirely different French verse replaced the following eight of the original print letter (fig. 42):

Aussi fiére que belle, et bisarre surtout,
Constance dedaignoit gens du plus haut étage:
Prince, Comte, Marquis, rien n'estoit à son gout.
Amour voulut punir cette Beauté sauvage.
Il vous lui met en tête un petit Fierabras,
Qui cruel à son tour se fait tenir à quatre.
Rien ne peut le gagner; pour se laisser abatre
Il exige en Tyran l'office le plus bas.

Pulcra Philis vano simul et tumefacta decore
Conculcarat opes, stemmata respuerat
Iratus sed enim Volucer Cythereius arcum
Tendit, et immitis corda superba ferit
Quid non vincit amor? claros quæ spreuit amores,
Nunc despecta, humili flagrat amore Philis.
Nempe trucem infelix quæ flectere possit amantem,
En serva abjectis fungitur officiis.

This is in marked contrast to the later version (fig. 43):

Si Constance dans Rome excelloit en beauté
Courtisanne jamais n'eut tant de vanité:
Rien n'étoit bon pour elle en cette grande Ville,
Quand son superbe cœur se rendit à Camille.
Quel changement alors! oubliant ses appas,
Pour toucher son amant rien ne lui paroit bas,
Et celle qui regnoit avec un fier Caprice,
Se rabaisse en tremblant au plus humble service.

Amour, rien ne t'arreste, et tu sçais étouffer
Tout sentiment qui semble à tes desseins contraire.
Constance en est l'exemple, elle en eut son salaire;
Par la soumission tu la fis triompher.

Camille satisfait à son tour s'humilie,
Dans un tendre lien il lui fait éprouver
Les solides plaisirs, la douceur infinie
Qu'en son métier galant elle n'eût pû trouver.

C. Moraine

Thanks to this change in orientation of his print letters, Fillœul also reveals the identity of the versifier for the newly announced prints, as well as the new verse for the old: a 'M. Moraine, de la Ville d'Angers.'[6] Since Moraine and Pierre-Charles Roy, the latter personage being the apparent reason for Voltaire's patronymic change in 1719 and a declared adversary after 1733,[7] are among the most prolific of Parisian print versifiers over the years, knowledge that the former is not a Parisian but a provincial comes as a revelation. However, Roy specializes in Lancret versification, while Moraine's extensive artist repertory is proof of his range and the demand for his services (see appendix B). Given their sheer number, Moraine's prints can also be grouped by subject matter, including nearly a dozen children's subjects.[8] Latin verse 'par Moraine' coupled with French versions (unsigned but presumably his) also appears on mythological pendants by Pierre Aveline after Boucher.[9] Their exhibition at the Salon of 1753 and unusual size (400 × 473 mm) are clear indications that, to be so featured, he was a personality to be reckoned with.

Repeated Compositions, with or without Verse

If a print is copied, the verse of the official version (copyrighted and with the painter's approbation of the engraver) may or may not be copied as well, but most such repetitions tend to introduce more simplistic verse. Thus Louis-Simon Lempereur's 1763 *Les Baigneuses* after Carle Vanloo has no verse,[10] while an unsigned and reversed repetition takes a minor compositional motif and elevates it to the level of the subject itself (figs. 44 and 45):

Le Chien est le tableau de la fidélité;
Ici, comme modele, il vous est présenté,
Jeunes cœurs enchantés des attraits de vos Belles.

Mais, n'en déplaise au sexe si vanté,
En trouvant des amans fideles,
Elles-mêmes le seront-elles?

As print commerce advanced into the century, editor-publishers, especially those issuing more popular prints, ransacked every cupboard in the search for usable images. Once settled on, these were nuanced or reinterpreted by changes in format and, particularly, in verse. It seems to have been a matter of indifference whether they were derived from individual prints or from suites. Moreau le Jeune's *Choix de chansons mises en musique par M. De La Borde* (1777) illuminates this process.[11] From twenty-three *livrets* (music by Moria and Mlle Vendôme, and a Moreau frontispiece), Chéreau transformed four into the Times of Day, increased their size from 125 × 93 mm to 203 × 160 mm, and gave them new, more titillating distichs.[12] This redirection removed any traces of their original context. They became prints, not vignettes, their new verse expressing a moral of sorts rather than a state of mind.

Different Compositions, Similar Verse

By extension, the same (or slightly modified) verse may appear with different images, although this is more likely to occur with a renowned painter who was known for variants on a few themes and whose work was engraved intensively, for example, Chardin.

Verse for an engraving of a small boy in 1738 (fig. 46):

> Sans soucis, sans chagrin, tranquille en mes desirs,
> Un moulin, un tambour, forment tous mes plaisirs. (Cochin père sc., 1738)[13]

Verse for an engraving of a small girl in 1742 (fig. 47):

> Sans souci, sans chagrin, tranquile en mes désirs:
> Une Raquette et un Volant forment tous mes plaisirs. (Lépicié sc., 1742)[14]

Repetition in Reduced Formats

If a reduction of a print appears, the smaller format often dictates less verse – and less sophisticated, often unsigned verse, as with Louis Desplaces's *Ledas* after Nicolas Fouché (figs. 48 and 49).[15]

> Cette belle encor toute neuve,
> Simple, sans fard et sans détour,
> Va faire vne fatale epreuve
> Des piéges que luy tend l'amour.

Ouy charmante Leda, ce Cigne qu'avec joye
Tu caresse si fort des yeux et de la main,
Friand des doux appas qu'estale ton beau sein,
Va devenir oyseau de proye.

<div align="center">Gacon</div>

As opposed to the verse accompanying the reduction:

Ce Cigne que sur tes genoux
Tu flattes avec tant de joye,
Dans peu belle Leda, quittant vn air si doux,
Va devenir oyseau de proye.

It is most unusual, as here, for the same engraver to do both formats – a form of quality control. Normally, reductions are done anonymously and, by implication, illegally.

When, however, a reduction of an engraver's work appears with his address, without any engraver's name or with the occasional excudit accompanied by another name, it bears looking into. The popularity of Moreau le Jeune's *Monument du Costume* (two suites of twelve prints) is undeniable; however, they appeared with titles only, leaving one to determine *unaided* the meaning and relationship of title to image.[16] Only the first of these was concurrently issued in dramatically reduced format (77 × 62 mm), with the same titles but now accompanied by explicative quatrains with a more or less continuous storyline.[17] This is, I think, explained by the exceptional iconographical coherence made possible by dividing Céphise's history in half, the first six subjects following her maternity from beginning to end, the last six showing scattered episodes from her public life. The unattributed verse of the reductions gives voice to the situations, anchoring while reducing to a narrative or a moralizing precis the sophisticated detail of Moreau's images and Rétif de La Bretonne's text. The case is virtually unprecedented for such illustrious creations.

Reductions after existing prints constitute a class apart, and diminutive repetitions seem to invite commentary if they are to be remarked or their images understood. A few lines of verse do the trick despite some inherent problems. For example, the few known Watteau reductions come early and fall into two groups. When reduced by Louis Crépy, his two earliest prints, after Louis Surugue's *Pour nous prouver que cette belle* and *Arlequin, Pierrot & Scapin* of 1719, merely repeat the verse.[18] Yet reductions after Cochin père's *Pour garder l'honneur d'une belle* and *Belle, n'écoutez rien, Arlequin*

est un traitre (two of the ten prints noted in François Chéreau's death inventory of 1729) take us in unexpected directions.[19] Instead of the original four lines arranged two by two, we find five new lines arranged three by two in *Pour guérir la mélancolie* and *L'Acteur qui fait l'amant d'une actrice folle,* both signed 'I. Fr.' None of the four large prints has attributed verse; only two of these reductions appropriated an image to the point of commissioning new and signed verse, making these modest prints acts of creation, not repetition. Versified Watteaus may have been a way of introducing a new print genre to the public, but there seems to be neither patternnor tradition in versified or unversified reductions, only examples.

Repetitions are a rough gauge of works that caught the fancy of printmakers. Watteau and Chardin spawned repetitions *and* reductions to a degree not seen before or after, proving that their compositions had, so to speak, entered the public domain by fair means or foul. And while the painter's name may be carried on, the prints themselves are often unsigned and bear no address. In such case they are presumed to have been circulated without being publicly announced and, as a result, are difficult to date except by that of their model.

It is one thing if repetitions of French prints are of French origin, but other repetitions must be seen in the context of both international printmaking and national traditions. In general, we find four patterns regardless of print size:

- repetition of a versified print with its reproduced verse and disposition (the expected norm)[20]
- repetition of a versified print without its verse (perhaps infirming its intent and meaning)
- repetition of a versified print with new verse[21]
- repetition of an unversified print with newly appended verse

While the original print possesses either a French or a French and Latin title, repetitions for the foreign trade often favour bilingual but vernacular ones – French and English, or French and German. Substituted verse, or verse merely doubled by a parallel column in a different linguistic group (fig. 55), may also be longer. Depending on how close in time to its model a compositional repetition falls, the need may be felt to explain an unfamiliar genre to a new audience, or to embroider upon the image, unmindful of its poetic integrity. This might explain the Watteaus engraved by Claude Dubosc, known for his work in England. A number of his repetitions were after original prints issued without verse, although they retain bilingual titles; in their second states published by

W. Humphrey, the titles are exclusively in English, and extensive English verse is appended.[22]

Annotations on Before-Letter States

A personal favourite in this documentary jungle remains the before-letter states with original annotations that do not correspond to the commercialized print (Cars's 1728 *Hercule & Omphale* after François Lemoyne, figs. 50 and 51).[23] This is like using someone else's notebook for one's own purposes. Today, such impressions might be collected as curiosities or, if acquired by a museum, acquired for the quality of the impression, not for the cultural or documentary import of their annotation. Before-letter states of portraits and allegories lend themselves more easily to pungent, even caustic comment. At the Salon of 1738 Simon-Henri Thomassin had shown a print after Louis Autreau incorporating Rigaud's portrait medallion of the Cardinal Fleury.[24] Reprised and reversed on an anonymous etching (fig. 52),[25] an appended inscription concerning the deceased Cardinal could scarcely have appeared on a print normally subject to censorship:

> quand tu veux honorer le défunt Cardinal,
> Tu te fais peu d'honneur, aveugle Diogene:
> Tu ne pouvois jouër une plus fade scene,
> Ni choisir ton héros plus mal.
> Un esprit plein de petitesse,
> Un cœur dur, insensible, une ame sans noblesse,
> Du portrait que tu tiens formoient l'original.

> De Pédan[t] fait Ministre, Enfant octogénaire,
> Des trésors de l'Etat il fut dépositaire;
> Mais loin de s'en servir à faire des heureux,
> Il fit une odieuse guerre
> Aux hommes les plus vertueux:
> Vincennes, la Bastille étoient les seuls endroits,
> Où l'on ait vû briller ses merveilleux exploits.

Same Composition, with Verse in Another Language

A suite of four Bouchers engraved by Claude II Duflos[26] was evidently thought worth copying (as was an infinity of other prints) in Augsburg

as *Les Amours pastorales/Schäffer-Liebe,* although the results betray differences in national styles of engraving and attempt an abridged poetic equivalent of verses by no less an author than Favart (figs. 54 and 55).

Verse in Serial Creation (Pendants and Suites)

By extension, the aforementioned German copies bring into question pendants and suites, that is to say, *serial creation* in both image and verse. By definition, pendants complement each other. Yet as prints, they must also function autonomously since they may be sold separately or even be created at different dates![27] Suites only multiply such problems: *one* print is easy, *two* must contrast, but *four* (the usual number for small suites) require real proficiency in achieving iconographical and literary cohesiveness.

Verse Addressing the Painter and/or the Engraver

One class of versified prints is particularly significant for art historians in that they address painters more or less directly. This profound change in orientation is best seen in a 1760 print after Philibert-Benoît Delarue[28] and in an anonymous print addressing those who would be painters or landscape painters (figs. 56 and 57):

Vous qu'un secret desir d'imiter la nature,
Dans l'empire des Arts, attache à la Peinture;
Vous, qui brûez d'offrir à mes yeux satisfaits,
Les formes, les couleurs, les plans et les effets:

D'un penchant qui vous flatte examinez la source;
Le desir, sans talens, offre peu de ressource:
Il faut être né Peintre; et ce don précieux,
Comme celui des vers, est un présent des Cieux.*
* M. *Watelet* dans son Poëme de l'*Art de Peindre.*[29]

As opposed to:

Son attention fait comprendre
Que la nature est son objet;
Mais pour la saisir et la rendre,
Il faut être Vernet.

Taken together, these opposing quatrains summarize for the unsuspect-
ing public at large two art-historical tenets of the times: the first, that art
is more than craft, that it is innate; the second, virtually uncontested by
critics and amateurs, that Vernet's rendering of Nature in his paintings
(and, through them, even in prints) is perfection. This intolerable situa-
tion coalesces in De Piis's witty *Epitaphe de Vernet* as Nature alludes to her
overdue and summary vengeance:

> «J'ai trop long-tems, insensible à l'injure,
> Souffert que l'art m'imitât trait pour trait.»
> Ainsi parloit l'autre jour, la Nature,
> Et sur le champ nous pleurâmes Vernet.[30]

In time, direct address shifts perceptibly from the *idea* of painting, or
of *being* a painter, towards the expression of personal sentiments or ad-
miration for a *given* painter, often with a dedication from the engraver
himself.[31] These are usually directed to artists of the stature of Watteau,
Boucher, Vernet, Michel-Ange Slodtz, and Teniers, or through one artist
to another, as Jean-Baptiste Massé and Charles Le Brun.
 For example, to Watteau, ten years after his death (fig. 58):

> Assis, au près de toy, sous ces charmans Ombrages,
> Du temps, mon cher Watteau, je crains peu les outrages;
> Trop heureux! si les Traits, d'un fidelle Burin,
>
> En multipliant tes Ouvrages,
> Instruisoient l'Univers des sinceres hommages
> Que je rends à ton Art divin![32]

To Boucher at forty-eight years of age (fig. 59):

> Loin des ornements pretieux,
> Dont la Coquette emprunte sa parure,
> Philis à la simple nature,
> Doit tous les agréments qu'elle étale à nos yeux.
>
> C'est ainsi que semant des fleurs toûjours nouvelles,
> Agréable Boucher, Peintre cheri des Belles
> Tu nous fais admirer dans ce charmant Tableau,
> Les attraits séduisants de ton brillant pinceau.[33]

To Joseph Vernet at forty-one years of age (fig. 60):

Toy qui peins d'une mer agitée ou tranquile
Et la riante paix, et la sublime horreur,
Toy dont la verité, la force, et la chaleur
Ont immortalisé le stile,
Illustre ami dont les heureux tableaux
Ont fixé de Louis les regards et l'estime,

Tandis que ce tribut anime
Et ton génie et tes pinceaux
Daigne jetter les yeux sur cet ouvrage,
Mon burin à toy seul se consacre aujourdhuy
C'est le cœur qui dicte l'homage
Quel Mécene vaut un Amy?[34]

To Michel-Ange Slodtz, at fifty years of age (fig. 61):

Toy dont le nom, pour nous, fut d'un heureux présage
Moderne Michel Ange, accepte cet homage.
Je le dois aux Talents que t'auroient envié

Les Praxiteles du vieux âge,
A ton Esprit ami du Badinage,
Et plus encore à l'amitié.[35]

To David Teniers the Younger, fifty-six years after his death (fig. 62):

Admirable Flamand tes précieux ouvrages
Des Connoisseurs gagnent tous les suffrages
Par leur beau coloris et leur naïveté

Et tu nous as, Teniers, fait un plaisir extrème
D'avoir transmis à la Postérité
Un Peintre inimitable, en te peignant toy même.[36]

While in 1747 the verse accompanying Le Bas's fortieth Teniers situates the artist historically, the prints dealing with his contemporaries Vernet and Slodtz formed numbers 62 and 63 of the same suite and were the first and second of six prints shown at the Salon of 1755, under no. 170.

Both significantly allude as much or more to the concept of Friendship as to the artist's work or reputation, an anomaly likely stemming from Le Bas's fabled obsession with engraving Teniers – a conceit particularly appropriate to engravers since praise is directed *through* one artist to another – or through one art to another – each of them personified. In one instance, Jean-Baptiste Isabey is even said to have captured all aspects – physical, spiritual, and historic – of the artist Hubert Robert, then about sixty-five years old, for accurate transmission to posterity by the engraver Miger (fig. 65):

> Isabey, tes crayons ont sçu donner la vie
> Au portrait que Miger retrace sur l'airain,
> Robert, tes traits, ton art, ton ame, ton genie,
> Tout respire sous ce burin.
> <div align="center">L.D. . . .[37]</div>

This type of encomiastic verse need not accompany images *created* by the artists addressed. Only occasionally does a portrait truly *facilitate* a print letter's verse. Wille's 1755 print of the engraver Massé comes on the heels of the 1753 publication of the Galerie des Glaces at Versailles,[38] yet depends upon a 1734 Tocqué showing Massé at forty-seven years old and the project in its early stages (fig. 64):

> Du célèbre LE BRUN, sous ses riches lambris,
> Versailles renfermoit les chef-d'œuvres sans prix,
> Qui de LOUIS LE GRAND nous ont tracé l'histoire.
>
> Secondé du burin, Massé, durant trente ans,
> Par des travaux d'un genre à triompher des tems,
> De la France et du Peintre étend par tout la gloire.
> <div align="center">Piron.</div>

We accept whatever verse accompanies an image without questioning how it got there. This, however, is the result, not the process itself. In reporting Wille's *agrément* to the Académie, we learn that Piron himself wanted all who saw this print to recall that it was to Massé's 'soins et intelligence' that they owed the engraved Galerie; these verses were separately printed at the end of the article, after two other Pirons, the first praising the Comte de Vence on a recent Wille print after G. Dou, the second terming Wille a 'voisin bien redoutable' of the engravers Masson, Edelinck, and Drevet.[39] The choice of a poet and elaboration of a sentiment could

have been a long and involved process, but we rarely have any sense of possible alternatives. In this case we do, since congratulatory verse sent by Pesselier to Massé concludes the long annonce of what was unquestionably one of the most significant engraving enterprises of its day:

> Des chefs-d'œuvres que l'art ne peut trop publier,
> Ta main incomparable assure la mémoire:
> Du Peintre & du Héros tu partages la gloire,
> Comme tu sçais l'étendre & la multiplier.[40]

Pesselier's congratulatory quatrain clearly lacks historical substance and resonance, serving only the moment. (It was too general for Wille's print, not that it could have been a likely candidate.) He had, to be sure, versified four Chardin prints,[41] but preferment was here given to Piron, who was some twenty years his senior and well connected with Wille and the Académie royale de peinture et de sculpture.[42] And while 'voiced' prints addressing artists are rare enough, prints voiced to represent one or both sides of a heated exchange between contemporary personalities are rarer yet. Witness the boxing match whose opponents are not onlyre cognizable but labelled by the open volumes of *Emille / ou l'Edu /cat / ion*, and *Henri / ade de / Voltaire* in an anonymous print datable to 1762 (fig. 71):

> Toi qui veux usurper le sceptre du Parnasse,
> Qui contre nos écrits parlas [*sic*] avec audace,
> Sur toi de mes malheurs, ces poings me vengeront . . .
> M'attaquer sur tes pieds! eh! bon Dieu! que diront
> Les quadrupedes tes confreres,
>
> Te voyant des humains prendre ainsi les manieres?
> Mais, l'épée au coté, se battre en porte-faix!
> Pourquoi non? les brocards te causent des allarmes?
> Un Sage, si tu l'es, ne s'écarte jamais
> Des loix de la Nature, et nos poings sont ses Armes.[43]

This process lent itself admirably to caricature as well. The balloon mania of the mid-1780s was particularly rich in situations culminating in verse that was introduced by lead-ins such as 'ce dont ce jeune homme se plaint en ces termes'[44] or 'et Madame la Comtesse exprime sa fureur par les vers suivant[s]' (figs. 66 and 67).[45]

With pendants, verse accompanying the other half of the set is invariably conventional in nature. By extension, some versified prints reproduce text to the exclusion of images while speaking eloquently to a painter's qualities, for example, the anonymous *L'Art et la Nature: Fable Allégorique* for Watteau.[46] As a rule, however, text-only prints are more likely to be in prose than verse and are usually unrelated to works of art.

Amended and Variant Verse

Versified prints can perpetuate personal relations, such as Charles-Antoine Coypel's print of his friend Jean-Antoine Maroulle (figs. 68 and 69). The first state was not commercialized, because the sitter's modesty prevented its issue; however, Maroulle had the kindness to die that same year (1726), so the print was completed with different verse.[47] The underlying issue here is that of alternative or emended verse, such as the verse for a 1776 François Watteau de Lille drawing of the painter Lantara (1729–78). Here the interpretation of the expression *vers pour être mis au bas d'un portrait* ultimately depends upon whether the 'portrait' was actually engraved, as opposed to remaining a painting or, more commonly yet, a purely literary genre. In Laurent Guyot's undated print (fig. 70), the verses read,

> Je suis le peintre Lantara;
> La Foi m'a tenu de livre,
>
> L'Espérance me fesait vivre,
> Et la Charité [l'Hôpital de la Charité, Paris] m'enterra.[48]

while a reported version is more measured, distanced:

> Tu vois le pauvre Lantara:
> La Foi lui tenait lieu de livre;
>
> l'Espérance le faisait vivre,
> Et la Charité l'enterra.[49]

Despite the incorporation of a reference to the Cardinal Virtues, the thrust of the liminary verse heralds Lantara as a prototype of a new and eccentric breed of artist who cares little for appearance and is sure to come to a bad end.[50] The lack of secure chronology and authorship in

such cases is unfortunate. Its counterpoise is the variations and emendations of given verse resulting from wide circulation and response. In restricted, usually artistic circles, the issues are significantly different. For Coypel the painter, and for Lépicié the engraver, the side issue of chronology or authorship is compounded. Early in their careers they prided themselves on their verse, with Lépicié commonly versifying his own reproductive prints after Chardin.[51] Interestingly, the career of Coypel's own father, Antoine Coypel, was launched in 1680 by a critique of his etching of the celebrated poisoner La Voisin (fig. 72), even though readers of the *Mercure* had to wait a month to discover the identity of the nineteen-year-old artist '[qui] a gravé la planche que je vous envoye, et fait les quatre vers qui sont au-dessous.'[52] A larger, more elaborate version followed, with six lines created to match the considerable iconographical changes in the surround (fig. 73).[53] Neither the confessional *quatrain* of the first print,

> Ie fus du Genre humain, la mortelle Ennemie,
> Par l'horreur de mes jours, on vit regner la mort.
> Et mon Crime par tout, portant son Infamie
> Fit la guerre aux Mortels, et termina mon sort.

nor the admonitory *sixain* of the second, is signed.

> Source de tant de maux maudite creature
> Qui par mille poisons destruisoit la Nature,
> Si la parque en fillant tes destables jours
> A fait regner la Mort, en prolongeant leur cours,
> Vn suplice effroyable et plein d'Ignominie
> A sceu trancher le fil de ton énorme vie.

One of the few instances where a painter's catalogue raisonné begins with a versified original print, this was not a precedent easily followed.

Transformations in Both Image and Verse

It is quite rare for a painter or engraver to versify his own work, much less that of others. What seems to be a unique example covering both seventeenth and eighteenth centuries is a vignette that goes through nine states, three engravers, and three modifications of subject, some of which later gave rise to verse of particular intent (figs. 74 and 75).

The first two states show a *St Claude* by Sébastien Leclerc, the third becomes a *Mary Magdeleine* by Charles Eisen (before 1756), and the fourth to ninth states a *St Pierre* by Cochin fils.[54] The fifth and sixth states have unsigned verse on a smaller accessory plate below:

Le Clerc de ce chef-d'œuvre eut la gloire et la peine,
Saint Claude y fut placé par son savant Burin;
Eysen l'en délogea pour une Madeleine;
Et Saint Pierre à son tour y fut mis par Cochin.

It traces successive transformations and names the engravers who were responsible for them. The seventh state has new verse signed by the engraver Gravelot on a small supplementary plate, saying much the same as that of the sixth state:

Saint Claude par le Clerc occupa cette place;
La Madeleine y fut mise après par Eysen;
De la main de Cochin S.ᵗ Pierre enfin l'eface,
C'est le Portier des Cieux, qu'il nous les ouvre, Amen.
 H. Gravelot.

Eventually, one returns to the image alone, as was the case with the earliest states. This is one of the most convoluted and interesting cases of changes in a *small* plate (110 × 113 mm) that ordinarily would not be deemed worthy of the trouble. Instead of explicating the subject itself, as was normal, the appended verse now elucidates the symbolic and iconographical changes in the image, while an extensive historical note of 1759 explains successive owners and printings (its owner Helle eventually *gilded* the copperplate to obviate further modification).[55]

Amateurs Who Versify Their Artworks

If it is quite rare for a painter or engraver to versify his own work, it is rarer still to find a painting's *owner* as author of its appended verse. To date, I have found only one example, but a truly splendid one: Laurent Cars's 1731 *Mlle Camargo* after Lancret, with verse by Leriget de La Faye (fig. 76):

Fidèle aux lois de la Cadence,
Je forme, au gré de l'art, les pas les plus hardis;

Originale dans ma danse,
Je puis le disputer aux Balons, aux Blondis.[56]

This may be explained in part since the print appeared six months before La Faye's death and one year after his election to the Académie Française – an inadvertent reminder that we might expect to find the work of other, better remembered, Immortals in the context of versified prints.[57] Beyond his art collections, however, his obituary particularly recalls 'son talent favori et son amour ardent pour les Vers,'[58] here put to unexpected use.

Latin Epigrams as Summation or Inspiration

Deceptive in their simplicity and necessitating collateral research, Latin epigrams may be borrowed or adapted from classical literature. Who dictates their use and in what context is another question if the source is merely cited. Jean Daullé's 1740 portrait of Jean-Baptiste Rousseau appeared with 'Certior in nostro carmine vultus erit. Mart. L. 7. Ep. 84,' and a letter from Rousseau to Louis Racine confirms that he asked the painter Aved to have this placed on the print,[59] raising the possibility that other authors personally chose citations for their portraits. Given its density and authority, Latin verse commonly led to paintings, so why not prints? When Marguérite Gérard engraved *Au Génie de Franklin* after her brother-in-law Fragonard, its annonce noted that he had visually rendered the Latin verse applied to Franklin – 'Eripuit cælo fulmen, sceptrumque tyrannis' – which appears above the print title. The resulting allegory 'remplit l'idée & les connoissances profondes de *Franklin* & de sa sagesse dans la révolution du nouveau Monde' (fig. 53), and, as contrasted with many overly ambitious or overcharged allegories of the day, 'le jet simple & rapide de cette composition est aussi clair & aussi facile que le vers, que l'on a voulu peindre aux yeux.'[60] Instead of merely being appended to an image, the verse here precedes and follows it, a distinguished and exceptional case when contrasted with usual practice.

Supplementary Plates with Verse and/or Music

Rarest of all – so rare that I have yet to *see* one – is an engraving with a printed musical score corresponding to non-operatic verse, as in Surugue fils' 1744 *Les Tours de Cartes* after Chardin (fig. 77), which in its second state has four bars of music (a supplementary copperplate) after verse by Antoine Danchet:

On vous séduit foible jeunesse
Par ces tours que vos yeux ne cessent d'admirer;

Dans le cours du bel âge ou [*sic*] vous allez entrer
Craignés pour votre cœur mille autres tours d'adresse.[61]

This is truly a class apart: prints alluding to theatrical and operatic scenes that may or may not be immediately identifiable as such to us moderns, and the occasional print featuring provincial dialect, even slang.

Reissued Prints with New Verse

Reissue by an engraver of one of his prints can better situate a topical scene. The engraver François-Anne David – who in his advertisements led his clientele to think that he was the painter Jacques-Louis David – illustrates a charitable act of 1773 of Marie-Antoinette as Dauphine, transforming its poetic statement to give it historical rather than anecdotal resonance (figs. 78 and 79).[62] This unusual procedure is interesting since the more effusive verses of the second state (March 1775) are by either the wife or daughter of the author of the verses of the first state (December 1774). The oblique allusions of the first state,

Sentir d'un Epoux vertueux
Palpiter le Cœur généreux,
Quelle volupté séduisante

Pour la main douce et bienfaisante
Qui chaque jour voudroit faire un heureux!
Cosson[63]

are rapidly succeeded by the narrative of the second state:

La divine Antoinette un jour en son chemin,
Rencontra Fillette gentille
Portant un potage mesquin;
Triste diner de sa pauvre famille
Qui travailloit au champ voisin,
En questionnant la jeune fille

La Princesse plaint leur destin
Et du bon Roi henry montrant le caractère
A la pauvrette elle dit aussi-tôt:
Prends cette piece d'or, et va dire à ta Mère
Qu'elle mette la poule au pot.
<div align="center">par M.^{lle} Cosson</div>

Transformed Image, Identical Verse

Rarer yet – excessively rare – are the instances when the verse remains the same from one state to another while the *image* changes, as with Vleughels's *Le Villageois qui cherche son Veau*, whose initial version raised the art of skirt-lifting to new heights. The authorities then intervened, resulting in an 'inexplicable' or, if you will, 'unmotivated' gesture and glance (figs. 80 and 81):

Perché sur cet ormeau que sert de t'y morfondre?
Pauvre sot, de ton veau va t'informer ailleurs.

Ne vois-tu pas que ces Acteurs
N'ont pas le tems de te répondre?
<div align="center">M.^r Roy[64]</div>

The voyeurism inherent in the subject was never at issue in this or in many a Boucher pastorale. What was morally intolerable, however, was the touching of the skirt in conjunction with the couple's glances. Censure of a political and religious nature occurs in Moreau le Jeune's *Tombeau de Jean Jacques Rousseau* since the reactions of visitors could be construed as a blasphemous, quasi-religious worship.[65] Suppressed in France in a fourth state that was published *avec privilège du Roi*,[66] a kneeling woman in adoration at the composition's lower left was reinstated in a copy by François-Guillaume Lardy, which was published in Geneva without any mention of Moreau, but now accompanied by this verse (fig. 63):

Entre ces Peupliers paisibles,
Repose Jean Jaques [*sic*] Rousseau,

Aprochez Coeurs vrays et Sensibles,
Votre Amy dort sous ce Tombeau.

Spawned Prints, With and Without Verse

The so-called pastiches, which I prefer to call 'spawned' prints, provide amusing and easily traced filiation. Simonet's 1770 *Le Couché de la Mariée*, known from Diderot's long criticism of the Baudouin's 1767 Salon gouache,[67] gave rise in 1774 to Sigmund Freudeberg's *Le Lever* (figs. 82 and 83, respectively), an abridgement from the first suite of the *Monument du Costume* that abruptly changes the original marriage context:

> Tu chasses le plus doux sommeil!
> Par des songes charmans mon ame étoit flattée:
> Je détesterois mon réveil,
> Si tes caresses, Galathée,
>
> En continuant mon délire,
> Ne consoloient mon tendre cœur:
> Est-ce plaisir, est-ce martyre?
> Ah, je ne sais, mais j'aime mon erreur.[68]

Another scene from this series (*L'Occupation*, fig. 84) appears to have had the *very first line* of its six-line stanza censored:

> .
> Cette Veste, où le goût a mis son art galant,
> De l'Amour est-elle un présent?
>
> Non, Charmante Thisbé, je n'ai point de maîtresse:
> Mais j'ai devant les yeux un objet séduisant
> Qui me fera connoître la tendresse.

Censored or Incomplete Citations

The surface and the support of any artefact are notoriously unstable, but printed poetry, whether invariable or constantly reworked, can be of aid in dating. Borgnet's view of the Bastille employs verse from the most famous play of Marie-Joseph Chénier (1764–1811), the tragedy of Charles IX.[69] Two lines have 'gone lost' on the print (fig. 85):

> Ces murs baignés sans cesse et de sang et de Pleurs,
> Ces tombeaux des vivans, ces bastilles affreuses,

S'écrouleront un jour sous des mains Généreuses:
. [70]

On verra les Français plus fiers que leurs ancêtres,
Reconnoissant des chefs, mais n'ayant point de maîtres;
Heureux sous un Monarque ami de l'équité,
Restaurateur des Loix et de la Liberté.

Yet the rhyme scheme *aabb* is respected. Here, the study of rhyme schemes seems to me far less significant than the examination of verse *content* in respect of the image it accompanies. After all, both gifted amateurs and consummate professionals face the same ascending curve of difficulty in the use of paired (*aabb*), crossed (*abab*), or framed (*abba*) rhyme (*rimes suivies, croisées, embrassées*, respectively).

This observation is proportionately confirmed in the versified prints repertoried to date. However, such 'finds' – which range from the merely curious to the truly illuminating – cannot, at an early stage at least, result from focused research. They are but sidelines of other work, and their information cannot be taken at face value. One dare not manipulate it without having insights into the greater mass of contemporary print production.

Problematic and Rejected States

Versified prints were for their period the *final* phase of a process, as well as being those prints that gave rise to some form of recorded poetic expression. This definition necessarily includes works such as Augustin de Saint-Aubin's 1773 *Piron* (fig. 5), which in their earliest preparatory states only are versified for reasons difficult to fathom. While recognizably 'incomplete,' these anomalies – most often portraits – are less likely to be appreciated unless the engraver has been the subject of particular study or a catalogue raisonné, failing which they have only curiosity value until assigned their place in a developmental sequence. Such changes have little to do with print size, and much more to do with complexity, use, and date of issue or reissue. For example, Saint-Aubin did three prints (Bocher V, nos. 196–198) after J.-S. Duplessis's iconic portrait of Necker, the first and third of which were shown at the Salon (1785, no. 279, and 1789, no. 328). The first has four states, and the third three, thus falling into the working pattern of two to five states that is usual with Saint-Aubin portraits; neither print was ever versified. However, the second portrait, published in August 1785, has eight states, only the

second and third of which – the latter accompanied only by the title
M^r Necker – bear the following verse:

> Des ministres de la Finance
> Que l'on connoit sans les nommer,
> Voici quelle est la différence,
> Ils nous avoient du Roi fait craindre la puissance,
> Et celui-ci la fit aimer.[71]

The print letter then continues to evolve over the next two decades to
the death of Necker in 1804.

The first portrait (323 × 234 mm) could have been framed, although
its annonce notes that an in-quarto version was being prepared for in-
sertion at the head of the *Compte rendu*, while the third portrait (123 ×
70 mm) was intended for placement on snuffboxes. For insertion as the
frontispiece to Necker's writings in-octavo, the fourth state of our for-
merly versified print (155 × 103 mm) was austerely titled *M^r NECKER. /
Ministre d'État, Directeur G^{al} des Finances*. Its annonce notes that a few in-
quarto impressions (printed on larger paper) were also available at three
livres, or twice the price of the general print run.

While Saint-Aubin's intermittently versified *Necker* is problematic both
in itself and within a series of repetitions, his 1786 *Condorcet* poses a co-
nundrum in that it may be one of those tantalizingly elusive prints that
are 'reported but not seen.' His cataloguer, Emmanuel Bocher, remarks
that the well-connected and generally reliable *Mémoires secrets* for
27 July 1787 read:

> On a mis au bas ces vers, qui flattent l'original pour le moins autant que le
> burin:
>
> D'un sage voici le modèle
> En même temps que le portrait.
> La vérité n'a point, dit-elle,
> De secrétaire plus fidèle
> Et de confident moins discret.

He adds that he has never actually seen this state and indicates it only
as a matter of interest (*pour mémoire*).[72] Working from the œuvre in the
Bibliothèque nationale completed by the celebrated collection of Dr
Roth, Bocher's catalogue represents the state of knowledge in 1879. One

hundred and thirty years on, someone, somewhere, may have chanced upon this presumed missing link.

The foregoing twenty classes are, I believe, the most highly character-ized types of text-image relationships to be found – and, as such, the most instructive. Whether additional ones can be adduced remains to be seen. The greatest freedom in versification logically lay in original (personal) prints where all-over creative control was exercised from beginning to end; yet these prints are swamped by the plethora of appropriated com-positions that were versified for purely commercial purposes. Those with contemporary or traditional socio-cultural content – genre scenes – may be intellectually less challenging since they build on all that is said and known. (They also seem to be inherently inventive.) Greater challenge theoretically lay with historically remote and mythological scenes, but the literate public's familiarity with their content in conjunction with limited typological range doubtless eased the task of versification. For every assertion, one or more counter-assertions is possible.

None of this takes into account the degree to which images speak to the viewer, much less their intrinsic quality. It is, moreover, abundantly clear that the technically and conceptually based spectrum of print typology – caricature or satire, popular or savant imagery, *gravure en grand* or *en petit, demi-fine* and *grande gravure* – has as great and far-reaching implications for modern exegetes as it did for those who were originally involved. The question remains whether the accumulation of case studies of given prints can ever lead to a grand synthesis as opposed to a repertory of instances mainly of use as enhancement for differential studies. Even this represents a step in the right direction.

5 Cautionary Notes

Our most basic and reliable information concerning the attribution, fabrication, and perhaps the dating of a print is derived from its lower margins, in the print letter. This may be supplemented by anecdotal details supplied by the annonces, and by other contemporary sources. Both, however, represent the very last stages of printmaking, that is, when the print is issued and subjected to critical discussion. The early stages – planning and execution – are a series of choices and alternatives that are usually known only through workshop (trial or artist's) proofs, which were not necessarily meant to survive. As illustration, four prints serve as cautionary notes relating to the fidelity of written or printed inscriptions on prints:

1 *Proof States as Models and for Attribution.* The first is Gaucher's 1762 print after Paulus Potter's *Bull*, with the engraver's own pencilled notations of the signatures, title, arms. and verse that were to appear, for engravers of print letters constituted a specialized branch of engraving (figs. 86 and 87). These lesser but necessary elements of print production were rarely acknowledged on the published plate (here we find a clear 'Petit Scripsit'). However, much may change in the execution.[1] Unless both documents are preserved, no study of intentionality or attribution is possible. Without this annotated impression we would have no inkling of Gaucher's role in a print signed by Louis-Joseph Masquelier.[2]

2 *Insider Information.* The second print reminds us that 'insider information' is at times the only way of knowing what actually went on. An inked note by the eighteenth-century print curator of the Royal Library informs us that both the verse and the print of a Rubens (fig. 88), nominally engraved by Gaspard Duchange, are instead by

the engraver Lépicié, who versified his own prints after many artists but became a prime engraver and versifier of Chardin after his appointment as secretary and historiographer of the Académie in 1737.[3] Obviously, we are dealing with two different career contexts and, most likely, a *collaborative* print from an established printmaker working in association with an upcoming one.

3 *Unacknowledged Sources.* The third print, an allegory on the (always) untimely death of a lady of quality, in this case the Baroness Grappendorf (fig. 91), is engraved by G.-F. Schmidt, a member of the Académie royale de peinture et de sculpture in 1744 who soon returned to his native Berlin. Early cataloguers insist on its rarity and desirability – not so much for its composition or technique as for its (unsigned) verses by no less than Frederick the Great,[4] something we would otherwise never know:

Reçois, Ombre cherie, au sein de l'Empirée
l'hommage que nos Coeurs doivent à tes Vertus,
du nombre des mortels ton Ame séparée
helas! nous laisse en proye aux regrets superflus!

si l'Esprit l'Enjoûment pouvoient fléchir la parque
ou qu'elle fût sensible aux traits de la beauté
tu n'eus jamais passé dans la fatale barque
et ton être eut joui de l'Immortalité.

4 *Reworked Print Letters.* The fourth print alerts us to the possibility of reworking the print letter once the painting changed hands – an involved process unlikely to occur with any regularity. When Le Bas issued *Prise du Héron* in 1741, it belonged to the wife of the painter Charles Van Falens (1683–1733) and was dedicated to Richard Mead, physician to His Britannic Majesty, which information was printed by the *Mercure de France* along with the following translation of the Latin verse for its readership:

Cruel Tyran des Habitans de l'Onde,
N'accuse que toi seul des rigueurs de ton sort;
Telle est la Loi, qu'un Tyran dans ce Monde
Devienne tôt or tard victime d'un plus fort.

This must represent the state shown by Le Bas at the Salon of 1741, made unrecognizable once the work, now bereft of its verse, passed into

the hands of the Comte de Brühl, Minister of State to the King of Poland and Elector of Saxony (fig. 89).[5] Modifications including the change of date to 1745 now pass unnoticed unless one has the versified print or has consulted the *Mercure*.

All the prints discussed here – and all that must have existed before them – are reminders that historical study depends on the type, the quality, and the complexity of contemporary documentation that is generated on a day-to-day basis. In deriving concepts from masses of prints examined to see where they lead, we should seek no overriding patterns, no particular paradigms. Such was not the nature of early French print-making, which was, first and foremost, a commercial enterprise. *Tendencies* are another matter, as are the *first recorded instances* of ideas that never quite took root and exist in splendid isolation. *Conventions* governing the placement of verse within the print letter seem to have been arrived at rather quickly, the earlier examples being printed as poetic texts in a single column, while the use of double columns is more modern and consciously aesthetic. Innovative presentations, such as the quatrains in the third person flanking an eight-line strophe in direct address under Jean-Etienne Liotard's *Le Chat Malade* after Watteau (fig. 90), remain isolated instances for all their charm.[6] Once the print corpus has been gone through, certain differences in poetic intent and application surface: portraits are versified encomia, while narratives must be created and applied to subjects.

What would induce a poet to go the route of print versification? The challenge of new ways of thinking about the role and presence of poetry in society? His past or present reputation? The lure of a new public or the extension of his earlier published work? The realization that a print was more easily bought and diffused than was a book, and in certain cases might prove even more prestigious? The answer must lie within the concept of poetry as print. Was print versification a series of 'one-offs' to go where and when they would or, since the fate of *pièces fugitives* was always uncertain, did these wind up in one's collected works?[7] Beyond this, there are intimations that the subjects of prints may in some way be derived from, or related to, beloved poets.[8] Eminently circumstantial when issued, poetry on prints may simply not have rated as circumstantial verse in the understanding of the term. The case of Paul Desforges-Maillard provides food for thought when applied to a portrait of Mlle Sallé after Fenouil (figs. 92 and 93). The verses for Petit's first state of 1740 refer specifically to the sitter; a second state of 1742,

referred to in a letter of 1745, generalizes everything – portrait, print title, and accompanying poetry – so that it may be included in a set of prints depicting the times of day and their female occupations. Des-forges-Maillard includes the former verse in his *Amusements du cœur et de l'esprit* of 1741, the latter verse in his *Œuvres* of 1759,[9] reminding us that an author's successive editions invariably include additions, suppressions, and emendations.[10]

Real and implied differences between the reactions of the poets themselves and of the public at large may also exist. These could only increase with time: we research the works of poets who are no longer current, but versified prints escape the strictures of time and 'editions' regardless of place and origin. Is original verse on prints intrinsically different than verse appearing in, say, the columns of the *Mercure de France*? If so, it is not because an image is present, but because so much print verse is signed, and so much more, even within pendant prints, is unsigned. The proportion of signed or anonymous verse is an issue for future study since the latter also comprises poetry set to traditional airs (figs. 99 and 100), as well as variations on classical topoi that may not be readily apparent.

Such borrowed metric schemes open up another parenthesis – that of caricature. Unlike fine art prints, social satire relies more on topicality than craft and on the sheer number of prints addressing an issue. Relative quality is, as a result, readily apparent. Like popular imagery, repetitions are inevitable (reversals, technical control, simplified or complexified compositions), and when several versions of an image exist, while immediately recognizable, they run the gamut from accomplished to defective clones or to unregulated counterfeits. If the text and disposition of verse are respected, startling differences still occur as the result of floating orthography, phonic equivalents, and the use (or absence) of punctuation for conceits widely circulated by mouth or in print, although proof requires more than two examples. Among the best, given its spectacular failure, are caricatures relating to the notorious Parisian balloon ascension of Janinet and Miollan in July of 1784, with three versions of *La Physique confond l'ignorance* and four of *La Montagne accouchant d'un souris ou la Prophétie accomplie dans le Luxembourg*, where verse created on well-known airs is more stable than the image it accompanies.

I rather see this phenomenon as the convergence of signed art and signed verse. But what of the latter's intrinsic *quality*, in itself and as it subtends the image? There is a fundamental difference between poetry and

mere versification, the former usually associated with a certain reputation, even fame. Yet talented amateurs abound in all epochs without seeking or receiving public recognition, much less having a collected œuvre. Regardless of author, each versified print must be judged on its own merits, just as each poet's 'repertory' must be assessed for its range, thrust, and content. Indeed, versification for fine art prints presumes that the poet, whoever he is, reflects upon the image and decides what to do with it – creating parallels, respecting or changing emphasis, leaving more or less to the imagination, fusing moralization and badinage in such 'mixed genre' paintings as Potter's *L'Amant de la Belle Europe* (fig. 87):

> Jupiter grand chercheur de joyeuse avanture,
> Jadis emprunta ma figure;
> Aussi ma vive ardeur ne sçauroit s'égaler,
>
> Ma vigueur est presque sans bornes,
> Et l'homme voudroit bien pouvoir me ressembler,
> Si néanmoins l'on excepte mes cornes.
> Par M. Moraine.

Reused verse, on the other hand, is more likely to apply to persons or events, and even to coexist with a reused image, for portraits of different format such as d'Alembert's 1774 portrait after Pujos; this was engraved *en grand* in 1775 by Maloeuvre with verse by Marmontel and reprised *en petit* by Dupin with the same but unattributed verse.[11] Such verse occasionally appears on prints whose quality and presumed clientele are so different that their source is difficult to isolate, their identification more often than not a happenstance. Le Bas's 1744 *Le Sifleur de Linot* after Teniers, thirty-fourth of the series, has a verse signed by the ubiquitous Moraine:

> Quand sans avoir appris ni musique, ni note,
> Ton flexible gosier imite en tous leurs tons
> Mes joyeux siflemens, mes gaillards chansons,
> Je me sens tout ravi, ma petite Linote.
>
> Ah, je t'aime bien mieux que ma femme Alison,
> Qui jamais avec moy ne fut à l'uni-son,
> Et qui ne manque point dans son humeur bizarre,
> Si je chante en Bé mol, de chanter en Bé quarre.
> Moraine[12]

This verse appears on *Le Savetier*, published by André Basset, who also reprises the all important bird-on-perch and bird-in-cage motifs (figs. 94 and 95).[13] These two cases only suggest how much remains to be done in the search for cheap and popular imagery derived from more artistic prints. *A contrario*, unsigned verse may, regardless of origin, have been the property of print editors. Some intimation of this is seen in the following quatrain found under a small print that accompanies the text of the convocation of the Assemblée des Notables (20 December 1786).

Citoyens assemblés par un Roy Citoyen,
Conseil de la Patrie, et son noble soutien,

Vous ne trahirez point l'attente génereuse
D'un Roi qui veut par vous rendre la France heureuse.

It was redirected thereafter to a large allegory relating to the Assemblée Nationale (4 May 1789), and both prints appeared chez Guyot (figs. 96 and 97).[14] Most interesting of all, however, are the minor copperplates that are unexpectedly reused and recombined – which is not new – but enhanced by supplementary plates in new and interesting ways. Pierre-Antoine Lebeau's portraits of Louis XVI and Marie-Antoinette, in themselves undistinguished and very minor in scale, were transformed into impressive *étrennes* for 1778 by the addition of no less than fifty-four verse lines (fig. 98).[15]

As we have seen, verse appears throughout the entire range of print-making, an observation in itself far more important than any rise in verse quality or any fall in the number or proportion of versified prints throughout the century. Yet our study would be seriously flawed were mention not made of the *suppression* of verse for reasons other than censorship. These relate more than anything else to the rise of neoclassic subject matter – the virtual death of the versified print – or to pragmatic decisions such as patronage; witness Pierre-Jacques Loutherbourg's pendant etchings *Tranquillité Champêtre* and *La Bonne Petite Sœur*,[16] whose first states (Baudicour: 'Très rare') have quatrains. In their second ('Rare'), the verse disappears, titles are effaced and redone, and the respective coat-of-arms of the Marquise de Gouy and the Vicomtesse d'Arsy appear along with dedications by Loutherbourg. Differences in the address of the remaining five states testify to the plates' passage from editor to editor after leaving Loutherbourg's own hands. This 'ennobling' action immediately lifted them to a higher plane where verse was not incompatible with social status, but not entirely necessary either. This change in the

print letter surely contributed to the restoration of the primacy of its image; whatever the latter's nature, it was presumed that the viewer needed no glosses or marginalia but could decide for himself what he was seeing. With it, the versified print was relegated, if not to the dustbin, at least to an object of passing curiosity.

When all is said and done, the *immediacy* of the versified print was its strength. Some of its most imaginative applications lie not in mythological or literary scenes, portraits, and allegories but in topical prints (*estampes d'actualité*). Popular in price, often derisive yet capable of great sophistication, they give unexpected twists to common themes, current events, and societal preoccupations. And at a time when the exchange of compliments within artistic and social circles was rampant, are we to suppose that Née and Masquelier's 1775 print of the expectant Mme de La Borde was really intended to be commercialized rather than distributed among family and friends, or that the three impressions known to the nineteenth century are all that have survived?[17] In iconographical matters only exceptional cases such as this count in themselves and in contrast to serial production. They give new life and nuance to familiar types and conceits, while providing unexpected insights and linkages between their creators. For example, we possess many street scenes by anonymous, named, and eminent artists entitled *L'Optique* or *La Curiosité* that show cross-sections of society crowding about a magic lantern. We will most likely recall, if we have ever run across it, that of the editor André Basset (fig. 100). Rather than the usual views and scenes, everyone is bidden to see something unique in the commerce:

> Marchandes de Croquet, Savoyards curieux,
> Soldats, gens de tout Sexe et de different age,
> > A cet ouvrage ingénieux
> > Venez donner votre suffrage.

> Accourez pour y voir sans tarder d'avantage
> Ce que partout ailleurs jamais on ne verra
> > On y montre le pucelage
> > D'une fille de l'Opera.[18]

The operator of the apparatus and the print 'voice' an invitation heard by all. Despite its subject, this particular layering of text and image provides the best example and definition of versified prints; while we read their texts, they speak to us through the ages.

Conclusion

Whatever their subject, whoever their sitter (for portraits), versified prints were historical documents at the subconscious level. They transmitted an image along with the voice of their creators, not only to their contemporaries but to posterity. They shared a perishable support – paper – with other poetic genres but had the singular advantage of appearing in the form of *individual sheets*. These could be continually restruck because the economics of their reprinting were different from those of books. As a result, prints remained a 'disposable' that was constantly renewed, recirculated, and re-experienced. As with books, they could be searched out by author, title, or subject, but if one stumbled across them, they quickly engaged the mind's eye of their finder in unexpected ways. This duality leads to five queries or issues in the later Ancien Régime:

1 What poets versified prints, and (quality aside) who versified most regularly or most often? Two names stand out within what seem, at this early stage of research, to be distinct groupings of men of letters and amateurs: Moraine, with roughly three times as many works as Roy, who in turn has roughly twice the total of Gacon once we exclude the small-format portrait series that is Odieuvre's *l'Europe Illustre*. Moraine may allude to the biographical doggerel that accompanies serialized portraits when he signs sixain after sixain for Petit's continuation of the *Suite Desrochers*.[1] Those who occasionally engaged in this *petit métier* are as numerous as the repertory, which is only beginning to take shape (see appendix A).

2 What artists (quality aside) were versified, and whose work was most regularly or most often set to poetry? Moraine wrote the verse for the very first print after Gabriel de Saint-Aubin, *Les Enfants bien avisés*

(1760).[2] For art historians, this is of great importance now that Saint-Aubin is primarily known and appreciated for his personal work, but it may not have been so at the time. Even in cases where names of artist, engraver, and versifier *all* appear on the print, and/or in the annonce, artistic debuts invite caution in period interpretation.

3 What engravers issued versified prints, in what quantities, and with what regularity?

4 What prints may be dated by examining both poetry and image, whether in themselves or in respect of finer precedents?

5 What prints employ *derived* verse schemes – traditional airs, as with versified Salon critiques – as the metric basis for new verse, whether signed or unsigned (figs. 99 and 101)? This class of prints may prove to be one of the most interesting and significant of them all, if only because it proves the ubiquity and continuity of music in the Ancien Régime.

These distinctions are roughly equivalent to those made in early print literature and which remain inescapable today: prints *by* given engravers versus prints *after* given artists. They establish print versifiers as an integral part of print culture and commerce, a *petit métier* inseparable from the omnipresent engraving of print letters. However, the *meaning* of versified prints shifts significantly when we consider statistics and focus on the artist, engraver, or poet. Chronology provides an armature, but the poet is surely the most important factor in the equation since his verse is specific to each print *as it was issued*.[3] This leaves unanswered questions as to the polishing of appended verse. There are, however, striking instances of poetic revision in successive states of given prints.

One such type is seen in Gaucher's portrait of the engraver Gravelot, where, one by one, only two lines of verse are revised, resulting in a 'new' poem by the third state.[4] Its dimensions (93 × 56 mm) correspond to the *Almanachs iconologiques* (1765–81) of Gravelot and Cochin fils, so poetry cannot in itself be seen as a function of the size or quality of its print; there must be reasons for signing verse – prestige, relations, occupation, contracts – when not signing it is more the rule.

The second type involves the historical revision of a copperplate so that it refers to an event other than that for which it was created. These, few in number, seem thus far to concern royal births, particularly when a daughter preceded a son. They are rarely versified, and one that is shows a truly innovative coordination of image and verse. This is Jean-François Janinet's colour aquatint *Les Sentimens de la Nation*, origi-

nally advertised in 1778 for four livres, and re-advertised in modified form in 1781 for only two livres and eight sols. As Anne Sanciaud has pointed out, the visible tenderness of a royal couple towards its progeny was an appealing 'modern' image of the monarchy (fig. 102),[5] but this goes further than enclosing the subject within a marble panel eaten away in the shape of a heart; it gives the impression of a domestic scene, while it is anything but. Only mother and child are real, while the dynastic presence of the father and maternal grandmother are seen in the marble bust and portrait medallion, an ingenious admixture of two- and three-dimensional figures. It is the verse that ties the frame's symbolic elements together,[6] although the words 'Dauphin et' of the third line are suspiciously smaller, cramped, and above the line, while a line preceding the address – 'Pour la naissance de M.^{gr} le Dauphin né le 22 Oct. 1781. à Versaille' – overprints the poet Guichard's signature.

> Antoinette, des Lys Espérance bien chère!
> Ce beau Jour met le Comble à la Félicité.
> Vous êtes dans nos Cœurs, Roi, Reine, Dauphin et Mère,
> Réunis par l'Amour et la fidelité.

Guichard's third line originally read, '. . . Roi, Reine, Enfant, & Mère,'[7] so Janinet's annonce anticipated by one day the birth of a child who turned out to be Marie-Thérèse Charlotte (Madame de France, born 20 December 1778), not the first Dauphin whose birth would have justified the blue sash of the Ordre du Saint-Esprit that echoes the heart-shaped opening in the marble frame. It is doubtful that Guichard would have been consulted for a retroactive correction of a few words, and these words in particular. Their maladroit insertion contravenes the artistry of the print itself. Whenever possible, fundamental (and hopefully less obvious) revision of print letters was the rule. The corrected verse appears in an unsigned and reversed etching (fig. 103), which suggests the latitude accorded once a print had appeared.[8] Both these prints were issued by the print editor F.-X. Isabey, which strongly suggests that he competed with himself so as to cover two levels of clientele. The question remains as to why Guichard was chosen to versify this particular print.

Verse signifies one thing for isolated prints, another for pendants (particularly when one is signed and the other is not). However, versified prints as a class are problematic in their creation and their diffusion. We presently have no real idea of the business arrangements existing between poets, artists, engravers, and publishers in the Ancien Régime

(logically they should be different for amateur and professional versifiers). Whoever the versifier is, whoever created the images to which his verse was applied, and whatever the number of prints so treated, historically speaking only the print editor counts. Only he brings it all together and puts his name on the finished product. But until contracts, correspondence, or other paper trails are discovered in sufficient quantity, several creative issues are obscured in the fabrication of versified prints. What was the lead time necessary for calling in a poet for a specific print and receiving his contribution (engraving a print letter was a minor consideration when compared with its image)? Was the verse engraved as received, or was it subject to revision – that is, who had ultimate approval? Was the versifier given free rein or guided in his approach when collaborating with reputed engravers and editors? Little latitude must have existed when versifying portraits of public figures. Subjects, however, presume close reading of the image to determine interpretative slant. When and under what circumstances did a poet intervene?

Paintings were often lent to the engraver (*prêts à domicile*), a practice traditionally thought to have the best results given the ongoing correction and adjustment possible yet not always practicable. Working from detailed drawings made to facilitate the engraving process also guaranteed a measure of fidelity.[9] Working from before-letter states was equally possible, but versification could well have been a last-minute affair dependent more upon the space allotted for this purpose than upon anything else. From a technical viewpoint, this third possibility makes sense only if one is accustomed to the making of verse. Mere facility is not at issue here or in an analogous situation – the versified Salon critiques that were the source of periodic amusement. On the appearance of *La Muse errante au Sallon, apologie-critique en vers libres* (1771), the reviewer noted that 'on est d'abord étonné comment cette muse a pu produire en si peu de tems près de mille vers sur les différens morceaux exposés au Sallon; mais cet étonnement cesse lorsqu'on lit les différentes descriptions que cette Muse babillarde nous donne des tableaux & des morceaux de Sculpture au Sallon.'[10] Despite rapid versification in both instances, the analogy ceases given the focus on one print rather than on dozens of paintings by many artists. What differs is the apparent poetic appropriateness and quality in critiquing works of art unseen by the reader on the one hand, and addressing the content of an accompanying image on the other.

Announcing a print is the next step. In this, the attention of prospective buyers must somehow be arrested in the absence of the prints them-

selves. Beyond mention of the artist or the subject, the appended verse becomes a commercial asset in advertisements. Seen in this light, significant differences exist between the type of verse necessary for comprehending the subject and verse merely appended to an image – roughly speaking, the difference existing between subjects and portraits. Verse can be cited in whole or in part, or its presence merely noted, but *signed* verse indicates the level of importance accorded its author within a given context. When all is said and done, I suspect that this process is an indication that visual literacy was not terribly advanced and that prints so advertised were both 'seen and understood' through literary conceits.

Whatever extra dimension poetry gave to images, the perennity of versified prints in the commerce can only have depended on subject matter that resonated throughout society as a whole. Has print production so changed since the eighteenth century that the images are now presumed to speak for themselves rather than address us through their appended texts as they once did? A study of the larger issues of print history as cultural history has yet to be written. When it is, versified prints will be seen as the intersection of two of the most popular modes of expression of the Ancien Régime.

Epilogue

The versified print did not disappear with the advent of the French Revolution (1789–99). How it was subsequently used and how often changed in the prints that were revolutionary in subject or time.[1] Didactic and political applications tend to shorter and unsigned verse. The rapidly evolving political situation meant the virtual disappearance of versified pendant prints as well. Adaptations of traditional airs continued unabated, sometimes with overtly scatological content reinforced by an ingenious cartouche – an iconographical substitute for armorials – such as that for Villeneuve's *Le Trium-Geusat* (fig. 99). Whether these prints should be considered apart from or as prolongations of the Ancien Régime is a matter of choice or conviction.

Yet the one is unthinkable without the other. New visions and new challenges spawned specialist collaborators whose combined efforts changed the course – and aesthetic – of prints in eighteenth-century France to the point that, were versified prints to amount to only 5 to 10 per cent of the mass, they would still represent a significant aspect of print history. Plotting their rise, vogue, and decline is another thing, although some reasons for this are readily apparent. Unlike prints made to or labelled as being in the same scale as their models, the best, the most reputed prints, adopt *enlarged* pictorial formats where the print itself is the thing. They are also after the fashionable artists of the day. Highly characterized works, they hold their own even within suites of various length and inspiration, where adaptations from scripture and literature share common ground with original subjects and historical art. A turning point of sorts came with the transition in painting from Watteau to Boucher, Lancret, Pater, and Chardin. The breakthrough came with engraver-editors such as Nicolas IV de Larmessin, who issued Sébastien Leclerc fils' *Enfant prodigue,*[2] and Le Bas, whose many published prints

after Teniers demonstrated the range of possibilities for verse commentary. By the 1740s, verse *meaningfully* extended imagery of all periods and levels, from the exotism of Boucher's chinoiseries to the contemporary domesticity of Chardin. Whatever its nature or intent, verse remained the printmaker's prerogative. Verse is generally excluded from crayon manner prints by Gilles Demarteau, perhaps because their models were presentation drawings or studies.[3] It appears intermittently on stipple and lavis Bonnets.[4]

The question remains as to whether a repertory of incipits and of poets signing versified prints is of use. Each forms a unique and highly visible corpus of discrete occasional verse that is difficult to use coherently in other contexts. Unlike poetry intercalated in the public papers or books, or entombed in manuscripts, we see an extraordinary range of images versified *by choice* for public consumption. As much as anything, they represent 'disposable' poetic effort on a perishable paper support, even if by means of subsequent restrikes they were virtually assured of survival throughout succeeding ages, more as an artistic curiosity than as a historical phenomenon. Typological study – portraits versus subjects, reproductive versus original prints, art versus caricature, the different genres – is counterproductive since little account can be taken of their complex imbrications. A repertory of the traditional airs (their source mentioned and their content circumstantially adjusted) whose verse schemes appear on so many dated or datable prints would be of more certain use in demonstrating the longevity of musical repertory in an unexpected context.

The underlying question of this enquiry – whether the public was willing and able to judge the quality of poetry and its appropriateness for the image it accompanied – remains open. It may be unanswerable in as much as the greater public saw and acquired prints, judging them in more different ways than was possible with painting and sculpture. The size of the print seems to matter little in the care taken, if, for example, a distich for Gaucher's portrait of Gravelot (93 × 53 mm) was greatly improved in its second state.[5]

A synchronic table of poets, painters, and print dates might prove helpful as well. Early in the century there are habitual poets as well as engravers for given painters: for example, Claude Ferrarois for Nicolas Vleughels; I.Fr. for Jacques Courtin; Moraine for Sébastien Leclerc fils; and Gacon for Nicolas Fouché. Bernard-François Lépicié's exceptional position as both engraver and versifier for Chardin in the 1740s may represent the end of an epoch. The rapid movement of printmaking into commerce meant that poetic specialization in an artist was over.

Print versifiers in demand henceforth dealt with a wider range of images and artists than ever before. This changes everything when one sees what Gacon, Pesselier, or Roy versified, or examines the overlapping generations and tendencies whose collaboration led to a print. The Suite Larmessin after the *Contes* of La Fontaine involves eight artists (Boucher, Eisen, Lancret, Leclerc, LeMesle, Lorrain, Pater, Vleughels); six engravers, principally Larmessin (aided by Schmidt) and Fillœul, but including Aveline, Legrand, Sornique, and Tardieu; and two principal versifiers (Moraine and Roy). La Fontaine may have provided the scenario, but its realization required multiple talents.

Assigning importance to the relative proportion of signed and unsigned verse on prints, particularly those of artistic and technical consequence, is also tricky. However, the *act* of signing makes reference to and publicity for living poets that is akin to the print annonces for engravers. (Citations from the deceased merely consecrate their fame.) Putting only one's initials to a versified print, though, is rather more likely to conceal than reveal one's identity. We might never identify Alexandre Tanevot's verse for a print by Pasquier after Depalmeus without having to hand the printed *Explication de l'Allégorie* in honour of Mr. Machaut (fig. 105).[6] Indeed, an entire chapter of Ancien Régime print creation could be written from such ephemera. Poetic comment, signed or unsigned, can also be found on the pages to which prints of historical personalities or events were affixed in private collections. On the mounting paper of a portrait of Jean Law (fig. 104) we even find a sequence of quatrains, the first an unsigned laudatory 'Contrevérité,' the second a venomous 'Réponse à l'auteur des vers précedents' signed 'Pierre,' who quite misunderstood the intent of the previous author.[7]

When all is said and done, the proportions existing between image, print margin, and copperplate remain a relatively sure indication as to whether versification was intended from the start. It is likely, but not proven, that smaller prints relied more on poetry for meaning than did the impressive larger formats, but over time the versified print may have seemed archaic, even anachronistic, as culture and society evolved. Seen as a measure of cost-efficiency, it is easier to recite poetry than to print it, and easier to print a text than to include it as one of many elements on a print. That so much verse on so many topics was committed to prints, where we least expect to find it, is something for which we should offer thanks.

Excursus: Music and Theatre Prints

One class of prints stands apart because of its intimate relation to poetry: prints derived from or inspired by music and theatre – perhaps both when a double derivation exists. We must then ask who, at the time, could have been ignorant of contemporary musical libretti when viewing a composition, reading a citation, or remarking a print title? Incipits, all-important for verse created to accompany models of disparate origin (usually paintings and drawings), are of no real use. What is needed is a number of quoted lines sufficient to recognize such sources. But how do such 'prompts' work when they appear in apposition to an image? Directly and immediately, or by a more subtle process of evocation and recollection that vanishes with time?

Our best introduction to these issues is seen in the works of Pierre-Antoine Baudouin (1723–69), son-in-law of Boucher and, in his Salon of 1765, Diderot's favourite whipping boy when contrasted to Greuze. This parallelism was rapidly applied to Collé and Sedaine.[1] Baudouin specialized in contemporary subjects or situations and was generally engraved posthumously. More than with most painters, then, it is what the engravers did with his gouaches that counts, for printmaking is an opportunistic medium.

Two such prints, Ponce's *Annette et Lubin*[2] and Simonet's *Rose et Colas* (fig. 106),[3] visibly correspond to their titles, provided one knows the argument. As a form of musical theatre, they are described as 'comédie en un acte en vers, mêlée d'ariettes et de vaudevilles' and 'comédie en un acte, prose et musique' and debuted on 15 February 1762 and 8 March 1764 respectively. While the images resume scenes 4 and 12 and are derived from various types of verse (much as book illustration resumes chapters), there is no accompanying verse. The viewer is left to connect

underlying text and image but can generally rely on a scene in doing so. However, when orienting print titles are lacking (fig. 107), one is left to one's own devices and must read what is necessary into a composition[4] that was not only a familiar *petit sujet* in painting and drawing – *la fille mal gardée* – but was likely a byword (here in italics) since the publication of a 1714 chanson with the word-picture:

> La fillette fut fragile,
> Et se leva.
> Toute nue en sa chemise,
> La porte ouvra.
> *Marchez tout doux, parlez tout bas*
> Mon doux ami,
> Car si papa vous entend,
> Morte je suis.

Interpretation becomes easier in a suite of four prints dating from the mid-1770s, engraved by as many engravers for the print dealer and entrepreneur Pierre-François Basan. Despite uniformity in presentation (female figure, oval surround in fictive stone, inscription), the suite is actually two pendants – one with a print title and three lines, and one with no print title and four lines. (All could be sold separately or in various combinations.) Of the former, Ponce's *Marton* gives the beginning of the ariette of *La Fée Urgèle*, scene 5, of 26 October 1765,[5] while Guttenberg's *Perrette* gives that of *Deux Chasseurs et la Laitière*, scene 4, of 21 July 1763.[6] Of the latter, Masquelier's *Jusques dans la moindre chose* gives an ariette from scene 8 of *On Ne S'avise Jamais de Tout* of 2 December 1761,[7] while Le Beau's *Sa taille est ravissante* features an air from scene 1 of *La Chercheuse d'Esprit* of 20 January 1741.[8] In none of these is there the equivalent of a credit line that situates the poetry's image – except in an undescribed fifth state of *Jusques dans la moindre chose* with the extra line 'Dans On ne s'avise jamais de tout' (fig. 108).

The question remains whether Baudouin created his gouaches to illustrate or to correspond with contemporary musical theatre. Beyond its concealed textual (iconographical) support, *Rose and Colas* have a stagey look about them even if they do not correspond to theatrical practice.[9] However, the suite is another matter and may correspond to stock types or types dependent on the theatre such as the milkmaid Perrette (fig. 109), which until 1994 was the corporate name of a convenience store in the province of Quebec.[10] By 1799 at any event, the Basan

catalogue reduces *Jusques dans la moindre chose* to a subject type suitable for decoration by changing its title to *L'Eplucheuse de roses.*[11]

Whatever the origins of a print's model, few foregone conclusions are possible where printmaking is concerned. There are simply too many layers of inspiration that may not be immediately translated into an image, and too great a succession of options and processes in working up a copperplate. Fixed images are, not surprisingly, rather more subject to misinterpretation than appearances suggest if they are analysed and commented only in their own right. Then as now, the iconographical 'corrective' is what one brings to them in prior knowledge and an ability to read between the lines. The number of versified prints depicting music and theatre remains problematic since it expands or contracts depending upon whether poetry is actually given or whether an image is derived from, or merely recalls, verse passages. It should, however, be noted that some prints actually gave rise to poetry that was widely diffused or printed in other contexts, although their identity and circumstances are likely to be known mainly from early print collections whose mounts have marginal annotations, such as 'M. le Comte de Caylus a gravé cette Muse Eclopée en 1727 [fig. 110], et peu de tems apres il parut la chanson Suivante, Sur l'air des Pellerins de Saint Jacques.'[12]

Appendix A: Some Print Versifiers

This repertory makes no claim to completeness. It excludes classical authors but includes authors of circumstantial verse, plays in verse, opera libretti, and poetry found on prints consulted or used in the elaboration of this essay. (No account is taken of the number of prints versified by given authors.) An asterisk preceding the name denotes professional painters or engravers, and some editors of prints bearing anonymous verse who, beyond their own activity, often bought up copperplates of earlier publishers. Given the present state of knowledge and the possibility of homonyms and phonic or transcriptional error, some identifications are of necessity provisional.

Initials may correspond to names given elsewhere in full. M. (alone or incombination) may indicate *Monsieur*:

M. ****
Mme ****

B.D.
D.B.
D.F.
D.R.S.
F.R.
H***
I.F. or I.Fr.
J.B.A.S.
J.D.F. See Du Fresne
M.D.L.P.
Mme L.B.
Y.

Arneaux, d', possibly F.-Th.-M. de Baculard d'Arnaud (1718–1805): poet, novelist, and playwright

Attaignant, Gabriel-Charles de l' (1697–1779): poet and playwright

Aubert, Jean

Auriol de Lauraguet, Abbé d': poet ca 1780–1810

*Basset, André, le Jeune (fl. ca 1750–85): print editor and dealer, known primarily for images d'actualité

Beaumelle. See La Beaumelle

Beffroy de Reigny, L.-A. 'Le Cousin Jacques' (1757–1811): collaborator of gazettes, and playwright

Bérainville, Chevalier Person de: lawyer, writer, and playwright

Bizot, D.: poet (Odes, 1707)

*Bligny: print editor and dealer (fl. ca 1762–82), known almost exclusively for portraits of famous or newsworthy people

Bocquet de Liancourt: playwright (fl. ca 1770–80)

Bosquillon, Édouard-François-Marie (1744–1814): philosopher

Chénier, Marie-Joseph (1764–1811): famous poet, journalist, and pamphleteer

*Chéreau, Jacques-Francois (1742–94): along with Pierre-François Basan, one of the most important print editors and dealers in France

Colardeau, Charles-Pierre (1732–76): academician, poet, and playwright

Cosson, Pierre-Charles (ca 1740–1801): professor and translator

*Courtois, Pierre-François (1736–63): known for pendant prints after Augustin de Saint-Aubin, discussed by the Goncourts

*Coypel, Antoine (1661–1722): painter, etcher, Director of the Académie royale de peinture et de sculpture (1714), and First Painter to the King (1715)

*Coypel, Charles-Antoine (1694–1752): painter, etcher, poet, playwright; Director of the Académie royale de peinture et de sculpture, and First Painter to the King (1747)

Cubières, Chevalier Michel de (1752–1820): poet, playwright, and Master of the Loge des Neuf Sœurs

Danchet, Antoine (1671–1748): poet and playwright

*Davesne: poet and/or portrait painter of the Académie de Saint-Luc

Delandine, Mme, wife of François Antoine Delandine (1756–1820): lawyer, historian, and librarian

Delaunay, Abbé. See Launay

Delisle or de Lisle, Dom Joseph (1688–1766): author of historical and religious works

Desforges-Maillard, Paul, pseudonym of Mlle de Malcrais de La Vigne (1699–1772): poet in French and Latin

Duboc, Pierre

Dubruit de Charville: playwright ca 1700–30

Ducis, Jean-François (1733–1816): poet and playwright

Du Fresne de Francheville, Joseph (1704–81): author of historical and archaeological books, founder of the Gazette de Berlin (1764–81)

Du Hamel, Abbé Jos. Rob.-Alex (?): writer, author of Un Philosophe

Duviquet, Pierre (1768–1835): lawyer, critic for the Journal des Débats

*Eisen, Charles (1720–78): along with Cochin fils, Gravelot, and Moreau le Jeune, one of the masters of book illustration

Favart, Charles-Simon (1710–92): playwright of vaudevilles, director of companies, renovateur of the Opéra-Comique

Ferrarois, Claude

Foci: known from prints after Boucher by F.-A. Aveline, J. Ingram, and J.-M. Liotard

Fougeret de Montbron (1706–60): poet and translator

Gacon, François (1667–1725): satirical writer

Galand, Comte Louis de

Garrick, David (1717–79): actor and playwright

Gentil-Bernard, Pierre-Joseph-Justin Bernard, dit (1708–75): military officer, poet, and playwright

Giraudet, (. . .)

*Gravelot, Hubert-François Bourguignon, dit (1699–1773): prolific draughtsman and illustrator active in both England and France

Guichard, Jean-François (1731–1811): poet and student of Alexis Piron

Henricil: known from prints after Bon de Boulongne, J.-B. Nattier, and J.-B. Santerre

Hérivaux, L.-P.: professor, poet for L'Année littéraire

Hion, L.-N.: pamphleteer

Houdar de La Motte, Antoine (1672–1731): lyrical poet, playwright, and author of Fables nouvelles (1719)

Imbert, Barthélemy (1747–90) or J.-Bapt. Aug.: poet and playwright

Jeson: known from prints after Boucher by Claude II Duflos

Joinville, (. . .)

La Beaumelle, Laurent Angliviel de (1726–73): professor, librarian, historian, critic, and polemist of Voltaire

La Faye, Jean-François Leriget de (1674–1732): diplomat, collector, and academician

La Fontaine, Jean de (1621–95): poet, and author of the Contes and Fables

Lafont de Saint Yenne, Étienne (fl. 1747–56): art critic, author of Réflexions sur quelques causes de l'état présent de la peinture en France (1747), and deemed to be the origin of French art criticism

La Gardette, Abbé C.-M. de: architect and author of books on architecture

Launay, Abbé C.-M. de: poet, publisher, and critic

Lebrun, Antoine Louis (1680–1743): poet, novelist, and playwright

or Lebrun, Guillaume (1674–1758): Jesuit and writer

or Le Brun, J.B.P. (1748–1813): painter and art dealer

or Lebrun-Pindare, Ponce Denis (1729–1807): poet

Lécluse, Louis de Thillay, dit (1711–91): academician, actor, and playwright

*Lépicié, Bernard-François (1698–1755): poet, engraver, secretary, and historiographer of the Académie royale de peinture et de sculpture (1737–55)

Leverrier, possibly Leverrier de la Conterie: author of École de la chasse aux chiens courants

Linant, Michel de (1708–49): poet, professor, and publisher of Voltaire's works

Lockman, John (1698–1771): author, and translator of Bayle's Dictionnaire (1734)

Lutaine, (. . .)

Marmontel, Jean-François (1723–99): poet, playwright, philosopher, and historian

Marsollier des Vietiers, Benoît-Joseph (1750–1817): lyric composer and playwright

*Miger, Simon-Charles (1736–1820): engraver

Molière, Jean-Baptiste Poquelin de (1622–1673): playwright

Montbrun, possibly Fougeret de Montbron (d. 1761)

Moraine (Moraine, Mr Moraine, C Moraine): see appendix B for further information

Moulins, (. . .)

Neufville, or Noefville de Brunau-Bois-Montador, Chevalier Jean Florent Joseph de (1707–?70): military officer, author, and critic

Ormeaux, d'

Palissot de Montenoy, Charles (1730–1814): playwright and critic opposed to the collaborators of the Encyclopédie

Panard, Charles-François (1694–1765): poet and playwright

Pelletier de Rilly: lawyer and writer

Pesselier, Charles-Etienne or Joseph (1712–63): officer of finance and playwright

Piis, Pierre-Antoine-Augustin de (1755–1832): playwright, and founder of Théâtre du Vaudeville

Piron, Alexis (1689–1773): poet and playwright

Reigny, L.-A. Beffroy de (1757–1811), dit le Cousin Jacques: see Beffroy de Reigny, L.-A.

Rollet, Bailly du: lyric composer

Roucher, Jean-Antoine (1745–94): poet, journalist, and author of Les Mois (1779)

Rousseau, Jean-Baptiste (1669/70–1741): poet and writer of comedies

Rousseau, Jean-Jacques (1712–88): writer and philosopher

Roy, Pierre Charles (1683–1764) (also M.R., Roy, Mr. Roy): poet and playwright

Sabatier de Castres, Antoine Sabatier (1742–1817), dit: journalist

Saderlet: known from prints after Boucher by F.-A. Aveline and J.-J. Balechou

Saint-Marc, Jean-Paul-André des Rasins, Marquis de (1728–1818): playwright

Schosne, Abbé Augustin-Théodore-Vincent Lebeau de: poet and playwright

Sedaine, Michel-Jean (1719–97): famous playwright of the théâtre bourgeois

Sticot(t)i, Antonio Fabio (1676–1742): actor and playwright

or Antonio-Jean (ca 1715–72): playwright

Tanevot, Alexandre (1692–1774): censor and playwright

Tessin, Carl-Gustav, Comte de (1695–1770): Swedish diplomat in France, author of letters

Vadé, Jean-Joseph (1720–57): poet and playwright

Verduc: known from prints after Lancret and Watteau

Vestris, Mme, wife of G.A.-B. Vestris (1729–1808): opera dancer

Villette, Charles, Marquis de (1736–93): translator, poet, and playwright

Voisenon, Claude-Henri de Fuzée, Abbé de (1708–75): poet and author of comedies in verse

Voltaire, François-Marie Arouet, dit (1694–1778): writer and philosopher

*Watelet, Claude-Henry (1718–86): amateur etcher, writer, and collector known primarily for L'Art de Peindre: Poëme (1760), Rymbranesques ou essais de gravures (1785), and posthumously published articles with the engraver Pierre-Charles Levesque for the Dictionnaire des arts de peinture, sculpture et gravure (1789–91).

Appendix B: Moraine as Versifier for Painters, Draughtsmen, and Engravers

'M. Moraine' was the premier print versifier in France from 1725 to 1764, being predominately active in the 1730s and 1740s. The following lists are doubtless incomplete but suggest the complexities of his *petit métier*. The first list concerns painters and draughtsmen whose work is reproduced, with one asterisk denoting engravers and two asterisks denoting a great number of prints after a given artist. The second list gives the engravers responsible for prints bearing Moraine's verse, with two asterisks denoting a number of prints after one or more artists, and three asterisks identifying female engravers (*graveuses*). This is by far the more significant of the two tabulations since versifiers worked directly for engravers; working through their complex interrelations would make for a significant case study.

Painters and Draughtsmen	Engravers
Aveline, P.**	Aveline, F.-A.
Beauvais, (. . .)	Aveline, P. **
Boucher, Fr**	Basan, P.-F.
Boullongne, L. de	Boily, Anne, femme Lefort***
Canot, P.	Boucher, Fr.
Champagne, (. . .)	Charpentier, J.-B.
Chardin, J.-B.-S.	Chenu, P.
Cochin, C.-N. fils**	Chevillet, J.
Corneille, M.	Cochin, C.-N. fils
Coypel, A.	Cousinet, C.-E., wife of L.-S.
Delafosse, C.	Lempereur***

Painters and Draughtsmen	**Engravers**
Dou, G.	Daudet, R. II
Dujardin, K.	Daullé, J.
Dumesnil, P.-L.	Duflos, C. II**
Dyck, A. van	Dupin, P.
Eisen, C.*	Dupuis, N.-G.
Fontaine, L. de	Fehrt, A.-J. de
François, J.-C.	Fillœul, P.**
Gravelot, J.-F. Bourguignon *dit***	François, J-C.**
Hallé, N.	Gaillard, R.
Hondius, A.-D.	Halbou, L.-M.
Humblot, (. . .)	Larmessin, N. IV de
Jeaurat, E.	Le Bas, J.-P.**
Lallemand, J.-B.	Le Grand, L.
Lancret, N.	Lemire, N.
Le Bas, J.-P.**	Marlié, R.-E., wife of B.-F.
Le Clerc, S. (II)	Lépicié***
Le Mesle, P.	Masquelier, L.-J.
Loo, Carle van	Michel, J.-B.
Loo, J.-B. van	Moitte, P.-E.**
Mieris, F. van	Ouvrier, J.
Mondon, F.-T.	Poilly, J.-J.-B. (?)
Parrocel, C.	Ravenet, S.-F.
Pater, J.-B.	Sornique, D.
Potter, P.	Surugue, P.-L.
Raguenet, N. *or* J.-B. fils	Tardieu, P.-F.
Ruysdael, J.-I. *or* S.-J.	Teucher, J.-C.
Saint-Aubin, G.-J. de	Thomassin, S.-H. *or* H.-S.
Santerre, J.-B.	
Schenau, J.-E.	
Teniers, D.**	
Velde, A. van de	
Vleughels, N.	
Watteau, J.-A.	
Wouwerman, P.	

Illustrations

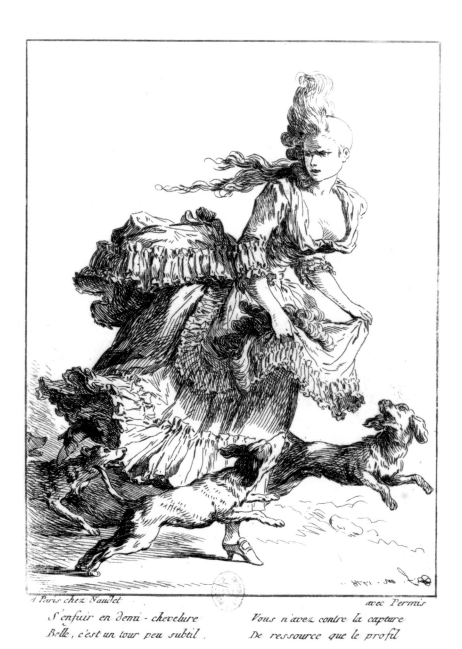

S'enfuir en demi - chevelure
Belle, c'est un tour peu subtil.

Vous n'avez contre la capture
De ressource que le profil

Fig. 1 Etcher 'G.R.': *S'enfuir en demi-chevelure . . .* (Half-Shorn Prostitute
Fleeing through the Streets), 1778

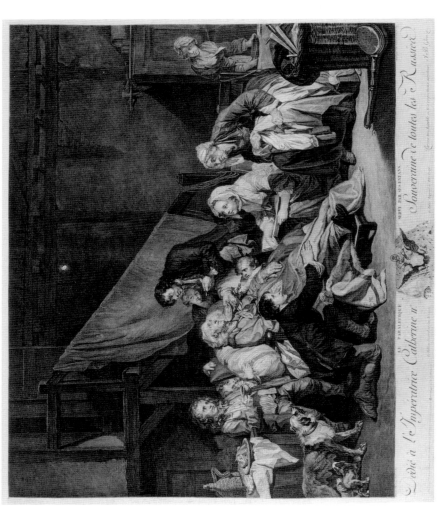

Fig. 2 J.-J. Flipart after Greuze: *Le Paralytique servi par ses enfans*, 1767 (state iv/iv), shown at Salon of 1767, no. 224

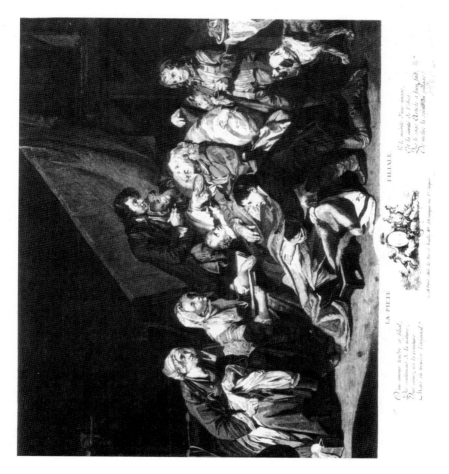

Fig. 3 *La Piété Filiale*, after the Flipart print (fig. 2)

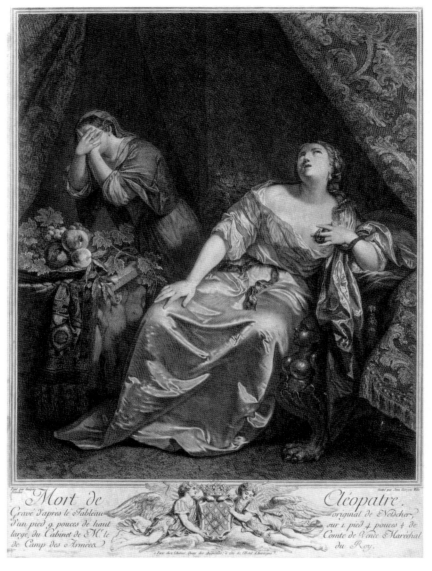

Fig. 4 J.-G. Wille after Netscher: *Mort de Cléopatre*, 1754 (state iv/iv)

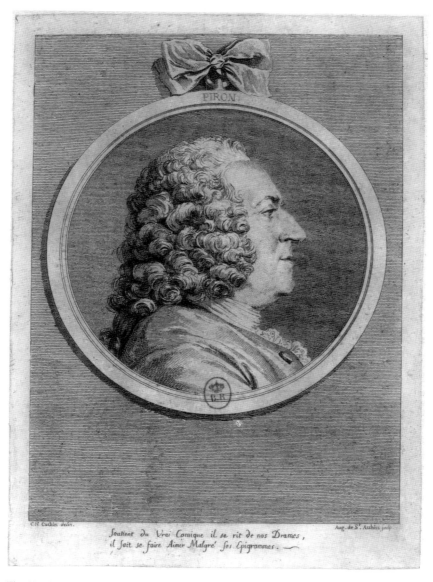

PIRON

Soutient du Vrai Comique il se rit de nos Drames,
il sait se faire Aimer Malgré ses Epigrammes.

C.N. Cochin delin. Aug. de S. Aubin sculp

Fig. 5 A. de Saint-Aubin after C.-N. Cochin fils: *Alexis Piron*, 1773 (state ii/v)

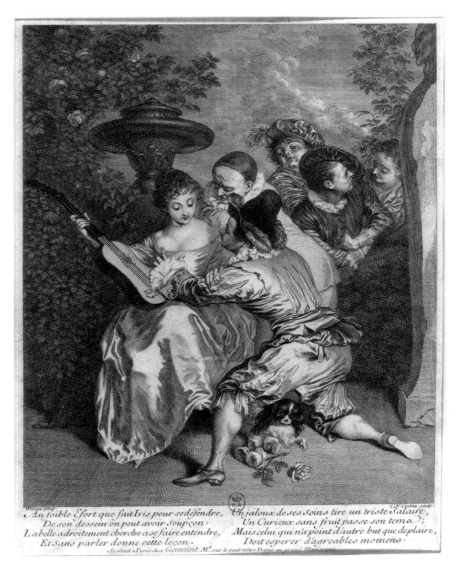

Fig. 6 C.-N. Cochin père after Watteau: *Au foible Efort que fait Iris pour se défendre*, 1727 (state ii/iv).

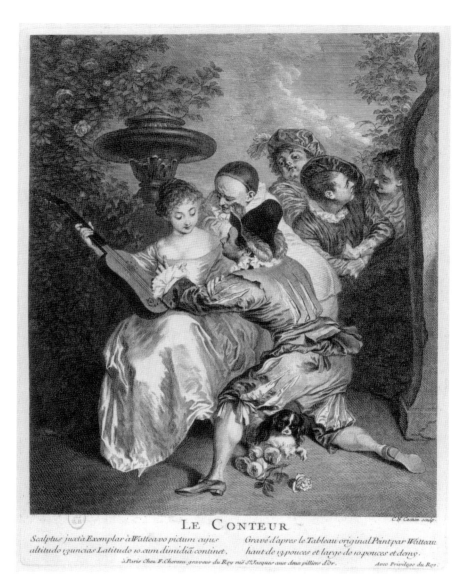

LE CONTEUR

Sculptus juxtà Exemplar à Watteavo pictum cujus altitudo 13uncias Latitudo 10 cum dimidiâ continet.

Gravé d'apres le Tableau original Peint par Watteau haut de 13 pouces et large de 10 pouces et demy.

à Paris Chez F. Chereau graveur du Roy rue St Jacques aux deux pilliers d'Or.

Avec Privilege du Roy.

Fig. 7 C.-N. Cochin père after Watteau: *Le Conteur,* 1727 (state iv/iv, corrected from *Le Compteur,* state iii/iv)

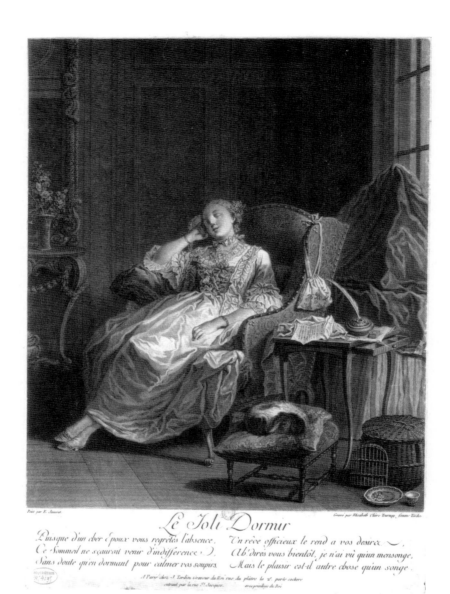

Peint par E. Jeaurat.　　　　　　　　　　　　　　　　　　　　　*Gravé par Elisabeth Claire Tournay, femme Tardieu.*

Le Joli Dormir

Puisque d'un cher Epoux vous regretés l'absence,　　　Un rêve officieux le rend a vos desirs,
Ce Sommeil ne sçauroit venir d'indifférence,　　　　Ah dirés vous bientôt, je n'ai vû qu'un mensonge,
Sans doute qu'en dormant pour calmer vos soupirs,　　Mais le plaisir est-il autre chose qu'un songe.

A Paris chez J. Tardieu graveur du Roi rue du plâtre la 2.º porte cochere
entrant par la rue S.ᵗ Jacques. avec privilege du Roi.

Fig. 8　E.-C. Tournay, femme Tardieu after E. Jeaurat: *Le Joli Dormir*, 1769 (state ii/ii)

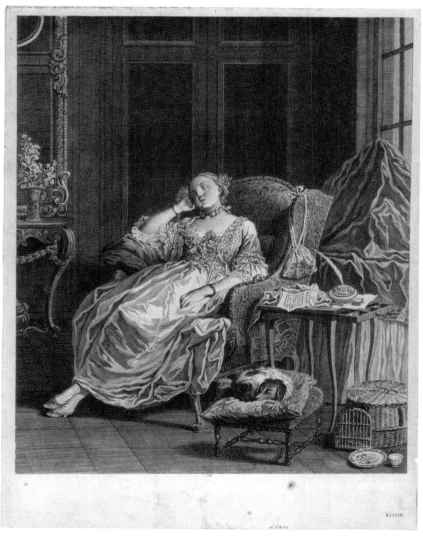

Fig. 9 E.-C. Tournay, femme Tardieu after E. Jeaurat: *Le Joli Dormir*, 1769 (state i/ii)

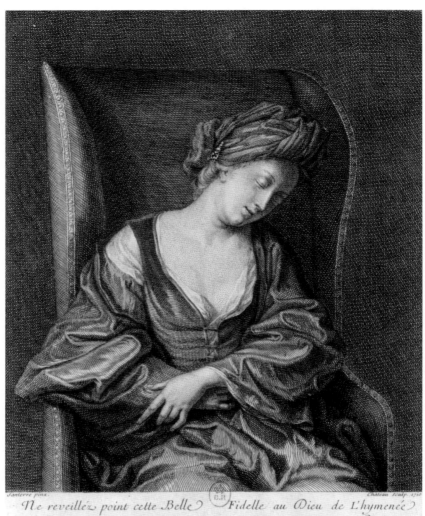

Santerre pinx. *Chasteau Sculp. 1710*

Ne reveilléz point cette Belle⟩ Fidelle au Dieu de L'hymenéé⟩
Marchéz doucement parlez bas; Elle veut en avoir un Fruit;
Epouse encor toute nouvelle Et ne dort pendant la journée
Le repos nourrit ses apas, Quafin de mieux veiller la nuit.

a Paris chez Chasteau sur le petit pont àtenant le G.Monarque CPR.

Fig. 10 N. Chasteau after J.-B. Santerre: Ne réveilléz point cette Belle, 1710

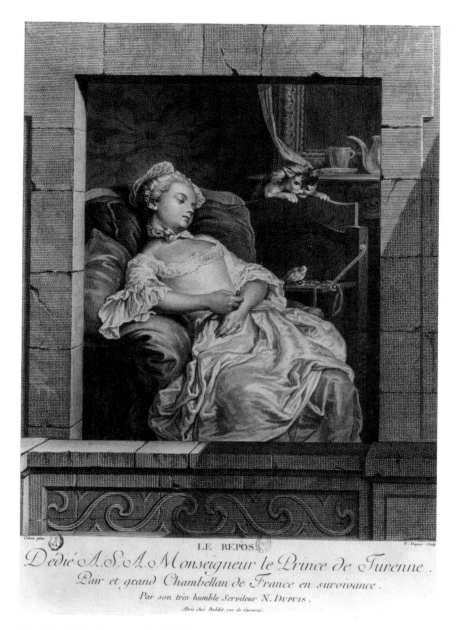

LE REPOS

Dédié A.S.A. Monseigneur le Prince de Turenne.
Pair et grand Chambellan de France en survivance.
Par son très humble Serviteur N. Dupuis.

Fig. 11 N.-G. Dupuis after F-G Colson: Le Repos, before 1771, after a painting
dated 1759

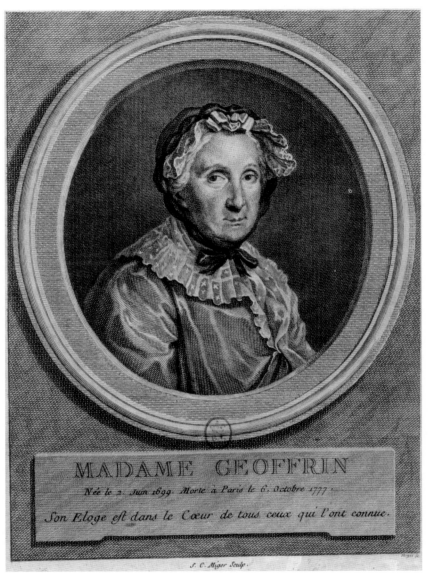

MADAME GEOFFRIN

Née le 2. Juin 1699. Morte à Paris le 6. Octobre 1777.

Son Eloge est dans le Cœur de tous ceux qui l'ont connue.

S. C. Miger Sculp.

Fig. 12 S.-C. Miger: *Madame Geoffrin* (state ii/ii), shown at Salon of 1779, no. 277

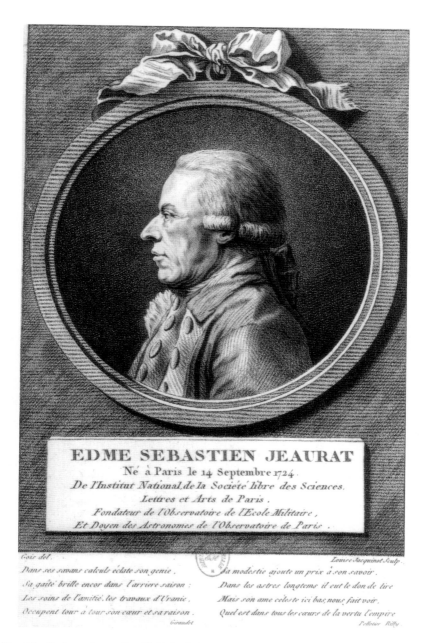

EDME SEBASTIEN JEAURAT
Né à Paris le 14 Septembre 1724.
De l'Institut National de la Société libre des Sciences.
Lettres et Arts de Paris.
Fondateur de l'Observatoire de l'Ecole Militaire,
Et Doyen des Astronomes de l'Observatoire de Paris.

Gois del. Louise Jacquinot Sculp.

Dans ses savans calculs éclate son génie. Sa modestie ajoute un prix à son savoir.
Sa gaité brille encor dans l'arriere saison : Dans les astres longtems il eut le don de lire
Les soins de l'amitié, les travaux d'Uranie. Mais son ame celeste ici bas, nous fait voir,
Occupent tour à tour son cœur et sa raison. Quel est dans tous les cœurs de la vertu l'empire

Girandot Pelletier Rilly

Fig. 13 L. Jacquinot after E.-P.-A. Gois: *Edme Sebastien Jeaurat*, 1789

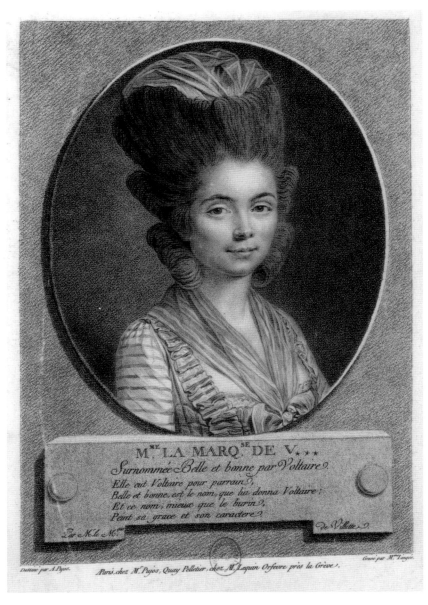

Fig. 14 T.-E. Hémery, femme Lingée after A. Pujos: *M.^{me} la Marq.^{se} de V**** [Villette], 1781

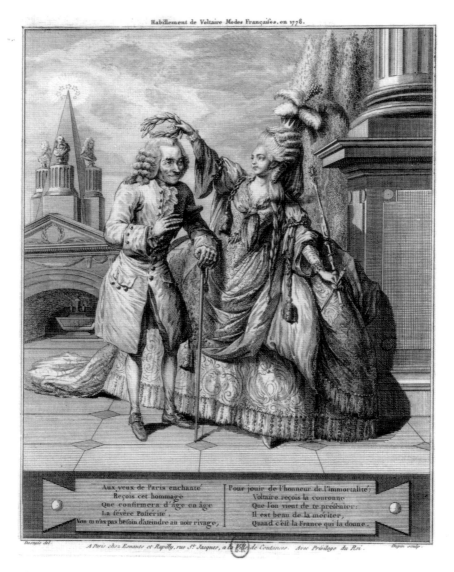

Aux yeux de Paris enchanté
Reçois cet hommage
Que confirmera d'âge en âge
La sévère Postérité,
Vou n'as pas besoin d'ateindre au noir rivage,

Pour jouir de l'honneur de l'immortalité,
Voltaire reçois la couronne
Que l'on vient de te présenter;
Il est beau de la mériter,
Quand c'est la France qui la donne.

Desrais del.

A Paris chez Esnauts et Rapilly, rue St. Jacques, a la Ville de Coutances. Avec Privilège du Roi.

Dupin sculp.

Fig. 15 N. Dupin after C.-L. Desrais: *Habillement de Voltaire Modes Françaises, en 1778*

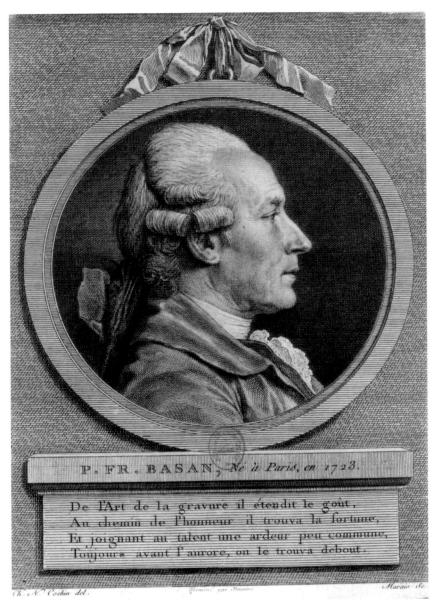

P. FR. BASAN, *Né à Paris, en 1723.*

De l'Art de la gravure il étendit le goût,
Au chemin de l'honneur il trouva la fortune,
Et joignant au talent une ardeur peu commune,
Toujours avant l'aurore, on le trouva debout.

Ch. N.° Cochin del. Terminé par Massard Marais Sc.

Fig. 16 H. Marais after C.-N. Cochin fils: *P. Fr. Basan*, after 1770

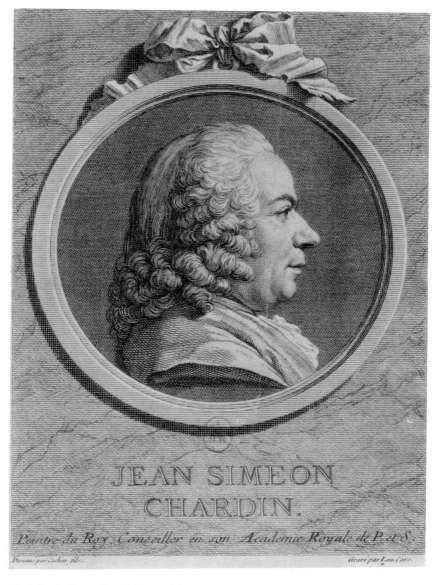

JEAN SIMEON
CHARDIN.

Peintre du Roy, Conseiller en son Académie Royale de P. et S.

Dessiné par Cochin, fils. Gravé par Lau. Cars.

Fig. 17 L. Cars after C.-N. Cochin fils: *Jean Simeon Chardin*, 1755, (state iii/iii)

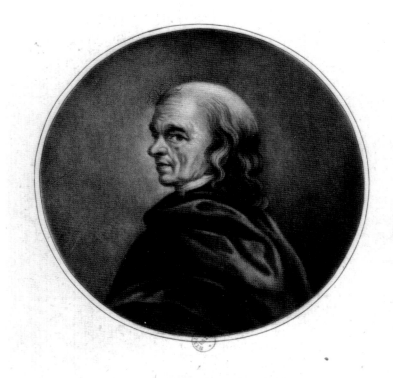

M. DE ROMAGNE,

Poëte détenu à l'Bastille depuis l'année 1749: sorti le 14 juillet 1789.

D'un pouvoir odieux malheureuse victime
Quarante ans d'esclavage ont expié son crime,
Eh! quel crime? d'avoir, dit on, en quatre vers,
Osé parler d'un fait connu de l'univers.

Se trouve chés Haid.

Fig. 18 J.-E. Haid: *M. de Romagne, Poëte détenu à la Bastille depuis l année 1749; sorti le 14 juillet 1789*

MLLE LE BRUN.

Dans ce Miroir cherche tu l'Art de plaire?
Aimable Enfant? crois moi, pour plaire en tous les tems,
Il faut joindre l'esprit, les graces aux talents;
Voila tout le secret, je le tiens de la Mere.

Dessiné et Gravé de Memoire par Horban, d'après le Tableau Peint par M.e le Brun exposé au Sallon en 1787.
A Paris chez les Campions frere, rue St Jacques No 8.

Fig. 19 Horban after E.-L. Vigée-Lebrun: *Mlle [Julie] Le Brun*, 1787, after a painting shown at Salon of 1787, no. 107

Fig. 20 C.-N. Cochin fils: Allegory on the illness of the Marquise de
Pompadour, 1764 (state ii/ii)

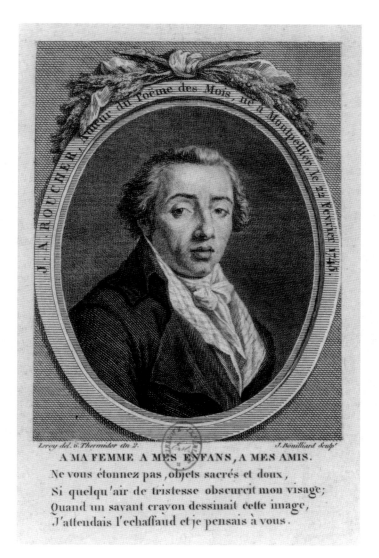

J. A. ROUCHER, Auteur du Poëme des Mois, né à Montpellier, le 22 Février 1745.

Leroy del. 6.º Thermidor an 2.º J. Bouilliard Sculp.

A MA FEMME A MES ENFANS, A MES AMIS.

Ne vous étonnez pas , objets sacrés et doux ,
Si quelqu'air de tristesse obscurcit mon visage;
Quand un savant crayon dessinait cette image,
J'attendais l'echaffaud et je pensais à vous.

Fig. 21 J. Bouillard after J.-F. Le Roy: *Jean-Antoine Roucher*, 1794

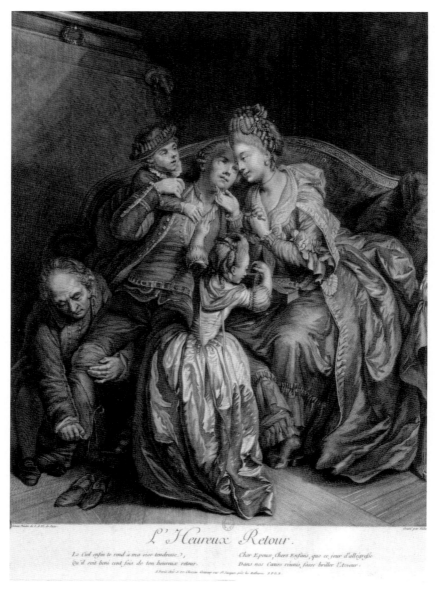

L'Heureux Retour.

Fig. 22 G. Vidal after J.-E. Schenau: *L'Heureux Retour*, 1772

Fig. 23 J.-B. Greuze: *Le Retour du Voyageur*, drawing. National Gallery of Canada, Inv. 17235

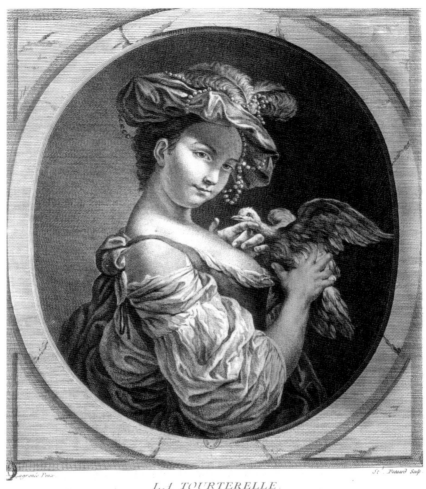

LA TOURTERELLE.

Objet de tous vos soins, dans vôtre plus bel age,
Cet Oiseau jeune Iris, a l'art de vous charmer ;
Vous le verrez un jour, par son tendre langage,
Apprendre à vôtre Cœur qu'il est fait pour aimer. Pelletier

Paris

l'auteur à la Bibliothèque du Roi rue de Richelieu
chez La Peure Chereau rue S^t Jacques *A.P.D.R*
Joullain Quay de la Mégisserie

Fig. 24 E. Fessard after L.-J.-F. Lagrenée: *La Tourterelle*, 1761

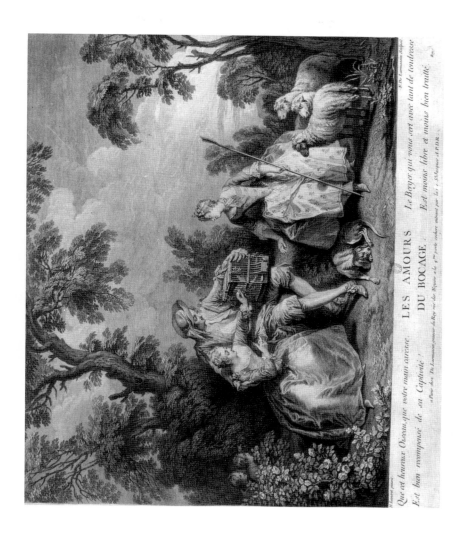

Fig. 25 N. IV de Larmessin after Lancret: *Les Amours du Bocage*, 1736

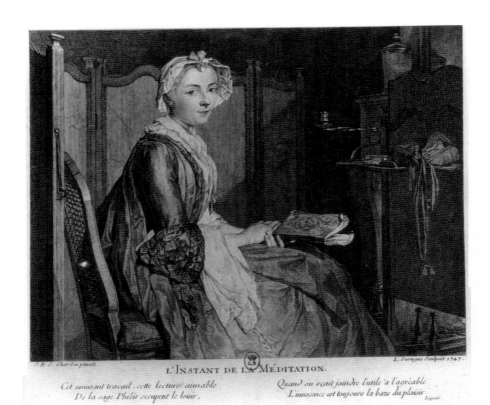

L'INSTANT DE LA MÉDITATION.

Cet amusant travail, cette lecture aimable
De la sage Philis occupent le loisir,

Quand on sçait joindre l'utile à l'agréable
L'innocence est toujours la baze du plaisir.

Fig. 26 L. Surugue after Chardin: *L'Instant de la Méditation*, 1747 (state i/ii),
shown at Salon of 1747 (2/4)

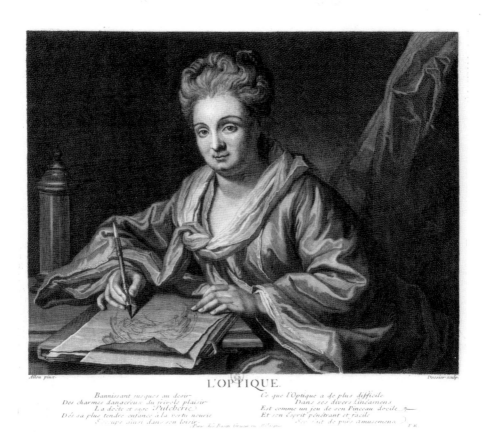

Fig. 27 M. Dossier after G. Allou: *L'Optique* [Mme Allou], as restruck in 1762 for the Recueil Basan II.122

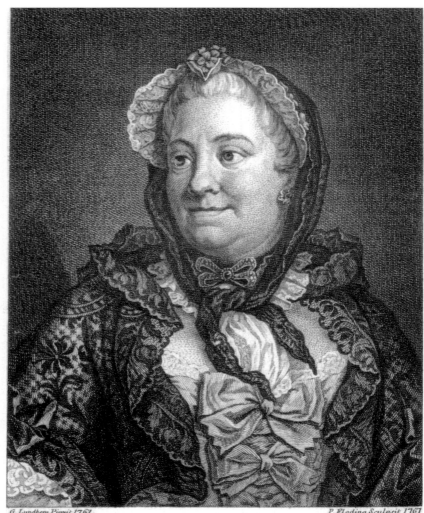

G. Lundberg Pinxit 1761. P. Floding Sculpsit 1761

ULRIQVE LOUISE COMTESSE TESSIN,
NÉE COMTESSE SPARRÉ.

Pour peindre la Vertu, la pureté des mœurs,
On emprunte ces traits, ouverts, rians, affables:
Pourpeindre la Fortune, on a d'autres couleurs,
Plus vives, il se peut; mais beaucoup moins durables.

Tessin.

Fig. 28 P.-G. Floding after G. Lundberg: *Ulrique Louise Comtesse Tessin, née Comtesse Sparre*, 1767

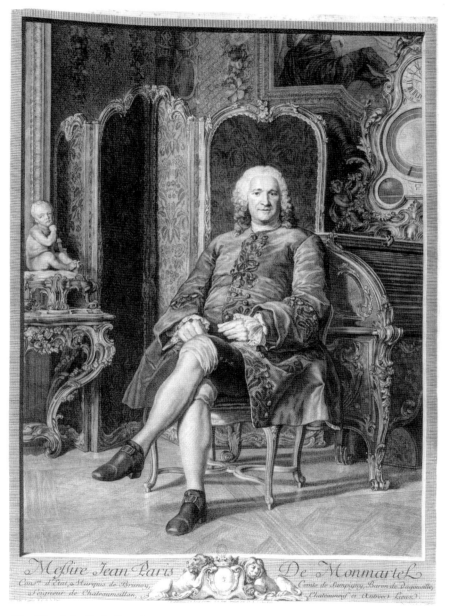

Fig. 29 J.-L. Cathelin after Maurice-Quentin de Latour, the clothes and setting by Cochin fils: *Messire Jean Paris De Monmartel*, 1772

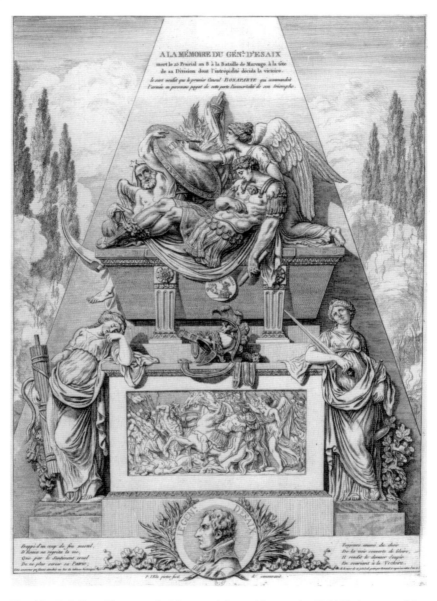

Fig. 30 P. Lélu: *Allegory to the Memory of General Desaix*, An X-1802 (presumably printed to three impressions only)

Fig. 31 N. Le Mire after F. Devosge: Allegory to M. Daviel and His Cataract
Operation, 1760

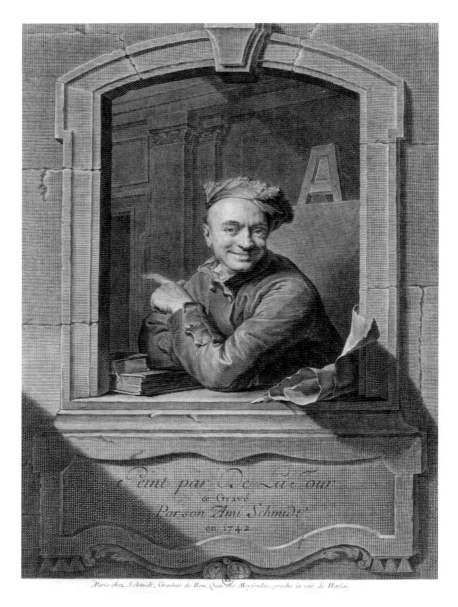

Peint par De La Tour
& Gravé
Par son Ami Schmidt
en 1742

Paris chez Schmidt, Graveur du Roy, Quai des Morfondus, proche la rue de Harlai.

Fig. 32 G.-F. Schmidt after Maurice-Quentin de Latour: The Artist 'Gravé par son Ami Schmidt,' 1742, shown at Salon of 1743

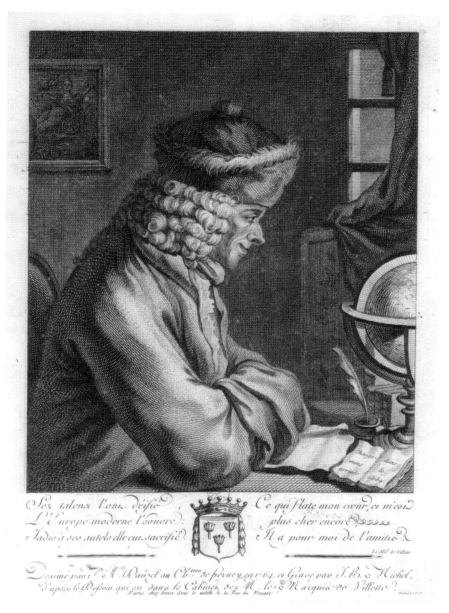

Ses talens l'ont déifié,
L'Europe moderne l'honore:
Jadis à ses autels elle eu sacrifié.

Ce qui flate mon cœur, et m'est
plus cher encore,
Il a pour moi de l'amitié.

Le Chr. de Villers

Dessiné par P. A. Danzel au Chteau de Ferney, en 1764, et Gravé par J. B. Michel,
d'après le Dessein qui est dans le Cabinet de M. le Marquis de Villette.
Paris chez Diace dans le milieu de la Rue du Fouare.

Fig. 33 J.-B. Michel after P.-A. Danzel, after the drawing of Voltaire by the
Chevalier de Boufflers: *Ses talens l'ont déifié*, 1766

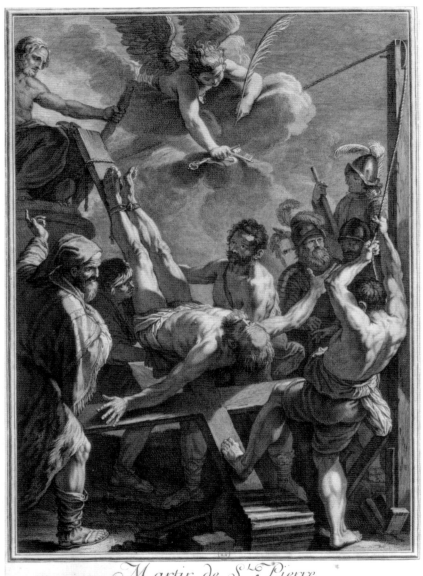

Martir de St. Pierre.

d'après le Tableau du Chevalier Calabrois qui est dans le Cabinet de Monseigneur Le Duc D'Orleans.

Haut de 10 pieds 6 pouces sur 7 pieds 11 pouces delarge Gravé par L. Desplaces

a Paris chez Desplaces

Fig. 34 L. Desplaces after M. Preti: *Martir* [*sic*] de St. Pierre, 1738

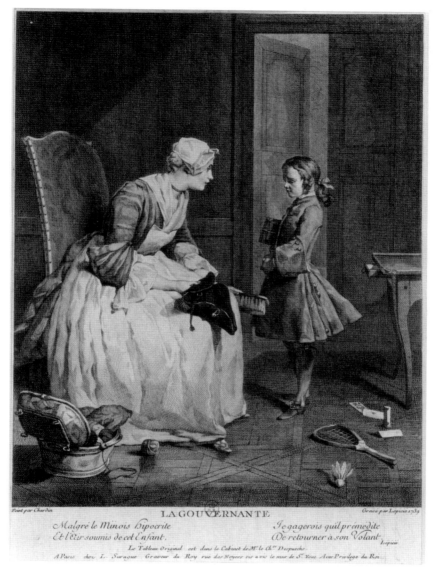

Fig. 35 B.-F. Lépicié after Chardin: *La Gouvernante*, 1739, shown at Salon of 1740 (1/6)

L'Amour Sentant un jour l'impuissance de l'Art;
 De Bastienne emprunta le nom et la figure;
 Simple, Tendre, Suivant pas à pas la nature,
 Et Semblant ne devoir ses talens qu'au hazard.

On demesloit pourtant la mine d'un Espiegle
 Qui fait des tours, Se cache, afin d'en rire à part;
 Qui Seduit la raison, et qui la prend pour regle:
 Vous voiez Son portrait Sous les traits de Favart.

Se vend chez Daullé, et du Roi rue St Pierre St Jacques dans les anciens murs à côté du College.

Fig. 36 J. Daullé after C. van Loo: *Mme Favart en Bastienne*, 1754 (state ii/ii),
shown Salon 1755, no. 169 (2/5)

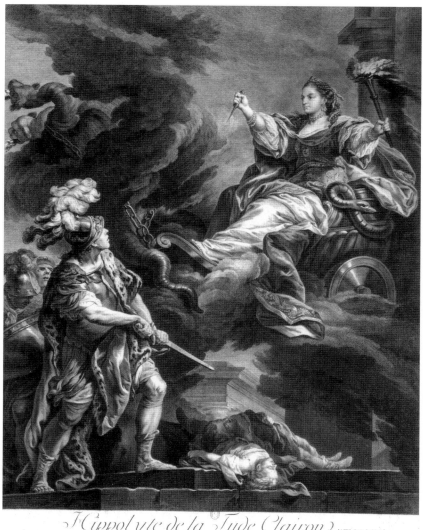

Fig. 37 L. Cars and J.-F. Beauvarlet after C. van Loo: *Hippolyte de la Tude Clairon. V.eme Acte de Medée*, 1764 (state iv/iv)

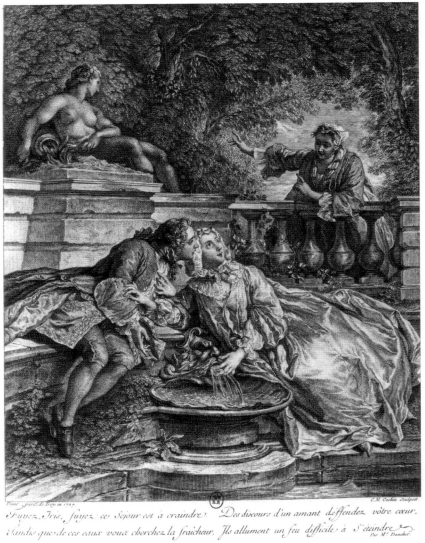

Peint par J. de Troy en 1727.

C.N. Cochin Sculpsit.

Fuyez, Iris, fuyez ce Sejour est à craindre. Des discours d'un amant deffendez vôtre cœur,
Tandis que de ces eaux vous cherchez la fraîcheur, Ils allument un feu difficile à s'éteindre.

Par Mr. Danchet.

A Paris chez l'Auteur place de l'Estrapade.

et chez le Sr. Duchange Graveur du Roy rue St. Jacques.

Fig. 38 C.-N. Cochin père after J.-F. de Troy: *Fuyez Iris, fuyez ce Sejour est à craindre*, 1736 (state ii/ii)

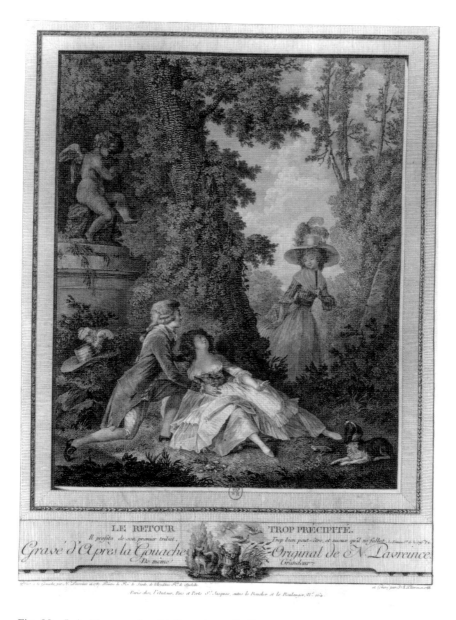

LE RETOUR TROP PRÉCIPITÉ.

Fig. 39 J.-A. Pierron after N. Lavreince: *Le Retour trop précipité*, 1788

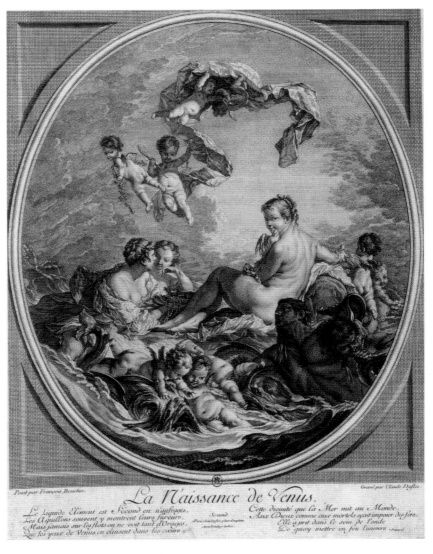

Peint par François Boucher. La Naissance de Vénus. Gravé par Claude Duflos.

Le liquide Élément est fécond en naufrages, Se vend Cette divinité que la Mer mit au Monde,
Les Aquilons souvent y montrent leurs fureurs, À Paris chéz Duflos père Graveur Aux Dieux comme aux mortels sçait imposer des fers.
Mais jamais sur les flots on ne voit tant d'Orages, Avec Privilège du Roi. Elle a prit dans le sein de l'onde
Que les yeux de Vénus en causent dans les cœurs. De quoy mettre en feu l'univers. Panard.

Fig. 40 Claude II Duflos after Boucher: *La Naissance de Vénus*, 1748 (state ii/ii)

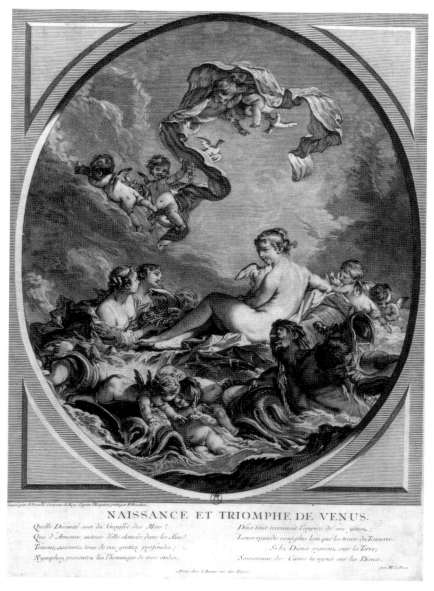

Fig. 41 J. Daullé after Boucher: *Naissance et Triomphe de Vénus*, 1750
(state iii/iii)

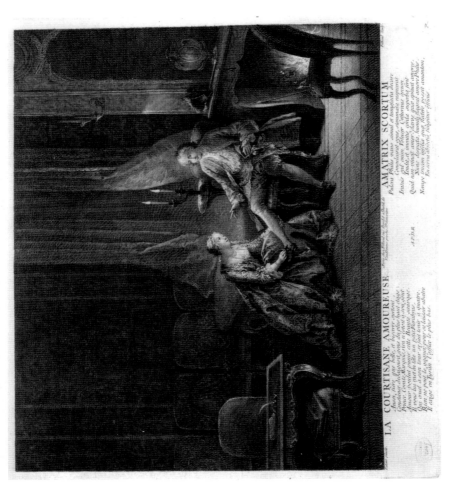

Fig. 42 P. Filloeul after J.-B. Pater: *La Courtisane amoureuse / Amatrix scortum*

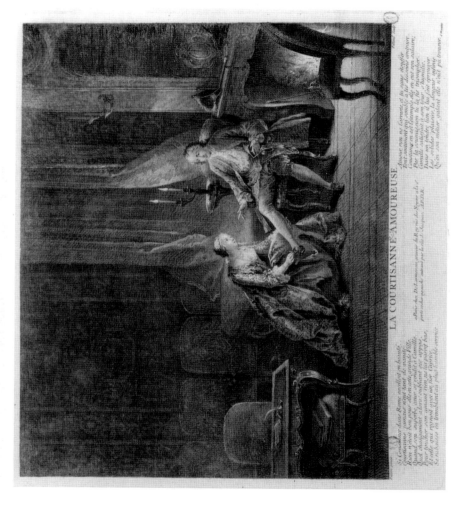

Fig. 43 P. Fillœul after J.-B. Pater: *La Courtisanne* [*sic*] *amoureuse*, 1734 (state ii/ii)

Carle Vanloo pinx.

Le Chien est le tableau de la fidelité;
La, comme modele, il vous est présente,
Jeunes cœurs enchantés des attraits de vos Belles.

B.R

Mais, n'en déplaise au sexe si vanté,
En trouvant des amans fidéles,
Elles - mêmes le seront - elles?

Fig. 44 Anon after C. van Loo: *Le Chien est le tableau de la fidelité*, after 1763

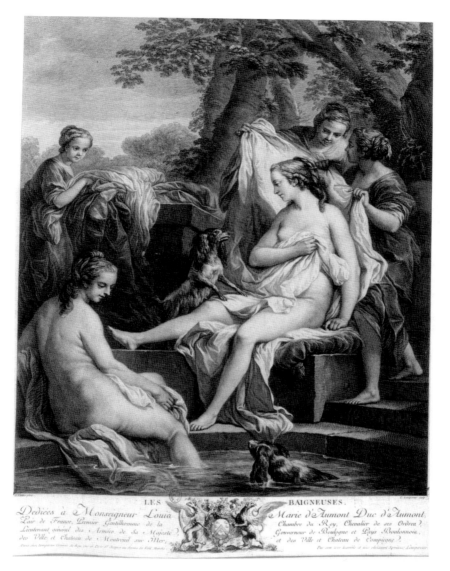

Fig. 45 L.-S. Lempereur after C. van Loo: *Les Baigneuses*, 1763

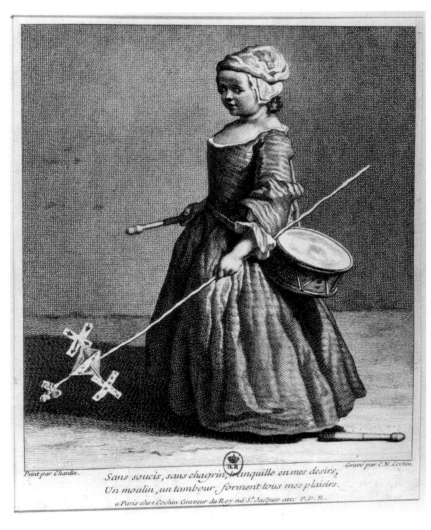

Within the image:
Peint par Chardin.

Grave par C.N.Cochin.

Sans soucis, sans chagrin, tranquille en mes desirs,
Un moulin, un tambour, forment tous mes plaisirs.

a Paris chez Cochin Graveur du Roy rüe S.^t Jacques avec. P.D.R.

Fig. 46 C.-N. Cochin père after Chardin: *Sans soucis, sans chagrin, tranquille en mes desirs* [Le jeune soldat], 1738 (state ii/ii)

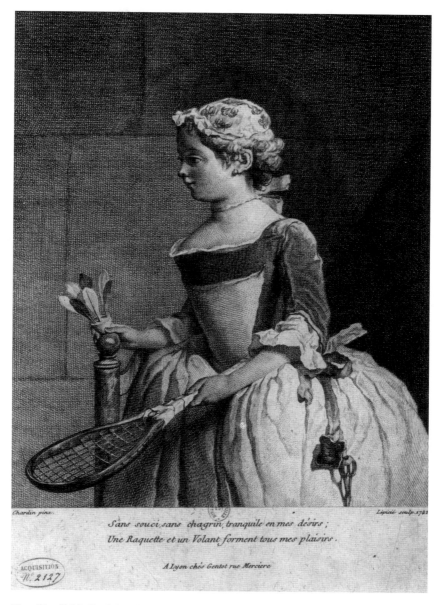

Chardin pinx. Lépicié sculp.1742

Sans souci, sans chagrin, tranquile en mes désirs ;
Une Raquette et un Volant forment tous mes plaisirs.

ACQUISITION
N.º 2127

A Lyon chés Gentot rue Merciere

Fig. 47 C.-N. Cochin père after Chardin: *Sans souci, sans chagrin, tranquile en mes désirs* [Jeune fille à la raquette], 1742 (state iv/iv)

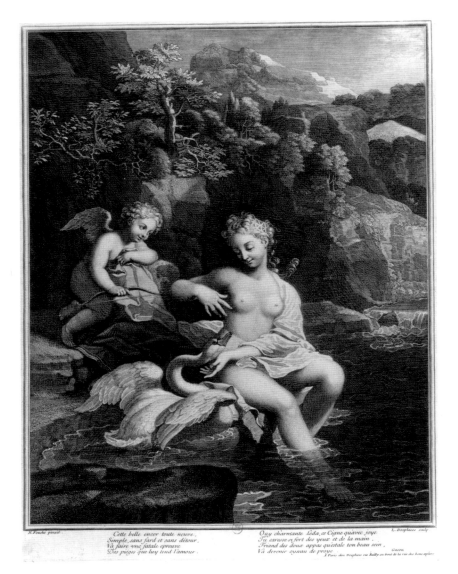

Fig. 48 L. Desplaces after N. Fouché: *Leda* (en grand), 'Cette belle encor toute neuve . . .'

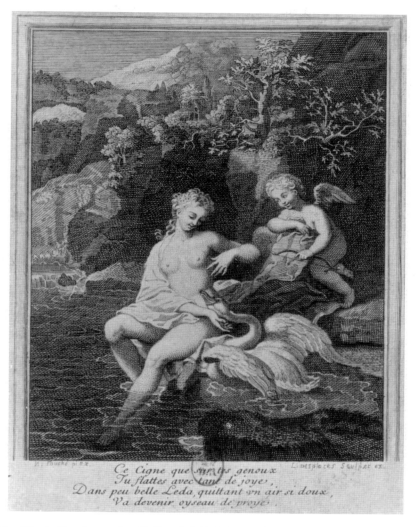

Fig. 49 L. Desplaces after N. Fouché: *Leda* (en petit), 'Ce Cigne que sur tes
genoux . . .'

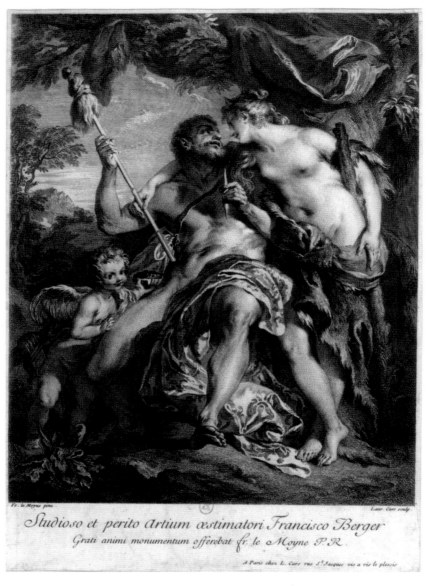

Fig. 50 L. Cars after F. Lemoyne: *Hercule et Omphale*, 1728 (definitive state, with Latin dedication)

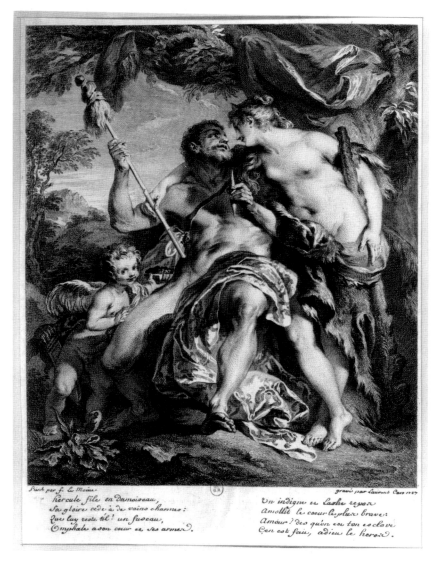

Fig. 51 L. Cars after F. Lemoyne: *Hercule et Omphale*, 1728 (before-letter state with manuscript verse 'Hercule file en Damoiseau . . .')

Fig. 52 Anon after S.-H. Thomassin's allegorical print (1738) of Diogenes' discovery of an Honest Man (André Hercules Cardinal de Fleury)

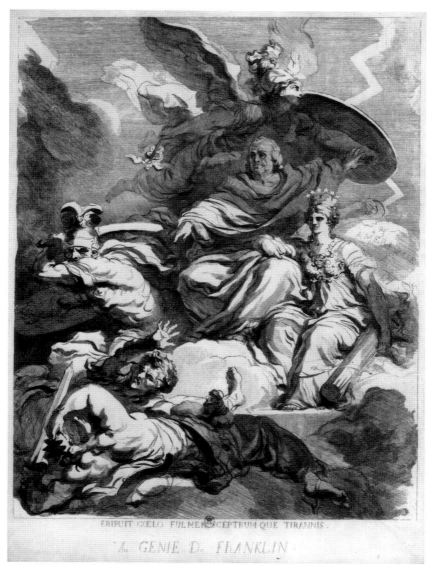

ERIPUIT CŒLO FULMEN SCEPTRUM QUE TIRANNIS.

A. GENIE D. FRANKLIN

Fig. 53 M. Gérard after Fragonard: *Au Génie de Franklin*, 1778

LES AMOURS PASTORALES

Approchons doucement, ou Thémire sommeille, Il quitte le trait qui va te déchirer,
Je ne crains plus le charme de ses yeux; Insensible et perçant, le cruel se repose;
Emparons de plaisirs mes regards curieux, Entre ses deux boutons de rose;
Découvrons... que d'attraits: Ah! l'Amour veille Fuis, Fuis, il n'est plus tems si tu veux respirer.

Fig. 54 Claude II Duflos after Boucher: *Les Amours Pastorales*

Fig. 55 I.-F. Schmidt after Boucher: *Les Amours Pastorales* / *Schäffer-Liebe* (bilingual title and verse)

LA PEINTURE.

Vous qui un secret desir d'imiter la nature ,
Dans l'empire des Arts, attache à la Peinture ;
Vous, qui brûlez d'offrir à mes yeux satisfaits
Les formes, les couleurs, les plans et les effets :

D'un penchant qui vous flatte examinez la source ;
Le desir, sans talens , offre peu de ressource :
Il faut être né Peintre ; et ce don précieux
Comme celui des vers, est un présent des Cieux .

Fig. 56 Claude II Duflos after P.-B. de La Rue: *La Peinture*, 1763

Son attention fait comprendre *LE PEINTRE* Mais pour la saisir et la rendre,
Que la nature est son objet; *de Paysage.* Il faut être Vernet.

Fig. 57 Anon: *Le Peintre de paysage,* undated

Assis, au près de toy, sous ces charmans Ombrages, En multipliant tes Ouvrages,
Du temps, mon cher Watteau, je crains peu les outrages ; Instruisoient l'Univers des sinceres hommages
Trop heureux ! si les Traits, d'un fidelle Burin, Que je rends à ton Art divin !

Fig. 58 N.-H. Tardieu after Watteau: *Watteau and Jean de Jullienne*, 1731 (state iii/iii)

Fig. 59 Claude II Duflos after Boucher: *La Toillette* [*sic*] *pastorale*, 1751 (state iii/iii)

Fig. 60 J.-Ph. Le Bas after Teniers: *Blanchisserie, Xᵉ Vue de Flandre*, 1754, shown at Salon of 1755, no. 170 (1/6)

Fig. 61 J.-Ph. Le Bas after Teniers: *Veue d'Anvers, ou XI^e de Flandre*, 1754, shown at Salon of 1755, no. 170 (2/6)

Fig. 62 J.-Ph. Le Bas after Teniers: *David Teniers et sa famille*, 1747, shown at Salon of 1746 (1/7)

TOMBEAU DE JEAN JACQUES ROUSSEAU

Vue de l'Isle des Peupliers, dite de l'Elisée, partie des Jardins d'Ermenonville,
dans laquelle J.J. Rousseau, mort à l'age de 66 ans, a été enterré le 4 Juillet 1778.

Entrée au Peupliers paisibles. Approchez Cœurs vrais et sensibles.
Reçois Jean Jaques Rousseau. Pour l'Amye der. Ami et Tombeau. A Baâle chez Chrétien de Mechel.

Fig. 63 F.-G. Lardy after Moreau Le Jeune: *Tombeau de Jean Jacques Rousseau, 1778*

Peint par L. Tocqué en 1754. Gravé par J. G. Wille, Graveur du Roy, en 1755.

JEAN BAPTISTE MASSÉ.

Peintre et Conseiller de l'Académie Royale de Peinture et de Sculpture.

Du célèbre Le Brun, sous ces riches lambris, Secondé du burin, Massé, durant trente ans,
Versailles renfermoit les chef-d'œuvres sans prix, Par des travaux d'un genre à triompher des tems,
Qui de Louis le Grand nous ont tracé l'histoire). De la France et du Peintre étend par tout la gloire.
 Pinon

Fig. 64 J.-G. Wille after L. Tocqué: *Jean Baptiste Massé*, 1755 (state iii/iii)

Fig. 65 S.-C. Miger after J.-B. Isabey: *Hubert Robert, peintre*, 1799 (state iii/iii), shown at Salon of 1799, no. 621

Fig. 66 Anon chez Basset: *Un Jeune Elégant ayant fait faire une Lévite à la
Malbrouk pour aller voir entre le Pont neuf et le pont Royal l'experience des Sabots
Elastiques*, ca 1784

Madame la Comtesse de M ... devant aller voir la fameuse experience de l'homme qui devoit se tenir
sur un Brasier ardent sans se reßentir des effets de la chaleur fit venir sa Couturiere pour
arranger sa plus belle robe que la dite Couturiere desirant l'escamoter se mit en place de bouffant un
Ballon quelle remplit par le moyen de l'air inflammable et Madame la Comteße exprime sa fureur
par les vers suivant

Voila donc des Balons l'usage dangereux Que pour jouer son role encor mieux
 Cette elegante Couturiere Par le moyen de ce perfide Globe
 N'avoit donc un si gros derriere Elle emporte a la fois et ma bourse et ma robe
 A Paris chez Basset rue St Jacques

Fig. 67 Anon chez Basset: *Madame la Comtesse de M . . . devant aller voir la
fameuse experience de l'homme qui devoit se tenir sur un Brasier ardent sans se ressentir
des effets de la chaleur*, ca 1784

Fig. 68 C.-A. Coypel: *J.-A. de Maroulle*, 1726 (state v/v)

I. A. DE MAROULLE

Dessiné et Gravé par son amy Ch. Coypel.

1726.

Voicy ce connoisseur profond, modeste & sage
Qui ne censura jamais rien;
Quand il se taist sur un nouvel ouvrage,
C'est qu'il n'en peut dire de bien.

M. Coypel avoit fait ces vers pour mettre au bas de ce portrait, l'extreme modestie de M. l'abbé de Maroulle
en empecha l'execution.

Fig. 69 C.-A. Coypel: *J.-A. de Maroulle*, 1726 (state iii/v)

Fig. 70 L. Guyot after F. Watteau de Lille: *Je suis le peintre Lantara,* after 1778

Fig. 71 Anon: Dispute of Rousseau and Voltaire or *Emile vs. La Henriade*,
after 1762

Ie fus du Genre humain, la mortelle Ennemie,
Par l'horreur de mes jours, on vit regner la mort;
Et mon Crime par tout, portant son Infamie,
Fit la guerre aux Mortels, et termina mon sort.

Fig. 72 A. Coypel: First *Portrait de la Voisin*, 1680

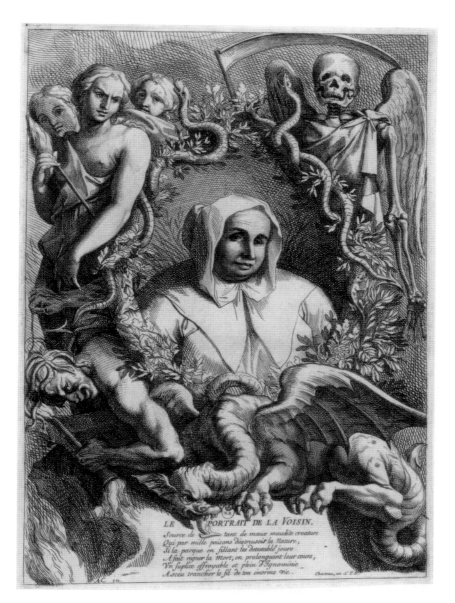

Fig. 73 A. Coypel: Second *Portrait de la Voisin*, 1680.

Fig. 74 Sébastien I Leclerc as modified by C. Eisen and C.-N. Cochin fils, unsigned verse: *St. Pierre* (states v–vi/ix), 1759

Saint Claude par le Clerc occupa cette place,
La Madeleine y fut mise apres par Eysen,
De la main de Cochin S.t Pierre enfin l'eface,
C'est le Portier des Cieux, qu'il nous les ouvre, Amen.

NOTE HISTORIQUE SUR L'ESTAMPE DE S. PIERRE
dans le temps de sa Pénitence.

CE joli morceau a été gravé par le célèbre Sébastien LE CLERC, Chevalier Romain, Dessinateur et Graveur du Cabinet du Roy. Il l'avoit fait pour M. Potier, Avocat au Parlement, Amateur zélé; et pour le lui rendre personnel, il y avoit mis S. Claude, son Patron.

M. Potier étoit alors fort jeune, et étudioit encore en Rhétorique. Dans ce temps, il y avoit beaucoup de Curieux d'Estampes, particulièrement de celles de Le Clerc : les principaux étoient le Marquis de Béringhen, le Marquis de Torci, M. de Clairembault, Généalogiste, Dom Godineau, Bénédictin, M. Turet, fameux Horloger, M. Bellanger, M. d'Argenville et quelques autres. Ils étoient jaloux des premières épreuves de tout ce que gravoit Le Clerc ; en effet cet Artiste, par la fécondité de son génie, étoit sujet à faire des changemens à ses planches, et par là donnoit à ces premières épreuves un degré de rareté qui les faisoit rechercher. Quelquefois il étoit arrivé que M. Potier prévenu de diligence par ses compétiteurs, n'avoit pu acquérir de ces premières Estampes; chagrin dont un Connoisseur seul peut connoître l'étendue. Soit pour se venger de ces petites mortifications, soit pour le plaisir singulier d'avoir ce que d'autres ne pourroient acquérir, M. Potier prit le parti de faire graver ce présent morceau par Le Clerc. Celui-ci, après avoir terminé sa planche, en fit tirer douze épreuves pour ses Curieux ; M. Potier les acheta. Ainsi maître absolu du travail de Le Clerc, il se vit assuré de donner la loi à ses rivaux. Il jouit effectivement de cette espèce de souveraineté. Peu satisfait de l'impression des douze épreuves de Le Clerc, il les condamna au feu, et en fit faire douze autres ; et, pour en augmenter la rareté, il fit supprimer le S. Claude, et chargea M. Ch. Eysen d'y graver une Magdeleine.

Les Curieux informés de l'existence de la première Estampe, et des envies plus ardens par la difficulté d'en avoir une des douze uniques épreuves, se trouvèrent obligés de recourir à M. Potier. Celui-ci eut le plaisir de contenter leur avidité, mais au prix d'une pistole la pièce.

Le S. HELLE, chargé par les dernières volontés de M. Potier de la vente de son riche Cabinet, a acquis cette précieuse Planche. Il la remet pour la troisième fois entre les mains des Amateurs, mais sous un nouvel aspect, ayant fait substituer à la Magdeleine, S. Pierre, son Patron, dans le temps de sa Pénitence. C'est M. Ch. Nic. Cochin qui s'est chargé de faire ce changement.

Le S. HELLE n'a fait tirer qu'un très-petit nombre d'épreuves de cette Planche qu'il a fait dorer ensuite, afin qu'elle ne donnât plus lieu à d'autres changemens.

Telle est l'histoire de ce morceau travaillé par trois célèbres Graveurs, Le Clerc et MM. Eysen et Cochin.

MDCCLIX.

Fig. 75 Sébastien I Leclerc as modified by C. Eisen and C.-N. Cochin fils, verse by H. Gravelot: *St. Pierre* (state vii–viii/ix), 1759

Fig. 76 L. Cars after N. Lancret: *Mlle. Camargo*, 1731 (state iv/iv)

Fig. 77 P.-L. Surugue after Chardin: *Les Tours de Cartes*, 1744 (state i/ii), shown at Salon of 1745 (2/2), to which music for verse by Danchet was added in the second state

Fig. 78 F.-A. David after J.-D. Dugourc: *Trait de Bienfaisance* (Marie-Antoinette), 1774 (state i/ii)

Fig. 79 F.-A. David after J.-D. Dugourc: *La Poule au Pot*, 1775 (state ii/ii)

Fig. 80 N. IV de Larmessin after N. Vleughels: *Le Villageois qui cherche son veau* (uncensored state)

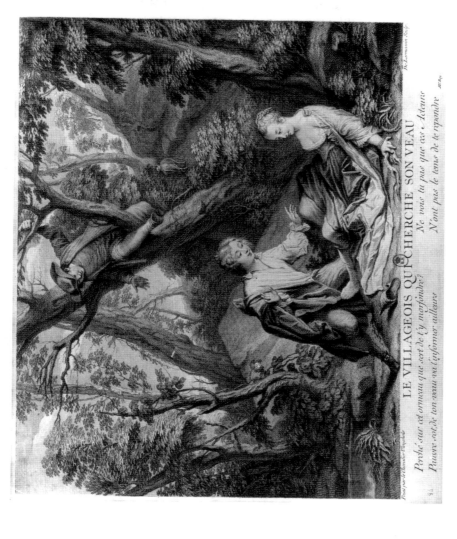

Fig. 81 N. IV de Larmessin after N. Vleughels: *Le Villageois qui cherche son veau* (censored state)

LE COUCHÉ DE LA MARIÉE

A très Haut et très Puissant Seigneur

Armand – Charle Emmanuel d'hautefort,

Comte d'hautefort, Marquis de Villacerf, Grand d'Espagne de la Premiere Classe,

& Mestre de Camp du Regiment de Cavalerie Royal Etranger

Fig. 82 Moreau Le Jeune (aquaforti) and J.-B. Simonet (terminavit) after P.-A.
Baudouin: *Le Couché* [*sic*] *de la Mariée*, 1770 (state v/v)

Fig. 83 A.-L. Romanet after J.-H. Eberts (invenit) and S. Freudeberg (delineavit): *Le Lever*, signed by Royal Censor, 'Permis de Graver le 17 X^bre 1774 Lenoir.' Ottawa, Carleton University Art Gallery

L' OCCUPATION

Cette Veste, où le goût a mis son art galant,
De l'Amour est-elle un présent?

Non, Charmante Thisbé, je n'ai point de maîtresse:
Mais j'ai devant les yeux un objet séduisant
Qui me fera connoître la tendresse.

Fig. 84 C.-L. Lingée after J.-H. Eberts (invenit) and S. Freudeberg (delineavit): *L'Occupation* (1774)

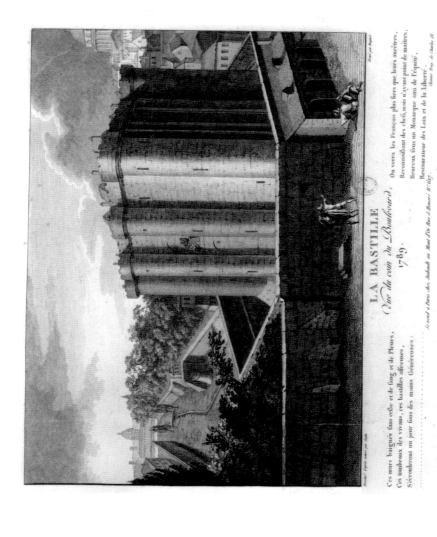

Fig. 85 Borgnet after Gudin (ad naturam): *La Bastille vue du coin du Boulevard*, 1789

Fig. 86 L.-J. Masquelier (aquaforti) and C.-.E. Gaucher (sculpsit) after
P. Potter: *L'Amant de la Belle Europe*, with indications for the *graveur en lettre*,
1762

L'AMANT DE LA BELLE–EUROPE.

Jupiter grand chercheur de joyeuse avanture,
Jadis emprunta ma figure;
Aussi ma vive ardeur ne sçauroit s'egaler,

Ma vigueur est presque sans bornes,
Et l'homme voudroit bien pouvoir me ressembler,
Si neanmoins l'on excepte mes cornes,

Par M.ᵣ Moreau

Tire du Cabinet de Monsieur le Comte de Chenevoul

a Paris chez Jac Ph. le Bas Graveur du Cabinet du Roy rue de la Harpe 1762

Fig. 87 L.-J. Masquelier after P. Potter: *L'Amant de la Belle-Europe*, 1762

Fig. 88 *Thomiris and Cyrus* after Rubens, published by G. Duchange, impression with manuscript note: 'Cette planche est une des premiers morceaux de M. Lépicié, qui pour lors étoit eleve de M. Duchage, les 12 vers sont aussi de ce jeune graveur.'

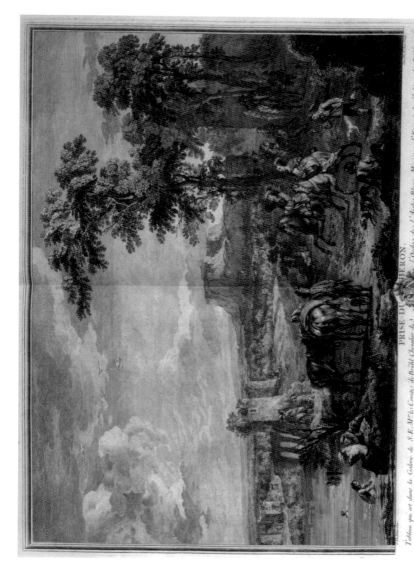

Fig. 89 J.-Ph. Le Bas after C. van Falens: *Prise du Héron*, 1745 (ii/ii), shown at Salon of 1741 (2/6)

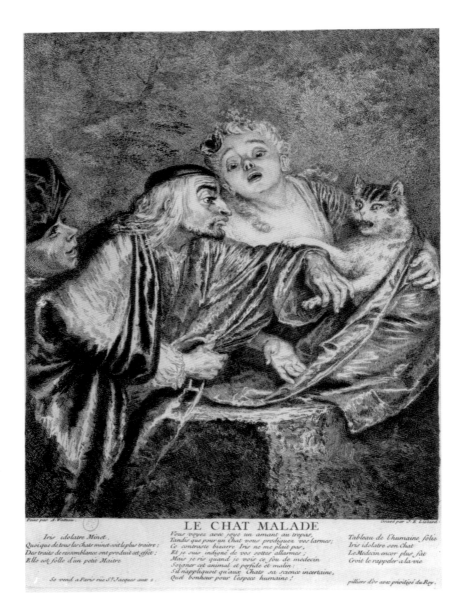

Fig. 90 J.-E. Liotard after Watteau: *Le Chat Malade*, 1731

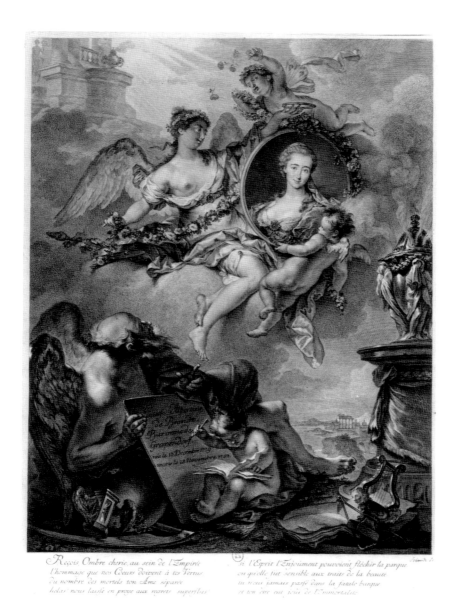

Fig. 91 G.-F. Schmidt after A. Pesne: Allegory on the death of Louise-Albertine
de Brandt, Baronness Grappendorf (1729–53), 1755 (state i/ii)

Fig. 92 G.-E. Petit after J.-C. Fenouil: *M.*[lle] *M.*[a]rie *Sallé la Terpsicore Françoise* (state i/ii).

Gravé par Petit.

L'APRÈS-DINÉ.
La Dame à la Promenade

À l'abri du Soleil et des traits de l'amour, Mile autres jouïroient mieux pendant l'ardeur du jour

Cloris sçaut s'amuser de ces Oiseaux fidèles. Avec des Moineaux francs, qu'avec des Tourterelles.

M. Inglinger-Maillard.

Avec privilege du Roi.

Fig. 93 G.-E. Petit after J.-C. Fenouil: *L'Apres-diné / La Dame à la Promenade* (state ii/ii)

LE SIFLEUR DE LINOTE.

Quand sans avoir appris ni musique, ni note,
Ton flexible gosier imite en tous leurs tons
Mes joyeux siflemens, mes gaillardes chansons,
Je me sens tout ravi, ma petite Linote.

Ah, je t'aime bien mieux que ma femme Alison,
Qui jamais avec moy ne fut à l'unisson,
Et qui ne manque point dans son humeur bizarre,
Si je chante en Bé mol, de chanter en Bé quarre

Moraine.

Tiré du Cabinet de Monsr. Orcy De Fulny Conseiller d'Etat Intendant des Finances.
A Paris chez l'Auteur Graveur ordinre. du Roy Rue de la Harpe 1744.

Fig. 94 J.-Ph. Le Bas after Teniers: *Le Sifleur de Linote,* 1744

LE SAVETIER

Quand sans avoir appris ni musique ni note
Ton flexible gosier imite en tous leurs tons
Mes joyeux sifflemens, mes gaillardes chansons,
Je me sens tout ravi ma petite Linote

Ah je t'aime bien mieux que ma femme Alison
Qui jamais avec moy ne fut a l'unisson ;
Et qui ne manque point dans son humeur bizarre
Si je chante en Bé mol de chanter en Bé quarre.

A Paris chez Basset rue S.t Jacques a S.t Genevieve

Fig. 95 *Le Savetier*, published by Basset, probably inspired by the Le Bas print (fig. 94)

Citoyens assemblés par un Roy Citoyen,
Conseil de la Patrie, et son noble soutien,

Vous ne trahirez point l'attente génereuse,
D'un Roi qui veut par vous rendre la France heureuse.

*La Lettre de convocation, écrite
par le Roi*

aux divers Membres, conçue en ces termes:

M

Ayant résolu d'assembler des Personnes de diverses conditions et des plus qualifiées de mon état, afin de leur communiquer mes vues pour le soulagement de mes peuples, l'ordre de mes finances et la réformation de plusieurs abus, j'ai jugé à propos de vous y appeller.

Je vous fais cette Lettre pour vous dire que j'ai fixé la dite Assemblée au 29 du mois de Janvier 1787 à Versailles, et que mon intention est, que vous vous y trouviez le dit jour à son ouverture, pour y assister et y entendre ce qui sera proposé de ma part. Je suis assuré que je trouverai en vous le secours que je dois en attendre pour le bien de mon Royaume, qui en est l'objet. Sur ce je prie Dieu qu'il vous ait en sa sainte garde).

À Versailles, ce 29 Décembre 1786.

A Paris Chez { G. rue St Jacques N.º 9
 Mde Lecolapart Libraire, rue du Roulle).
A Versailles Rue Dauphine chez les Associés.

Fig. 96 Anon: *L'Assemblée des Notables,* after 20 December 1786

Fig. 97 Anon: *Liste de MM.^R Les Députés de Paris à l'Assemblée Nationale*, after 4 May 1789

Fig. 98 P.-A. Le Beau: *Vœux de la Nation au Roi et à la Reine Pour le Jour de l'An,*
1778

Fig. 99 Anon, published by Villeneuve: *Le Trium-Geusat*, 1792

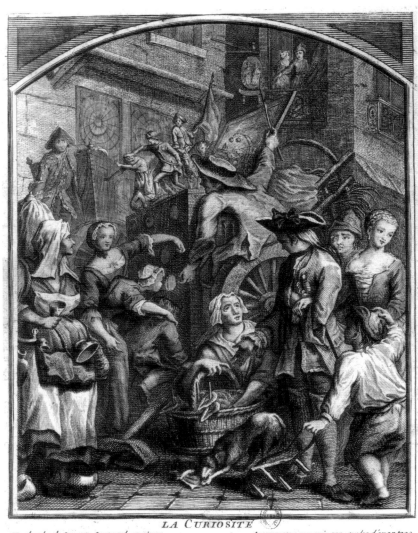

LA CURIOSITÉ

Marchandes de Croquet, Savoyards curieux ,
Soldats, gens de tout Sexe et de different age ,
À cet ouvrage ingénieux
Venez donner votre suffrage .

Accourez pour y voir sans user d'avantage
Ce que partout ailleurs jamais on ne verra
On y montre le pucelage
D'une fille de l'Opéra

a Paris chez Basset le Jeune, rue St Jacques au coin de la rue des Mathurins

Fig. 100 Anon, published by André Basset: *La Curiosité*, undated

Fig. 101 Anon, with new verse by 'D.R.S.': *Têtes à changer: Vaudeville du tems. Air: Vive la faribole &c.*, 1783

LES SENTIMENS DE LA NATION

Fig. 102 J.-F. Janinet after J.-B. Huet: *Les Sentimens de la nation*, 1781
(state ii/ii)

Fig. 103 *Le Cœur de la nation*, repetition also published by F.-X. Isabey, after Janinet's *Les Sentimens de la nation* (fig. 102)

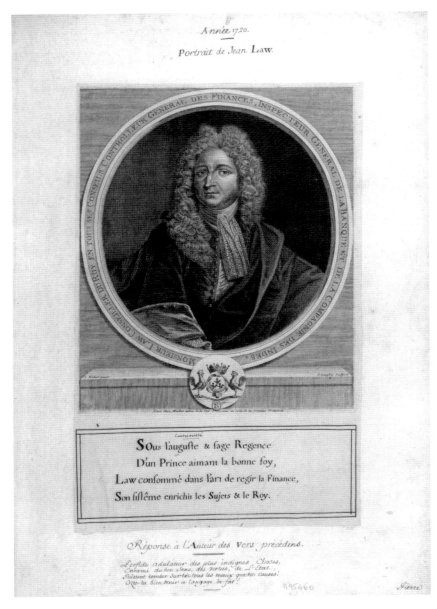

Fig. 104 J. Langlois after J. Habert: *Monsieur Law, Conseiller du Roy en tous Ses Conseils, Controlleur General des Finances, Inspecteur General de la Banque et de la Compagnie des Indes,* ca 1720

Fig. 105 J.-J. Pasquier after Depalmeus: *Par un Choix imprévue chargé du Ministere* (allegory to M. Machault as Joseph minister to Amasis of Egypt), 1749

ROSE ET COLAS

Gravé d'après le Tableau
par P. A. Baudouin,

Original Peint a gouache
appartenant à M.' Prault

Baudouin pinx

Simonet sculp

Se vend à Paris chez Basan et Poignant Marchand d'Estampes rue et Hôtel Serpente

Fig. 106 J.-B. Simonet after P.-A. Baudouin: *Rose et Colas*, as restruck in 1779
for the Recueil Basan VI.31 (state iii/iii)

Fig. 107 P.-P. Choffard after P.-A. Baudouin: *'Marchez tout doux, parlez tout bas,'* 1782, after a gouache shown at Salon of 1767, no. 77 (state iii/iii)

Fig. 108 L.-J. Masquelier after P.-A. Baudouin: *Jusques dans la moindre chose,*
datable 1774 in its third state of five (as restruck in 1779 for the Recueil Basan
VI.31) (state iv/iv)

Fig. 109 H. Guttenberg after P.-A. Baudouin: *Perrette*, as restruck in 1779 for the Recueil Basan VI.30 (state iii/iii)

Fig. 110 Caylus: *Muse Eclopée*, 1727

Notes

1. The Phenomenon Defined

1 Baron Roger Portalis, *Les dessinateurs d'illustrations au dix-huitième siècle* (Paris: Morgand et Fatout, 1877), I, p. 318, for Lancret's Times of Day.
2 Poetry as print title may mask larger iconographical considerations. Magdeleine Horthemels's untitled suite after Lancret (Emmanuel Bocher, *Les gravures françaises du XVIIIe siècle: Nicolas Lancret* [hereafter cited as Bocher IV], nos. 47, 62, 65, 67) is in reality the four Times of Day, as Guiffrey saw, but Bocher did not. J.-J. Guiffrey, *Éloge de Lancret*, p. 60, nos. 33–6.
3 M. Huber and C.C.H. Rost, *Manuel des curieux et des amateurs de l'art*, VIII (1804), pp. 146–7, s.v. Etienne Fessard.
4 Ryan Whyte, 'Understanding Painting, Print and Verse': Chardin's *Le Négligé ou Toilette du Matin*,' in *Word and Image in the Long Eighteenth Century: An Interdisciplinary Dialogue*, ed. Christina Ionescu and Renata Schellenberg (Newcastle: Cambridge Scholars Publishing, 2008), p. 53.
5 Cf. Prosper Dorbec, 'La Peinture française de 1750 à 1820 jugée par le factum, la chanson et la caricature,' *Gazette des Beaux-Arts*, IV/XI, Jan. 1914, pp. 69–85; Feb. 1914, pp. 136–60.
6 Maurice Tourneux (ed.), *Correspondance littéraire, philosophique et critique par Grimm, Diderot, Raynal, Maistre, etc.* (Paris: Garnier Frères, 1877–82), XII (1880), p. 163 (Sept. 1778). After his arrival in France, Antonio Mattiuzzi debuted at the Comédie Italienne on 20 September 1759; later he became particularly known as author of its *Trois Jumeaux vénitiens* (1773, modelled on a work by Goldoni), in which he played all three roles. Grimm's touching evocation of his nature and family life is echoed in other relations of the day.
7 *Inventaire du fonds français: Graveurs du XVIIIe siècle* (Paris: Bibliothèque nationale, 1930–) [hereafter cited as *Inv. 18e s.*], IX (1962), p. 236, no. 140.

8 Dimensions of 349 × 440 mm as opposed to Flipart's 487 × 627 mm format (subject).

9 Engravers were largely in control of portraits whose verse, whether in French or Latin, was presumably assigned and approved by the sitter or the sitter's admirers or associates. Cf. Voltaire's 1746 reference to the smallish print by Balechou after Jean-Etienne Liotard: *Inv. 18e s.*, I (1930), pp. 419–20, no. 32.

10 Mme Guibert de F., 'A M. Flipart, sur une marine gravée d'après M. Vernet,' *Mercure de France*, June 1768, p. 88 – notable for its comparison of oversize prints of 1757 and 1765 by master interpreters of Vernet.

11 *Catalogue du cabinet de tableaux de Monsieur le Comte de Vence* (Paris: Veuve Quillau, 1759), p. 24.

12 'Petits métiers d'autrefois: Les versificateurs d'estampes en France au XVIIIe siècle,' *Bulletin de la Sociéte archéologique, historique et artistique 'Le Vieux Papier'* XXX, Oct. 1985, pp. 377–84.

13 R. Hecquet, *Catalogue des estampes gravées d'après Rubens: Auquel on a joint l'oeuvre de Jordans, & celle de Visscher*, p. 6 of Jordans.

14 Émile Dacier and Albert Vuaflart, *Jean de Jullienne et les graveurs de Watteau au XVIIIe siècle*, III (1922) (hereafter cited as Dacier and Vuaflart), pp. 41–2, no. 84.

15 Ibid., pp. 7–8, no. 4, one of twenty-two prints from 'cette gracieuse Œuvre' announced by François Chéreau: *Mercure de France*, Dec. 1727, I, pp. 2676–7.

16 *L'Avant-coureur*, no. 8, 20 Feb. 1769, p. 114: 'Une jeune & aimable femme qui s'endort en pensant à son mari, du moins les vers mis au bas de l'estampe le font entendre, forme le sujet de cette nouvelle composition.'

17 *Inv. 18e s.*, IV (1940), p. 232, no. 14.

18 Pendant to *L'Action* after the same painter: *Inv. 18e s.*, VIII (1955), p. 399, nos. 59–60 (both rare).

19 The relative proportion of before-letter and definitive states often accompanying the sales of copperplates by engravers and editors reveals the failure of this speculative ploy. At the 1810 sale of Basan fils, a lot composed of seven *sujets gracieux* after Baudouin, Dugourc, and Saint-Quentin, some of which had been published by his family firm, were described thus: '7 pl. en H., 237 Epr. de six des Pl.; 95 des Epr. sont avant la lettre.'

20 Michel de Montaigne, *Essais*, Liv. III, ch. XIII. De la phisionomie: 'Ce sont inductions et similitudes tirées des plus vulgaires et cogneues actions des hommes; chacun l'entend.'

21 W. McAllister Johnson, 'L'estampe en France au XVIIIe siècle: Titre ou absence de titre,' *Nouvelles de l'estampe*, no. 230, May–June 2010, pp. 16–18.

2. Methodological Issues

1 W. McAllister Johnson, ed., *Hugues-Adrien Joly, Garde du Cabinet des Estampes de la Bibliothèque du Roy: Lettres à Karl-Heinrich von Heinecken, 1772–1789* (Paris: Bibliothèque Nationale, 1988).

2 Antony Griffiths, 'Proofs in Eighteenth-Century French Printmaking,' *Print Quarterly* XXI, March 2004, pp. 3–17.

3 See Craig Hartley, 'Moreau's "Heloise et Abeilard,"' *Print Quarterly* XII, June 1995, p. 185.

4 Baron Roger Portalis and Henri Beraldi, *Les graveurs du dix-huitième siècle* (Paris: Damascène Morgand et Charles Fatout, 1880–2) (hereafter cited as Portalis and Beraldi), I/1 (1880), pp. 60–1, had already remarked on the unexpected implications for art history of the verse below Pierre Aveline's great *Enseigne* print of 1732, where Watteau is said to have imitated the manner of the painters whose work is displayed in Gersaint's shop – a trait characteristically assigned to the greater reproductive engravers of the time. Cf. Dacier and Vuaflart, pp. 56–7, no. 115.

5 Emile Bellier de la Chavignerie, *Biographie et catalogue de l'oeuvre du graveur Miger* (Paris: J.-B. Dumoulin, 1856) (hereafter cited as Bellier de la Chavignerie, *Miger*), p. 113, no. 222 (cf. his p. 10).

6 François Métra, *Correspondance secrète, politique et littéraire*, XI (1788), p. 379 (25 July 1781), with reference to the fashionable Redoute Chinoise of the Foire S. Laurent.

7 The flood of prints relating to Jacques Necker's retirement was dammed by his disgrace, hence the rigour inflicted against the author of *Allégorie pour la fin du Compte rendu*: 'Necker victime de l'envie / Fait pleurer tout bon citoyen, / Pauvres à qui sa femme a conservé la vie / Gémissez sur la perte & n'espérez plus rien' (ibid., XI [1788], pp. 311–12 [14 June 1781]).

8 Emmanuel Bocher, *Les gravures française du XVIIIe siècle, IV: Augustin de Saint-Aubin* (Paris: Librairie des Bibliophiles / Rapilly, 1879) (hereafter cited as Bocher V), pp. 333–4, no. 85. The 'blasphemous' quatrain reads: 'C'est l'honneur et l'appui du nouvel hémisphère, / Les flots de l'Océan s'abaissent à sa voix: / Il réprime ou dirige à son gré le tonnerre. / Qui désarme les dieux peut-il craindre les rois?' (Tourneux, *Correspondance littéraire*, XII, p. 3 [Oct. 1777]). In its Latin form – 'Eripuit cœlo fulmen sceptrum que tirannis' – it inspired Jean-Honoré Fragonard and Marguerite Gérard's *Allegory to Genius of Franklin*, and appears on its second state. Cf. exhibition *Regency to Empire: French Printmaking, 1715–1814* (Baltimore/Boston/Minneapolis, 10 November 1984–23 June 1985), pp. 232–3, no. 78 (repr,).

9 *Journal de Paris*, no. 90, 31 Mar. 1781, p. 364 (chez Née, 1 liv. 4 sols.). Cf. Georges Duplessis, *Inventaire de la collection d'estampes relatives à l'histoire de France léguée en 1863 à la Bibliothèque Nationale par M. Michel Hennin* (Paris: Henri Menu, 1877–82) (hereafter cited as Collection Hennin) III (1881), p. 435, no. 10691.

10 Tourneux, *Correspondance littéraire*, XII (1880), pp. 68–73, especially p. 72.

11 *Inv. 18e s.*, IX (1962), pp. 501–4, no. 154.

12 *Inv. 18e s.*, VIII (1955), pp. 224–5, no. 42.

13 As does the fascinating, if fanciful, anonymous print *Voltaire, Couronné par les Comédiens François, le 30 Mars 1778.* Cf. exhibition *Voltaire. Un homme un siècle* (Paris: Bibliothèque nationale, 1979), p. 220, no. 657 (hereafter cited as exhibition *Voltaire*).

14 *Un siècle d'histoire par les estampes, 1770–1871: Collection De Vinck, Inventaire analytique*, Bibliothèque nationale, Département des Estampes (Paris: Bibliothèque nationale, 1909–29) (hereafter cited as Collection De Vinck), II (1914), p. 80, no. 1639. For the identity and transgressions of the seven prisoners found there, see Collection De Vinck, II, p. 77, no. 1628. In general, see exhibition *La Bastille ou 'l'Enfer des vivants'* (Paris: Bibliothèque de l'Arsenal, 9 Nov. 2010–11 Feb. 2011).

15 'Dans ses savans calculs éclate son genie . . . [Giraudet] and Sa modestie ajoute un prix à son savoir . . . [Pelletier Rilly]' (*Inv. 18e s.*, XI [1970], p. 633, no. 1). Although other states give the date of both model and print as 1789, this heavily retouched state seems to have figured at the Salon of 1800, no. 1001.

16 Among them, Baillieul, Borde, and Mlle Niquet, femme L'Epine. There is a general movement in better prints from broad-manner to fine-manner print letters; this had consequences for prints of larger format, where verse appeared in parallel columns, often separated by armorials. Although still seen in apposition, the image now dominates to the point that it and its verse must be *studied and integrated* rather than being taken in at a glance on equal terms.

17 François Courboin, *Graveurs et marchands d'estampes au XVIIIe siècle* (Paris: Société pour l'étude de la gravure française, 1914), p. 131: 'Ils [les graveurs] ont le culte de l'épigramme, c'est une vieille tradition, et raffolent du quatrain moral, sentimental ou léger, dont la calligraphie magnifique joue au bas de l'estampe le rôle décoratif d'un cul-de-lampe.'

18 *Mercure de France*, June 1755, I, p.197; cf. *Inv. 18e s.*, III (1934), pp. 501–2, no. 139.

19 Cf. *Inv. 18e s.*, VII (1951), pp. 134–266, nos. 14–625, suite continued by Gilles-Edme Petit; cf. *Catalogue de différens portraits gravés par feu E. Desrochers,*

graveur du Roy, et qui se vendent à présent chez G.-E. Petit, graveur, demeurant à Paris, rue Saint-Jacques, à la Couronne d'Epine, pres les Mathurins (1754).

20 Contemporary portrait series reflect timelines and inherent differences in intent (design, preparation, technique, and quality). Publicity for Jean-Baptiste Vérité's *Collection des Portraits de MM. les Députés à l'Assemblée Nationale* ('distingués par leur zèle pour le bien public') notes that each has a quatrain 'qui renferme l'éloge et les traits principaux du caractère de ceux qu'ils représentent' (Collection De Vinck, II [1914], pp. 230–43, nos. 1084–2133). The print letter features the area of France that each represents, but not all portraits are versified, much less signed; those that are signed feature the work of Lutaine, Berainville, or Pierre Duboc. Levachez's rival series (Collection De Vinck, II [1914], pp. 243–85, nos. 2134–377) instead stresses the *fidelity* of likenesses as certified by the sitters on the preparatory drawings (BnF. Est. Na 43–43a). These prints are but rarely versified (a notable exception, F.-A. Delandine's portrait, is signed by his wife).

21 Including those portraits engraved after Cochin from 1770 to 1790 and those inspired by or derived from his model.

22 Charles-Antoine Jombert, *Catalogue de l'œuvre de Ch. Nic. Cochin fils* (Paris: Prault, 1770) (hereafter cited as Jombert, *Cochin*), p. 126, no. 320 (57); *Inv. 18e s.* IX (1962), p. 229, no. 122 (state ii/iii).

23 Jombert, *Cochin* (pp. 122–31, no. 320), gives 121 portraits, most without verse, from the two preceding decades. A contrario, the Suite Odieuvre deals with personages before the reign of Louis XV; their quatrains and shorter verse, rarely signed but attributed to François Gacon, run the gamut from laboured to genuinely witty.

24 Bocher V, p. 82, no. 217 (170 × 123 mm).

25 The momentous transition in 1754 from engraver to editor alluded to in this print, and its ramifications for all Europe, is traced by Jean-Pierre Casselle: 'Pierre-François Basan, marchand d'estampes à Paris (1723–1797)' (*Paris et Ile-de-France*, XXXIII [1982], pp. 99–184).

26 *Inv. 18e s.*, V (1946), pp. 99–100, no. 331.

27 Jombert, *Cochin* (pp. 102–3, no. 278, whose transcription I follow), advises: 'Il faut avoir l'eau-forte & le fini, *s'il est possible*' (italics added), indicating its rarity. A painting of similar subject and futility by Carle Vanloo prompted Diderot to comment: 'C'est le morceu qu'un artiste emporteroit du Salon par préférence; mais nous en aimerions un autre, vous et moi, parce que le sujet est froid, et qu'il n'y a rien là qui s'adresse fortement à l'âme. Cochin, prenez l'allégorie de Vanloo, j'y consens; mais laissez-moi la pleureuse de Greuze' (*Diderot: Salons II*, ed. Jean Seznec, Salon de 1765 [Oxford: Clarendon Press, 1979], p. 67). Diderot naturally thinks of paintings that could

give rise to prints, but this is not to reckon with the opportunism of print-makers. The moment had passed; neither Cochin nor any other courtesan or engraver had reason to take up his suggestion.

28 'La modestie de M. Houdon lui a fait apporter tous ses soins à empêcher que les vers qu'on lui a adressés de tous côtés ne fussent imprimés dans aucun papier public. En voici que M. de Rulhière fit sur-le-champ, après avoir admiré sa *Diane* [Salon 1777, no. 248] . . .' (Tourneux, *Correspondance littéraire*, XI [1879], p. 529).

29 As, for example, F.-H. Drouais's *Mme du Barry*, shown at Salon 1769, no. 60, whose controversial costume prompted queries as to whether a man or a woman was depicted. The royal favourite's disrespect for convention doubt-less inspired the same comments for Beauvarlet's print, which sedulously avoided poetics of any kind. *Inv. 18e s.*, II (1933), pp. 239–40, no. 72.

30 *Journal de Paris*, no. 42, 11 Feb. 1781, p. 168.

31 *Journal de Paris*, no. 44, 13 Feb. 1781, p. 176. At latest, this insertion would have been submitted the day after the *annonce* for appearance the next day (the *Journal de Paris* was a daily).

32 Métra, *Correspondance secrète, politique et littéraire*, XI (1788), p. 109 (21 Feb. 1781).

33 Cf. Heinecken, *Idée générale d'une collection complette d'estampes*, pp. 504–5.

34 In domestic context, a landscape not destined for commerce and dedicated to his wife by La Live de Jully bears a quatrain beginning 'Iris de mon essay recevés les premices' (*Inv. 18e s.*, XII [1973], p. 324, no. 9).

35 W. McAllister Johnson, 'Les servitudes de la gravure, III: Compositions faites "de mémoire, de souvenir ou de réminiscence,"' *Nouvelles de l'estampe*, no. 212, May–June 2007, pp. 38–53.

36 *Inv. 18e s.*, III (1934), pp. 305–6, no. 16 s.v. Bouillard. The drawing is discussed and illustrated in C. Ponsonailhe, 'Le peintre-graveur Joseph-François Le Roy,' *Réunion des Sociétés des beaux-arts des départements*, XXIV (1900), pp. 649–50 and 652–3. Particularizing portrait prints in the margins or on the back with verse, regardless of source, that addresses family or commemorates friends is known from impressions in the Nachlass of the engraver Miger's 1806 'autoportrait' after a painting of identical date by Marie-Gabrielle Capet (Bellier de la Chavignerie, *Miger*, frontispiece and pp. 125–7, no. 259).

37 Such portraits seem to have been the object of a thriving commerce, though few are likely to have been engraved (ibid., p. 651).

38 *Inv. 18e s.*, XII (1973), p. 408, no. 58.

39 *Inv. 18e s.*, VII (1951), p. 299, no. 9 s.v. M. Dossier.

40 As, for example, Pierre Aveline's allegory to the Cardinal de Fleury after Chevallier, *Inv. 18e s.*, I (1930), p. 323, no. 63. It still took the publisher Odieuvre two *annonces* to get there: *Mercure de France*, Mar. 1740, p. 553 (summary description, verse merely cited); then *Mercure de France*, May 1740, pp. 972–3 (extensive description ending with 'Il y a au bas de la Planche les quatre beaux Vers de M. de *Linant*, que nous avons déja raportés').

41 *Mercure de France*, Jan. 1736, pp. 135–6.

42 *Mercure de France*, Dec. 1740, I, p. 2709.

43 *Mercure de France*, Sept. 1743, pp. 2060–1.

44 'Deux petits Tableaux, dont les sujets sont tirez de Rousseau' appear in the Salon *livret* (1743, nos. 35–36) without the usual benefit of subject description or title, only the verse. The verse is cited in their *annonce*, this time with 'On lit ces vers au bas de feu M. Rousseau' (*Mercure de France*, May 1744, p. 979). This is a rare case where the passages that inspired paintings were publicly stated thus by the artist, then used on the corresponding prints.

45 *Mercure de France*, Feb. 1751, pp. 152–3.

46 Pierrette Jean-Richard, *L'Œuvre gravé de François Boucher dans la Collection Edmond de Rothschild, Musée du Louvre* (Paris: Musée nationaux, 1978), p. 238, nos. 918–19 (repr.).

47 Chardin, to whom the debut and popularization of the *artistic* versified print is largely due, and Jeaurat (both 1699), and Dandré-Bardon (1700). The pre-eminence of Boucher (1703) is largely derived from his drawings.

48 By number of prints versified: Moraine, Jeson, Favard, D'Arneaux, Sticoti, and Panard. Beyond individual sheets and pendants, Duflos characteristically produced in sets of four (Jean-Richard, *François Boucher*, pp. 236–42, nos. 901–39 [repr.]).

49 *Mercure de France*, Dec. 1744, p. 137. *Inv. 18e s.*, XIV (1977), pp. 409–10, no. 70. (Also engraved by his wife, Renée-Elisabeth Marlié, after his print rather than the painting [idem, p. 422, no. 12].)

50 *Inv. 18e s.*, IX (1962), pp. 86–7, nos. 398–9.

51 Colin B. Bailey, *Patriotic Taste: Collecting Modern Art in Pre-revolutionary Paris* (New Haven and London: Yale University Press, 2002), ch. 2.

52 *Catalogue historique du cabinet de peinture et sculpture françoise, de M. de Lalive* (Paris: P.A. Le Prieur, 1764), pp. 101–2.

53 Gunnar W. Lundberg, 'Le graveur suédois Pierre-Gustave Floding à Paris [1755–64] et sa correspondance,' *Archives de l'Art français*, nouvelle période, XVII (1932), pp. 249–359. Floding sollicited permission of his protector Count Tessin to engrave both portraits as early as 17 March 1767 (Lettre 14, pp. 332–4).

54 Ibid., pp. 334–5, Lettre 15 (23 March 1767): 'Pour peindre la Vertu, la pureté des mœurs, / On emprunte ces traits, ouverts, rians, affables: / Pour peindre la Fortune, on a d'autres couleurs, / Plus vives, il se peut; mais beaucoup moins durables.'

55 Ibid., pp. 342–4, Lettre 20 (2 Nov. 1768).

56 Ibid., pp. 344–6, Lettre 21 (12 Nov. 1768).

57 Ibid., pp. 346–8, Lettre 23 (26 Nov. 1767).

58 Ibid., pp. 348–9, Lettre 24 (15 Jan. 1768). Etching, reversed and reduced to 164 × 130 mm from the 64 × 52 cm of Lundberg's pastel (Nationalmuseum, Stockholm, NMB 127). Put in perspective, the print is not much larger than the average (145 × 100 mm) for much of the Desrochers/Odieuvre suite, yet more demanding in subtlety of detail and expression.

59 Ibid., p. 350, Lettre 25 (21 Jan. 1768).

60 Ibid., pp. 351–2, Lettre 26 (29 Jan. 1768).

61 Ibid., pp. 352–3, Lettre 27 (16 March 1768): 'Si vous prennés, Monsieur, la peine de le graver, ce ne sera, s'il vous plait, qu'à condition de n'y pas mettre mon nom, mais simplement les vers suivans: Tous les jours des humains, comptés avant les tems, / . . . / Leur vices, leur vertus, leur fortune et leur mort.'

62 Per Hedström, writtten communication of 7 April 2009. Nationalmuseum, Stockholm, NMB 126, also 64 × 52 cm.

3. Poetry as Cultural Expression in Prints

1 Alf. Bonnardot, *Histoire artistique et archéologique de la gravure en France* (Paris: Deflorenne Neveu, 1849), p. 115.

2 Or phenomenon, as for example Count d'Imbert de la Platière's brochure, *L'Invention des Globes aérostatiques: Hommage à MM. de Montgolfier* (Paris: Cailleau, 1784).

3 The range of subjects covered, whether as isolated insertions or integrated into reportage, is astonishing.

4 *Mémoires secrets pour servir à l'histoire de la république des lettres en France, depuis MDXXLXII jusqu'à nos jours* (London: John Adamson, 1780–9) (hereafter cited as *Mémoires secrets*), XXIII (1784), p. 119, 13 Aug. 1783: 'C'est le dix-neuf de ce mois, en effet, que le Sieur Luigi Massari, Romain, poëte improvisateur, membre de plusieurs académies, doit tenir une assemblée publique, où il *improvisera* en vers italiens sur tous les sujets que les assistans voudront lui proposer. Il chantera, ou déclamera les vers sur differentes mesures, au gré des audiences.'

5 Ibid., XXV (1786), pp. 138–9, 24 Feb. 1784.

6 *Journal de Paris*, no. 344, 10 Dec. 1785, p. 1419, for the following day.

7 See the no less than thirty-five prose portraits in de Lescure, *Correspondance complète de la marquise du Deffand avec ses amis le président Hénault – Montesquieu – d'Alembert – Voltaire – Horace Walpole* (Paris: Plon, 1865), II, pp. 733–79. A closed circle is one thing, the public at large quite another in this type of enterprise; yet both tend to characterize and situate the 'sitter' as would any frontispiece or small-format print.

8 *L'Avant-coureur*, no. 22, 1 June 1772, p. 140. Louis-Jacques Cathelin's print letter 'La Tête d'après M.Q. de la Tour, L'Habillement et le Fond dessinés, et le Tout Conduit par Ch. N. Cochin Fils' documents a rare type of artistic collaboration in portraits (*Inv. 18e s.*, IV [1940], pp. 20–1, no. 42).

9 Chevalier de Cubieres, 'Vers à M. le Comte DE BUFFON, pour le remercier du présent qu'il m'a fait d'une Gravure dédiée aux Mânes de J.J. Rousseau,' *Journal de Paris*, no. 95, 5 Apr. 1782, p. 377–8. Response time suggests that the print is more likely by Pierre Malœuvre after Paul, than by Vidal after Charles Monnet, cf. respectively *Gazette de France*, no. 5, 15 Jan. 1781, p. 26; and *Journal de Paris*, no. 130, 9 May 1780, p. 535.

10 *Journal de Paris*, no. 268, 25 Sept. 1783, pp. 1107–8, with examples for the Grands Hommes / Hommes Illustres.

11 *Mercure de France*, Oct. 1767, II, p. 179: 'Nous finirons cet article par une réflexion. Le public est plus clairvoyant qu'on ne pense. Il n'a point pris le change sur les ouvrages d'un de nos plus habiles peintres de portraits, qui en a exposé plusieurs sans les faire annoncer. Ses talens ont parlé pour lui. La vérité a trahi son secret, & nous osons assurer que cent personnes l'ont reconnu à travers le voile de sa modestie. Au revers du portrait de M. DEMOURS, Médecin Oculiste du Roi, on a trouvé ces vers: *Dibutade, autrefois conduite par l'Amour, / Traça de son amant une image frappante. / Aujourd'hui l'Amitié, triomphant a son tour, / Pour rendre d'un ami l'image ressemblante, / A conduit le crayon du célèbre la Tour.*' Not everything shown at the Salon appeared in the livret. Had his name but appeared there, La Tour might well have had a grouped entry such as that for his next Salon (1769, no. 37): 'Plusieurs Têtes sous le même N°.' We can now say with certainty that his apparent absence in 1767 is fictive, and we can identify one of his 'lost' sitters. Paul Ratouis de Limay, *Le Pastel en France au XVIIIème siècle*, 2nd. ed. (Paris: Baudinière, 1946, p. 214), makes no mention of La Tour for this Salon, so the question remains whether La Tour was identified by his medium more than his work.

12 *Inv. 18e s.*, XIV (1977), pp. 74–5, no. 76.

13 *Mercure de France*, Dec. 1731, I, p. 2842–3.

14 E. Dacier, 'La Sedaine du Musée Condé, ou Gabriel de Saint-Aubin poète,' *Revue de l'art ancien et moderne*, XXXVIII, June 1930, pp. 5–18; July–August 1930, pp. 93–104.

15 Giving artists in roughly chronological order by birth date and frequency, Iris, for example, is the topos used for works by Courtin and Lancret (4); Santerre, Watteau, Pater, and Boucher (3); J.-F. Detroy, Cochin fils, and Bénard (2); then L.-J.-F. Lagrenée, Canot, Eberts, Schenau, C.-A. Coypel, Dumonchel, Chardin, Fr. Lemoyne, Carriera, Dumont le Romain, C. Parrocel, Natoire, Lalive de Jully, Robert de Séri, N. Guérard, Duflos, Bonnart fils, and Wouwerman.

16 As, for example, the 'Vers de M. le Comte de Rivarol à M. Boze, sur le portrait de Louis XVI, gravé par M. Henriquez' (Tourneux, *Correspondance littéraire*, XIV [1880], p. 371). Cf. *Inv. 18e s.*, XI (170), p. 335, no. 69: print announced in April; the Rivarol verse assigned to May of 1786.

17 'LETTRE de M. DANZEL à M. DE LA PLACE,' *Mercure de France*, Jan. 1766, I:183; cf. Collection De Vinck, II (1914), p. 726, no. 4116. All is not quite as represented, for this is an exact copy by the artist P.-A. Danzel, engraved by J.-B. Michel, of the celebrated Boufflers portrait (Collection De Vinck, II, no. 4115). Originally sold exclusively by Auvray, Danzel's *doreur*, for three livres, it was shortly joined by a Rousseau pendant (a common pairing) at the same place and price (*Mercure de France*, Mar. 1766, p. 164, and Apr. 1766, I, pp. 170–1). Both were being sold a few months later by the engraver P.-J. Duret, and the price reduced to fifteen sols each to facilitate their acquisition (*Mercure de France*, Sept. 1766, pp. 181–2).

18 'EXTRAIT d'une Lettre de M. DE VOLTAIRE, à M. le Marquis DE VILLETTE,' *Mercure de France*, Jan. 1766, I, pp. 184–5.

19 Georges Duplessis (ed.), *Mémoires et Journal de J.-G. Wille, graveur du Roi* (Paris: Veuve Jules Renouard, 1857), I, pp. 116 and 119 (10 July and 25 Aug. 1759). Manuscript text in *Johann Georg Wille (1715–1808). Briefwechsel*, ed. Elisabeth Decultot, Michel Espagne, and Michael Werner (Tübingen: Max Niemeyer Verlag, 1999), pp. 211–12.

20 As, for example, La Coretterie's '*IMPROMPTU à une dame, en lui envoyant l'estampe des* Incroyables [by Darcis after Carle Vernet],' *Journal de Paris*, no. 116, 26 Nivôse an V – 15 Jan. 1797, p. 466. See 'Des Caricatures,' *Journal de Paris*, no. 156, 6 Ventôse an V – 24 Feb. 1797, pp. 625–6, where A.F. fears that the word *incroyable* may yet become for its day a 'dénomination de parti, comme le fut en 92 celui de sans-culotte.'

21 As, for example, Le Comte de Cubières' 'Vers à M. le Comte DE BUFFON, pour le remercier du présent qu'il m'a fait d'une Gravure dédiée aux Mânes de J.J. Rousseau,' *Journal de Paris*, no. 95, 5 Apr. 1782, pp. 377–8. It is rare for a dedication to serve as title for any print, much less two: G. Vidal's

after Monnet (*Journal de Paris*, no. 130, 9 May 1780, p. 35) and P. Malœu-vre's after Paul, launched by subscription 1–31 December 1779 (*Journal de Paris*, no. 275, 2 October 1779, pp. 1122–3), noted as being engraved shortly thereafter (*Journal de Paris*, no. 350, 16 December 1779, p. 1431). It was eventually distributed to subscribers 15 January 1782 and to the public eight days thereafter (*Journal de Paris*, no. 11, 11 January 1782, p. 43). We are then dealing with the more recent print, unquestionably more satisfying in every way.

22 'LETTRE A M. ***. En lui envoyant une nouvelle Estampe de M. le Bas,' *Mercure de France*, Mar. 1751, pp. 143–5. Cf. *Inv. 18e s.*, XIII (1974), pp. 230–1, no. 402 (518 × 735 mm).

23 Or a pseudonym, as the quatrain by 'Le Désinteressé' for G.-F. Schmidt's *Louis de La Tour d'Auvergne, Comte d'Evreux*, after Rigaud, when it was an-nounced several months after its appearance (*Mercure de France*, May 1740, pp. 971–2).

24 As, for example, Le Marquis D.E.***, Chevalier d'Honneur de l'Ordre de Malthe, 'VERS pour mettre au bas d'une Estampe que le Sieur LAU-RENT, Graveur du Roi, proposé par Souscription, & dans laquelle il doit représenter la belle action de feu M. D'ASSAS, Cap. Au Rég. d'Auvergne,' *Journal de Paris*, no. 245, 2 Sept. 1778, p. 977.

25 *Mercure de France*, Oct. 1745, p. 105 (*Inv. 18e s.*, VII [1951], p. 167, no. 159): 'Chéri du Dieu des Arts, craint & haï des sots, / L'ignorance en courroux fremit de ses bons mots.' Precious little was risked by their inclusion in a suite of such enormity.

26 'VERS pour mettre au bas du Portrait de M. l'Abbé GOUJET, gravé par M.[Benoît II] AUDRAN Par un Ch. Reg. D.S.G.' (*Mercure de France*, Dec. 1762, p. 20). Cf. *Inv. 18e s.*, I (1930), p. 247, no. 53.

27 *Mercure de France*, May 1740, pp. 971–2 for G.-F. Schmidt's *Comte d'Evreux* after Rigaud: 'Cette Gravûre a donné lieu de peindre le cœur de ce Sei-gneur dans ces Vers, pour être mis au bas de son Estampe.'

28 Expression taken from E. Delignières, *Catalogue raisonné de l'œuvre de Jean Daullé* (Paris: Rapilly, 1873), p. 17, concerning manuscript notes relating to the portrait of Philippe Hecquet. For this print in context, see W. McAllister Johnson, 'Compositions faites "de mémoire, de souvenir ou de réminis-cence,"' *Nouvelles de l'estampe*, no. 212, May–June 2007, p. 39 and fig. 3.

29 *Mercure de France*, Aug. 1755, p. 213; cf. *Inv. 18e s.*, IX (1962), p. 381, no. 33 s.v. R. Gaillard.

30 Thus the author of the quatrain for Valperga's *Abbé Arnaud* after Duples-sis, indicated only as being 'M. L.M.D.M.' in *Journal de Paris*, no. 127, 7 May 1785, p. 516 ; the same verses, unsigned, are attributed to 'un illustre confrère de l'Abbé Arnaud, qui aime lui-même tous les arts, & qui est fort

connu par des ouvrages de société, pleins d'esprits [*sic*], d'élégance & de naturel' in *Mercure de France*, 21 May 1785, pp. 137–8.

31 *Mercure de France*, Dec. 1743, I, p. 2615: 'A M. de la Tour, de l'Académie Royale de Peinture, pour le remercier de son Portrait, dont il a fait présent à l'Auteur.'

32 'CATALOGUE abbregé des Ouvrages de Mrs. les Peintres, Sculpteurs & Graveurs de l'Académie Royale de Peinture, aujourd'hui vivans, exposées dans le Salon du Louvre, le 5. du mois d'Août dernier jusques & compris le Dimanche premier Septembre' (Sept. 1743, p. 2059).

33 *Catalogue raisonné de l'oeuvre de feu George Fréderic Schmidt, graveur du roi de Prusse, membre des académies royales de peinture de Berlin et de Paris, et de l'académie impériale de St. Petersbourg* (London, 1789), pp. 25–6.

34 From student engravers to engravers, engravers to engravers, and engravers to painters and sculptors. See W. McAllister Johnson, '"*Serviteur, Elève et Ami*": Some Print Dedications and Printmakers in 18th-Century France,' *Gazette des Beaux-Arts*, VI/CXI, Jan.–Feb. 1988, pp. 49–54.

35 *Mercure de France*, Nov. 1762, p. 13; prints announced in *Mercure de France*, Dec. 1765, p. 171. Cf. *Inv. 18e s.*, VI (1949), p. 11, nos. 3–4 (lacunes).

36 *Mercure de France*, Sept. 1738:2020, and *Mercure de France*, Mar. 1739:539; cf. *Inv. 18e s.*, vol. 7 (1951), pp. 79–80, no. 19 s.v. Desplaces.

37 Originally sold with an EXPLICATION DE LA PLANCHE CI-JOINTE. *Mercure de France*, July 1752, pp. 55–60; reprinted by J. Hédou, *Noël Le Mire et son œuvre* (Paris: J. Baur, 1875), pp. 59–62, no. 25, and considered 'Tres rare, surtout avec l'Explication.' See also *Inv. 18e s.*, XIV (1977), p. 134, no. 253.

38 With extensive subject iconographical explication. *Mercure de France*, Dec. 1739, II, pp. 3112–13.

39 *Mercure de France*, Oct. 1740, pp. 2321–2.

40 *Inv. 18e s.*, II (1933), pp. 229–31, no. 58 s.v. Beauvarlet.

41 *Inv. 18e s.*, VI (1949), pp. 107–8, no. 105 s.v. Daullé.

42 *Inv. 18e s.*, XIV (1977), p. 163, no. 352, said to come from a trip to France made fifteen years earlier.

43 *Mercure de France*, Apr. 1765, I, p. 70.

44 As, for example, those of a certain M. Blaincourt, friend of the Pierre Lacour family at Bordeaux, referring to Gravelot vignettes for a drama by Baculard d'Arnaud, cited in *Notes et souvenirs d'un artiste octogénaire, 1778–1798*, ed. Philippe Le Leyzour and Dominique Cante (Bordeaux: Musée des Beaux-Arts, 1989), p. 19.

45 *Mémoires secrets* of 9 June 1776, cited in Bocher V, p. 98, no. 269, and attributed to Voltaire himself. Verse circulated in conjunction with a print is merely allusive. Sources reading 'on a mis au bas' give one to understand

that such a print actually exists. Bocher never found an impression of Saint-Aubin's portrait of Condorcet with the addition of verse reported in the *Mémoires secrets* for 27 July 1787, citing it only *pour mémoire* (Bocher V, pp. 21–2, no. 51).

4. Case Studies of Text versus Image

1 *Inv. 18e s.*, IV (1940), p. 622, no. 168 s.v. Cochin père. As opposed to the allusive verses of its period, Cochin's plate is reissued 'A Paris chez Basan' with a formal title, which reveals just how far society had moved away from such practices: BnF Est. Oa 22 (101).

2 Emmanuel Bocher, *Les gravures française du XVIIIe siècle, I: Nicolas Lavreince* (Paris: Librairie des Bibliophiles / Rapilly, 1875) (hereafter cited as Bocher I), p. 43, no. 54.

3 *Inv. 18e s.*, VIII (1955), pp. 70–1, no. 105 s.v. Cl. II Duflos (its pendant is *La Toilette de Vénus*, no. 106).

4 *Inv. 18e s.*, VI (1949), pp. 98–9, no. 87 s.v. J. Daullé.

5 *Mercure de France*, July 1736, p. 1641: '. . . pour leur en substituer d'autres, qui étant tous en François, et n'étant point répétés dans une autre Langue, remplissent leur place plus avantageusement, et donnent la facilité d'étendre [*sic* for entendre?] davantage.' Depending on the correct reading, reference is made to either balance in a two-column print letter or better comprehension of what is depicted, probably the latter. This candlelight scene, difficult to print well to begin with, in its second state and/or restrikes can show serious deterioration, that is, loss of detail, uneven tonality, crude retouching, or indifferent printing.

6 *Mercure de France*, July 1736, pp. 1640–1. This is the only printed mention of origin for someone active between 1727 and 1764 who became the workhorse of the industry and was versatile to the point of providing an encomium for a *Veue de l'Hôtel de Ville de Paris par l'hôtel des Ursins* by L.-C. Legrand after Raguenet. Cf. *Inv. 18e s.*, XIII (1974), p. 640, no. 351. By the early 1740s, he also contributes incidental verse (*étrennes*), for example, *Mercure de France*, Jan. 1742, pp. 3–5, and Feb. 1742, pp. 268–70. When the *Almanach de Priape* for 1741 and those responsible for it were seized, so was the manuscript of a Ch. Moraine, who was interned at the Bastille and then at Bicêtre from 17 December 1740 to 10 March 1741; in addition, he was questioned between 19 February and 1 March 1741 as to the *Histoire de Dom B, portier des Chartreux* and to prints sent to him for versification as a result of a quarrel between the owner of the copperplates and the engraver who had retouched them (François Ravaisson-Mollien, *Les Archives de la Bastille. Documents inédits*, XIII [1881], pp. 202–3, 205–9, 211). Homonym or not, this possible

identification, communicated by Anne Azanza-Sanciaud, has implications for how work could have been conducted intermittently in Paris, or between Paris and the provinces.

7 'J'ai été si malheureux sous le nom d'Arouet que j'en ai pris un autre surtout pour n'être plus confondu avec le poète Roi,' shown exhibition *Voltaire* (Paris, 1979), p. 11, no. 31, Voltaire to J.-B. Rousseau, 1 March 1719. Cf. Gustave Desnoiresterres, *Iconographie voltairienne. Histoire et description de ce qui a été publié sur Voltaire par l'art contemporain* (Paris, Didier, 1879), no. 72.

8 See Anne Sanciaud, 'Images de l'enfance: La Représentation de l'enfant dans l'estampe française du XVIIIe siècle' (Thesis, Ecole nationale des Chartes, 1996), 2 vols.

9 *Naissance de Bacchus* and *Enlevement d'Europe*, featured by Pierre Aveline at the Salon of 1753; *Inv. 18e s.*, I (1930), pp. 328–9, nos. 86–7.

10 *Inv. 18e s.*, XIV (1977), pp. 292–3, no. 118.

11 Henri Cohen, *Guide de l'amateur de livres à gravures du XVIIIe siècle* (Paris: A. Rouquette, 1912), cols. 534–8.

12 Emmanuel Bocher, *Les gravures françaises du XVIIIe siècle, VI: Moreau le Jeune.* Paris: Damascène Morgand et Charles Fatour, 1882 (hereafter cited as Bocher VI), pp. 312–23, nos. 867, 874–5, 878.

13 *Inv. 18e s.*, IV (1940), pp. 637–8, no. 255.

14 *Inv. 18e s.*, XIV (1977), p. 405, no. 63.

15 *Inv. 18e s.*, VII (1951), p. 82, nos. 32–3.

16 Bocher VI, pp. 486–91, nos. 1348–59.

17 Ibid., pp. 497–501, nos. 1372–83.

18 Dacier and Vuaflart, pp. 45–8, nos. 96 and 97B (77 × 100 mm rather than 183 × 235 mm).

19 Ibid., pp. 39–41, nos. 82B and 83C (92 × 125 mm rather than 201 × 265 mm).

20 As, for example, Chardin's *La Gouvernante* (Bocher III, pp. 76–8, no. 24B-F) and *La Mère laborieuse* (Bocher III, pp. 35–7, no. 35B-E), any minor differences in orthography and punctuation being, of course, negligible.

21 Restrikes and repetitions of Chardin's *La Pourvoïeuse* have two different verses: Lépicié's 'A votre air j'estime et je pense' (retained by Bocher III, pp. 45–8, no. 45A-B, D-J) and an unsigned 'A nourir notre corps, nous bornons tous nos soins' printed on a separate plate (Bocher III, no. 45C).

22 Dacier and Vuaflart, nos. 125A, 147A–148A, 222A–223A.

23 *Inv. 18e s.*, III (1934), pp. 463–4, no. 12.

24 Between nos. 149 and 150 (only paintings and sculptures were then numbered in the livret or handlist).

25 Collection Hennin, III (1881), p. 147, no. 8413.

26 *Inv. 18e s.*, VIII (1955), p. 79, nos. 141–4.

27 Not easily done with Beauvarlet's *Le Départ/L'Arrivée du Courier* after Boucher, where not only the titles and images are coordinated, but the quatrains as well: the boy and the girl fear the same predators for their carrier pigeons, the latter with a sotto voce 'Viens vite, je ne vois n'y vautour n'y chasseur; Mais je tremble plutot d'appercevoir ma mere . . .'

28 *Inv. 18e s.*, VIII (1955), pp. 87–8, no. 177, pendant of no. 176, *Le Dessein*, after Louis Aubert. Cf. W. McAllister Johnson, Véronique Meyer, and Stéphane Roy, 'Le Chevalier de Damery (1723–1803) et la gravure de collections privées en France au XVIIIe siècle,' *Nouvelles de l'estampe*, no. 223, March–April 2009, pp. 22, 30, and 32 (cat. 2, 16). Only a few Damery prints were, in fact, versified or lent themselves to versification.

29 Claude-Henri Watelet, *L'Art de Peindre: Poëme; Avec des Réflexions sur les diférentes parties de la peinture* (Paris: B.-L. Guérin and L.-F. Delatour, 1760), Chant Premier, pp. 5–6, with slight typographical variation. The work itself is modelled on Bossuet's *Art poétique*. Printed six years after the reading of successive chapters within the Académie, the text for the first chapter was evidently completed by 2 September 1752 (reread on 7 September 1753). *Procès-verbaux de l'Académie royale de peinture et de sculpture*, ed. A. de Montaiglon, VI (1885), pp. 332 and 363. For further stages of development leading to its gifting: VI, pp. 396 (7 Sept. 1754), 425–6 (10 Sept. 1755) ; VII (1886), pp. 97–8 (28 July 1759), 118 (9 Feb. 1760).

30 *Journal de Paris*, no. 10, 10 Jan. 1790, p. 38.

31 McAllister Johnson, '"*Serviteur, Elève et Ami,*"pp. 49–54.

32 Dacier and Vuaflart, p. 6, no. 3. Consummate artistic and poetic integration is rarely fortuitous. Close personal and professional relations are exceptionally given to view as three levels of reality and of perennity: Watteau painting outdoors = a Watteau painting = a N.-H. Tardieu print of Watteau painting outdoors. Jean de Jullienne (ca 1686–1776) made his life's work the unique and unprecedented project to engrave the entire corpus (drawings as well as paintings) of Watteau (1684–1721). Its presentation in four bound volumes gained him the rank of *conseiller-honoraire amateur*. *Procès-verbaux de l'Académie*, V (1883), pp. 264–5 (31 Dec. 1739).

33 *Inv. 18e s.*, VIII (1955), p. 74, no. 119, pendant of no. 120, *Les confidences pastorales*. The word *Belles* alludes to Boucher as *peintre des Grâces* in the same way that Greuze became known as *peintre de la Nature et du Sentiment*.

34 *Inv. 18e s.*, XIII (1974), p. 233, no. 405. Mention of Louis XV refers to Vernet's being called back from his Italian sojourn (1734–53) to execute the *Ports de France* series. These oversized commissions figured prominently at

the Salon from 1755 on, while their large-format prints by Le Bas and Cochin fils were shown from 1761 on. Reputed throughout Europe for marine landscapes with storm-tossed seas, shipwrecks, and atmospheric effects, his works in both painting and reproductive prints enjoyed virtually undiminished critical acclaim up to his death in 1789.

35 *Inv. 18e s.*, XIII (1974), pp. 233–4, no. 406. Rare are such public commemorations of friendships existing between artists in general and of the Académie as the prints Le Bas addressed to Vernet and Slodtz. Both Vernet and Slodtz worked extensively in Italy, but upon their return the former prospered while the latter remained underappreciated and underemployed because of his Baroque style and his reluctance to do portrait busts.

36 *Inv. 18e s.*, XIII (1974), pp. 222–3, no. 386. The vogue for Teniers and other artists of the Low Countries virtually dominated Paris salesrooms, although the former was one of the predilections of the engraver Le Bas (1707–83), who issued some ninety-three generally unversified Teniers.

37 Dated 'An 7,' shown at the Salon of that year (1799, no. 621) opening 1 Fructidor / 18 August (Bellier de la Chavignerie, *Miger*, p. 133, no. 276). Called 'Robert des Ruines' for paintings shown at the Salon from 1767 to 1798, where ruins were the subject rather than incidental motifs, Robert (1733–1808) ran afoul of the Revolution, was imprisoned in 1793–4, but emerged to become a driving force in what eventually became the Louvre as a repository of national patrimony. Like Slodtz and Vernet, his formative years (1754–65) were spent in Italy.

38 It was another eleven years before Massé offered a bound copy to the Académie, along with 2,000 livres for its widows and children, as well as his bust by Lemoyne; see *Procès-verbaux de l'Académie royale de peinture et sculpture*, VII (1886), p. 251, 26 May 1764. For the genesis of this suite, see Jean-Gérard Castex, 'Graver Le Brun au siècle des Lumières: Le recueil gravé de la Grande galerie de Versailles de Jean-Baptiste Massé,' 2 vols., PhD diss., Université de Paris X-Nanterre, 2008.

39 *Mercure de France*, Nov. 1755, pp. 189–93.

40 *Mercure de France*, Nov. 1753, pp. 154–60.

41 All by Pierre-Louis Surugue fils: *Le Négligé ou la Toilette du Matin* (1741); *L'Antiquaire*, *Le Peintre*, and *L'Inclination de l'Age* (1743). See Bocher III, nos. 38A, 2, 42 and 25 respectively, pp. 38–9, 8, 43, 28.

42 Piron had celebrated Netscher's *Cléopâtre* in 1754 (fig. 4), which served as Wille's *morceau d'agrément* (30 Aug. 1755), while Cochin fils did the figures and frontispice to Piron's first collected edition in 1758. C. Michel, *Charles-Nicolas Cochin et le livre illustré au XVIIIe siècle* (Geneva: Droz, 1987), pp. 271–2, no. 107.

43 Compositionally innovative and compelling, the implied conflict of philo-
sophical systems is a bit forced given the generation gap existing between
Voltaire and Rousseau, and the intent and reception of the titles alluded to
(published 1723 and 1762 respectively).

44 'Voyez vous ce Coquin comme il emporte vite / Au beau milieu des airs ma
charmante Lévite // Je Comptais m'habiller pour voir marcher sur l'eau /
Mais par la mon tailleur met le projet à vau-l'eau.'

45 'Voila donc des Balons l'usage dangereux. / Cette élegante Couturiere /
N'avoit donc un si gros derriere // Que pour jouer son role encor mieux. /
Par le moyen de ce perfide Globe, / Elle emporte a la fois et ma bourse et
ma robe.'

46 Dacier and Vuaflart, pp. 5–6, no. 2.

47 *Inv. 18e s.*, V (1946), pp. 347–8, no. 22.

48 Text, with the occasional variant in spelling and capitalization but with the
second line reading 'La foi *me servit* de livre,' in the margins of the death
certificate. See E. Bellier de la Chavignerie, 'Actes de naissance et de décès
d'Etienne Villequin, Pierre Legros, Jean Franç. Hue et Simon Mathurin
Lantara,' in *Archives de l'Art français: Documents,* V (1857–8), p. 191.

49 Tourneux, *Correspondance littéraire,* XIV (1880), pp. 164–5, under the date
June 1785. The drawing, reattributed to François from Louis Watteau de
Lille, is lost. Gaëtane Maës, *Les Watteau de Lille* (Paris: Arthéna, 1998),
p. 409, no. FD 1.

50 George Levitine, 'Les origines du mythe de l'artiste bohème en France:
Lantara,' *Gazette des Beaux-Arts* VI/LXXXVI, Sept. 1975, pp. 49–60. A num-
ber of his landscapes were engraved by P.-J. Duret in 1762 and François
Godefroy in 1773; cf. *Inv. 18e s.*, VIII (1955), pp. 409–10, nos. 9–12, and X
(1968), pp. 370–2, nos. 34–40 (some states reattributed to Casanova).

51 The Abbé de Fontenai notes Lépicié's early study of poetry 'pour laquelle la
nature lui avoit donné un goût irrésistible & une facilité étonnante,' and his
composition of 'plusieurs odes, & différentes pieces de poésie légere, qui lui
mériterent l'approbation & l'estime des gens de lettres les plus distingués,'
as well as the fact that 'ses vers dans différents genres ont de la noblesse, de
l'expression, de la finesse, du sentiment.' *Dictionnaire des artistes* (Paris: Vin-
cent, 1776), II, pp. 24, 25. This increases the likelihood that the unsigned
verse in Lépicié's prints after Coypel is indeed his.

52 See Nicole Garnier, *Antoine Coypel, 1661–1722* (Paris: Arthéna, 1989), pp.
11–12, and p. 181, no. 146 (two states).

53 Ibid., p. 181, no. 147, and fig. 5 for the print; for its preparatory drawing,
see p. 188, no. 163 and fig. 4.

54 *Inv. 17e s.*, VIII (1980), pp. 42–3, no. 18 s.v. S. Leclerc (all states illustrated).

55 The closest analogy to this process, with the qualification that the plate was exclusively for display once its unique printing was completed, seems to be the '*Epithalame*, certaines Estampes, que des Graveurs en Hollande font en l'honneur de nouveaux Mariés, & dans lesquels ils les représentent avec des attributs, & sous des symboles convenables à leur état. On ne tire de ces Estampes, que le nombre nécessaire pour distribuer aux parens & amis des Mariés: on dore ensuite la Planche & on l'encadre; c'est ce qui rend ces Pieces très-rares. Bernard Picard s'est fait beaucoup de réputation dans ce genre. Jacques Lacombe, *Dictionnaire portatif des beaux-arts*, nouvelle édition (Paris: J.-T. Hérissant / Frères Estienne, 1759), pp. 238–9.

56 *Mercure de France*, Jan 1731, pp. 138–9; cf. *Inv. 18e s.*, III (1934), pp. 469–71, no. 24. His obituary mentions his taste for painting, poetry, and music, noting that 'Son talent favori et son amour ardent pour les Vers a assez paru dans les petits Poëmes que nous avons de lui, qu'il récitoit si agréablement et sans trop se faire prier, mais toutefois sans se jetter, pour ainsi dire, à la tête; car il étoit toujours le dernier à croire qu'il eût fait quelque chose de bon. Il avoit si peu d'amour propre qu'il recevoit avec plaisir les corrections; il en adoptoit même trop légérement.' *Mercure de France*, July 1731:1773.

57 Among them, numbered by order of their election, La Fontaine (100), Houdard de La Motte (141), Danchet (146), Leriget de La Faye (182), Voltaire (207), Watelet (227), Voisenon (233), Marmontel (235), l'abbé Delille (247), A.-M. Lemierre (258), M.-J. Chénier (295). See Émile Gassier, *Les Cinq Cents Immortels: Histoire de l'Académie Française, 1634–1906* (Paris: Henri Jouve, 1906), passim.

58 *Mercure de France*, July 1731, pp. 1769–77, esp. 1773.

59 Cited in *Inv. 18e s.*, VI (1949), pp. 77–8, no. 40. Nearly forty years later, when the copperplate had passed into the hands of the dealer F.-X. Isabey, the annonce notes that this device 'a beaucoup de rapport avec cette strophe de Rousseau, qui semble en être la paraphrase: Le pinceau de Zeuxis, rival de la nature [etc.].' *Mercure de France*, 15 July 1778, pp. 192.

60 *Journal de Paris*, no. 319, 15 Nov. 1778, pp. 1278–9 (4 liv.). Cf. George Levitine, 'Jacques-Louis David and François-Anne David at the Police Station: An Incident of Homonymic Confusion,' *Art Bulletin* LXIII (December 1958): 346–54.

61 Bocher III, pp. 52–3, no. 51B.

62 *Inv. 18e s.*, VI (1949), pp. 139–40, no. 13 (both).

63 Presumably Pierre-Charles Cosson (ca 1740–1801), professor at the Collège Mazarin, who did a Latin translation of a Marmontel quatrain for a portrait of J. Le Rond d'Alembert that was engraved by Malœuvre after Pujos 'qui ne

se vend point, & que M. de Beaufleury a fait graver à l'insçu de M. d'Alembert [et] dédié à M. de Voltaire.' *Mercure de France*, Apr. 1775, I, pp. 168–9.

64 *Inv. 18e s.*, XII (1973), p. 414, no. 74 s.v. Larmessin. Bernard Hercenberg, in *Nicolas Vleughels, peintre et directeur de l'Académie de France à Rome, 1668–1737* (Paris: Léonce Laget, 1975), p. 108, no. 136*, fig. 147, knew and judged the work on the basis of the second state.

65 Bocher VI (1882), p. 99, no. 257; unversified but heralded by Guichard's 'VERS Sur le Tombeau de J.J. ROUSSEAU, dessiné & gravé par M. Moreau le jeune' (*Journal de Paris*, no. 309, 5 Nov. 1778, p. 1237). Despite numerous differences, the Lardy is catalogued as the fifth and final state of Moreau's print.

66 Métra, *Correspondance secrète, politique et littéraire*, IX (1787), pp. 248–9 (1 Jan. 1780), recounts the reasoning behind the motif's suppression: 'Rousseau dans sa dernière retraite, prenoit soin d'une bonne femme du village, & qu'on a trouvé cette pauvre femme, accablée de la mort de J.J. à genoux devant le tombeau de son bienfaiteur. Les personnes qui l'ont prise sur le fait, lui ayant demandé pourquoi elle étoit à genoux: «Hélas!» dit-elle, «*je pleure & je prie.*» – Mais, ma bonne, M. Rousseau n'étoit point catholique. – «Il m'a fait du bien: *je pleure & je prie.*» Ce fut avec toutes les peines du monde qu'on arracha de la tombe cette bonne femme qui fondoit en larmes, on la retrouve sur les premieres épreuves (*recte* états) de la gravure où M. Moreau a consigné le tombeau de ce Philosphe.'

67 Bocher II, pp. 18–29, no. 16.

68 E. Dacier, 'Les trois "Suites d'estampes" de Freudeberg et Moreau le Jeune et le "Monument du Costume,"' *Bulletin du bibliophile et du bibliothécaire*, 1951, pp. 50–63.

69 *Inv. 18e s.*, III (1934), p. 254, no. 56. *Charles IX, ou l'école des Rois, tragédie; par Marie-Joseph de Chénier* (Paris: P.-F. Didot jeune, 1790), act 3, scene 1, p. 44 (speech of the Chancellor de L'Hôpital), premiered on 9 November 1789 after misgivings as to the suitability of its subject for public representation. The Paris edition has the misprint *Ges* for *Ces*, and the progressive spelling *Reconnaissant*, while the second edition (Beaucaire: J.M. Garrigan, 1790), pp. 30–1, corrects the misprint and retains *Reconnoissant*.

70 'Au prince, aux citoyens imposant leur devoir, / Et fixant à jamais les bornes du pouvoir.'

71 Bocher V, pp. 74–5, no. 197.

72 Ibid., pp. 21–2, no. 51. The impersonal declarative lead-in normally indicates unsigned verse. It is unlikely that reference is being made to a unique annotated before-letter impression rather than a generally available one.

5. Cautionary Notes

1 A similar before-letter state for P.-L. Dumesnil's *Le Supot de Bacchus* has verse signed by Jean-Joseph Vadé in Gaucher's hand. *Inv. 18e s.*, IX (1962), p. 460, no. 3. This seems not to have been retained, perhaps because the print was included in the first volume of Basan's *Recueil*, no. 44.

2 *Inv. 18e s.*, IX (1962), pp. 461–2, no. 6.

3 *Inv. 18e s.*,VII (1951), pp. 394–5, no. 58, s.v. Duchange.

4 W. McAllister Johnson, *Hugues-Adrien Joly, Garde des Estampes de la Bibliothèque du Roy: Lettres à Karl-Heinrich von Heinecken, 1772–1789* (Paris: Bibliothèque nationale, 1988), p. 37, no. 167; information unknown to [Crayen] *Catalogue raisonné de l'œuvre de feu George Fréderic Schmidt, graveur du Roi de Prusse* (London, 1789), p. 37, no. 74: 'Cette estampe est sans contredit une des plus rares de Schmidt & presque introuvable, même à Berlin, ce qui fait qu'elle se vend toujours très-chère. Schmidt même de son vivant ne la vendoit pas moins de 3 à 4 Fréderics d'or' (Crayen). As is usual with portrait medallions inserted into allegorical surrounds, the latter (attributed to B.N. Le Sueur) was of less importance than the former, for which see Ekhart Berckenhagen et al., *Antoine Pesne* (Berlin: Deutscher Verein fûr Kunstwissenschaft, 1958), p. 140, no. 136.

5 *Inv. 18e s.*, XIII (1974), p. 158, no. 155.

6 Dacier and Vuaflart, p. 21, no. 32. Here especially, giving the distribution of the verse – 'Sous le titre, 16 vers sur 3 col. (4 à gauche, 8 au milieu, 4 à dr.)' – is of little help in determining order of precedence, which is essential for interpretation.

7 This quandary is best summarized in two comments of the mid-1770s. For Gentil-Bernard: . . . et un assez grand nombre de pièces fugitives répandues dans différents recueils; mais il s'en faut bien qu'on nous les ait données toutes, et la plupart de celles qui sont imprimées ne l'ont été que sur des copies très-defectueues.' Tourneux, *Correspondance littéraire*, XI (1879), p. 200 (Feb. 1776). It is unlikely that signed verse on prints was considered of sufficient consequence to merit inclusion in literary anthologies, a conclusion supported by the comment that a seven-volume edition of Piron could have been reduced to two without damage to his reputation: 'encore ces deux volumes ne seraient-ils guère composés que des ouvrages qui sont entreles mains de tout le monde, [comme . . .], d'une demi-douzaine d'épigrammes et d'un assez petit nombre de pièces fugitives, [comme . . .].' Tourneux, *Correspondance littéraire*, VII (1879), pp. 58–9 (Apr. 1775). Once linked to an image, verse was invested with an indissociable particularity and became meaningful in that context only.

8 As Balechou's *L'Opérateur Barri* after Jeaurat, in *Inv. 18e s.*, I (1930), p. 14, no. 20, where the annonce ends: 'On lit au bas, la dixiéme Épigramme de feu M. ROUSSEAU, qui exprime très-heureusement le sujet.' *Mercure de France*, Sept. 1743, p. 2060.

9 Emile Dacier, 'Sur deux portraits gravés de Mlle Sallé,' *Revue de l'art ancien et moderne* XXIX, 1911, pp. 313–15.

10 Desforges-Maillard's portrait was engraved in 1744 for the *Suite Desrochers*, with verse by J.-B. Rousseau alluding to the pseudonym of Mlle Malcrais de La Vigne under which he corresponded with La Motte, Fontenelle, and Voltaire. *Inv. 18e s.*, VII (1951), p. 167, no. 160.

11 For the reprise *en petit* by Dupin, see *Inv. 18e s.*, VIII (1955), p. 254, no. 17. Both may be found in Collection Hennin, III (1881), p. 344, nos. 9941 and 9942 respectively.

12 *Inv. 18e s.*, XIII (1974), pp. 219–20, no. 379.

13 Collection Hennin, III (1881), p. 188, no. 8686.

14 Collection De Vinck, I (1909), pp. 633–4, no. 1325, and II (1914), pp. 11–12, no. 1444.

15 Collection De Vinck, I (1909), p. 100, no. 229.

16 Prosper de Baudicour, *Le Peintre-graveur français continué*, II (1861), pp. 247–9, nos. 19–20.

17 Portalis and Beraldi, III, 1 (1882), p. 42, no. 10: 'Femme adorée et bientôt tendre mère, / Reçois ici l'hommage qui t'est dû. / L'époux que tu choisis, lorsqu'il eut tout perdu, / Retrouve tout puisqu'il a su te plaire.' The impressions then known were all bound into copies of the *Choix de chansons mises en musique par M. de La Borde*, with illustrations by Moreau le Jeune. Deemed 'rien de remarquable,' the portrait remains one of the two earliest productions in the extraordinary career of its artist as well as evidence of close relations with La Borde. *Dominique-Vivant Denon: L'œil de Napoléon* (exhibition Paris: Louvre, 1999–2000), p. 68, no. 3.

18 Collection Hennin, III (1881), p. 250, no. 9197.

Conclusion

1 Moraine wished he were as learned as the philosophy professor François Rivard since '. . . en un mot ce grand homme / Auroit alors des vers dignes de son Portrait.' *Mercure de France*, Oct. 1745, pp. 103–4.

2 In *Gabriel de Saint-Aubin, 1724–1780*, exhibition Louvre, 21 Feb.–26 May 2008, p. 35 (repr. fig. 20).

3 Albeit unsigned, these lines could have been written by none other than the draughtsman (Watelet) for his mistress' portrait by Lempereur: 'Lecomte,

c'est pour toi ce que Nature à fait; / Et que l'Art ne peut rendre, en gravant ton portrait.' See *Inv. 18e s.*, XIV (1977), pp. 269–70, no. 54.

4 *Inv. 18e s.*, IX (1962), p. 466, no. 23.

5 Anne Sanciaud, '"L'enfant des dieux": Les représentations d'enfants royaux en France au XVIIIe siècle,' *Nouvelles de l'estampe*, no. 156, Dec. 1997, pp. 18–19.

6 A flaming altar inscribed 'AMOUR' balances the dog of Fidélité, while both appear before entwined roses and fleurs-de-lis and the anchor of Espérance.

7 *Journal de Paris*, no. 354, 20 Dec. 1778, p. 1428.

8 *Inv. 18e s.*, XII (1973), p. 46, no. 79 (Collection De Vinck, I [1909], p. 311, no. 733), a reduction measuring 209 × 147 mm as opposed to the 230 × 205 mm of the Janinet.

9 In making his own detailed portrait drawings to ensure proper linear and tonal translation by his engravers, Hyacinthe Rigaud (1659–1743) was in a class of his own. But while etched preparations by specialists (*mise à place*) were one thing, reliance on preparatory drawings had the potential to change things for the worse. While the prints of J-F Beauvarlet and the Salon drawings *destinés à graver* of his late manner were praised for their *moëlleux, onction* and *beau fini,* he was reproached for his 'nouvelle mode de graver autrement que d'après le tableau, c'est-à-dire de le réduire d'abord en dessin, pour le transmettre ensuite au burin. Il est certain qu'à travers toutes ces manipulations, si je peux me servir de ce terme, l'esprit de l'original s'évapore ; il n'en reste plus que le matériel': *Mémoires secrets,* XIII (1780), pp. 189–90 (24 Sept 1775). In lesser hands, it did just that.

10 *L'Avant-coureur*, no. 39, 30 Sept. 1771, p. 623.

Epilogue

1 Both the drawing and the print of P.-C. Coqueret's Neuf Thermidor allegory after Guillon Lethière figured in the Salon of 1798, nos. 282 and 712; cf. *Inv. 18e s.*, V (1946), p. 256, no. 34. A before-letter impression (AA5 Coqueret) bears a manuscript print letter and a manuscript quatrain of Malherbe ('Que diriez Vous Races futures . . . '). An impression with full print letter, but before the address of 'Potrelle, Successeur de Dulac' (Qb^5 1798), bears no verse whatsoever. This appears to be the intended definitive state since presentation copies with that address (De Vinck 6551 f 5 and AA5 Lethière) and inscribed by Lethière to 'Réveillière Lépeau, Membre du Directoire Executive' and 'Ducis, Membre de l'Institut national' bear

a manuscript quatrain by Jean-François Ducis ('Anarchistes tremblez le gouvernement veille . . .').

2 *Mercure de France*, July 1751, p. 155 (six plates forming 'une Histoire très-instructive, qu'on devroit mettre sous les yeux des jeunes gens').

3 A rare exception is the portrait of the Abbé Pommyer after Cochin fils. *Inv. 18e s.*, VI (1949), pp. 414–15, no. 262.

4 Jacques Hérold, *Louis-Marin Bonnet (1756–1793): Catalogue de l'œuvre gravé* (Paris: Maurice Rousseau, 1935).

5 *Inv. 18e s.*, IX (1962), p. 466, no. 23.

6 Portalis and Beraldi, III/2 (1882), p. 283: Qb¹ 1749. Tanevot also publishes 'A M. BARJAC, en lui demandant l'Estampe qu'il a fait graver d'après le Tableau de M. Autreau [S.-H. Thomassin's Diogenes with the portrait of the Cardinal de Fleury, shown at the Salon of 1738], dont on a parlé dans le Mercure de Septembre dernier.' *Mercure de France*, Mar. 1739, pp. 536–7. Friends unto their deaths in 1773, both Tanevot and Piron began their careers with the financier and art patron Jean de Boullongne (1690–1769). See Comte de Saint-Aymour, *Une famille d'artistes et de financiers aux XVIIe et XVIIIe siècles: Les Boullongne* (Paris: H. Laurens, 1919), pp. 79–81 (survey of Tanevot's writings, p. 80, note 2).

7 *Inv. 17e s.*, VI (1973), p. 333, no. 55: Qb¹ 1720–22 (additional location).

Excursus: Music and Theatre Prints

1 Tourneux, *Correspondance littéraire*, VII (1879), p. 373 (July 1767): 'Le premier est peintre de gravelures et de libertins, le second, peintre de bonnes mœurs et d'honnêtes gens. Les mœurs de Collé sont vraies, mais ce sont les mœurs corrompues de Paris; les mœurs de Sedaine sont vraies et bonnes, et sont celles que vous désirez à votre femme, à votre fille, à votre maîtresse.'

2 Emmanuel Bocher, *Les gravures françaises du XVIIIe siècle, II*: Pierre-Antoine Baudouin (hereafter cited as Bocher II), pp. 10–11, no. 9.

3 Ibid., pp. 41–2, no. 42.

4 Ibid., pp. 31–3, no. 30, from *Le Chef d'œuvre d'un inconnu*.

5 Ibid., pp. 33–5, no. 31.

6 Ibid., pp. 37–8, no. 36.

7 Ibid., pp. 28–9, no. 27.

8 Ibid., pp. 43–4, no. 43.

9 *Annette et Lubin* reprises, albeit uninterestingly, a typical Boucher pastorale.

10 Cf. L.-M. Bonnet's *The Milk Woman* of 1774 in exhibition *Colorful Impressions: The Printmaking Revolution in Eighteenth-Century France* (Washington, DC:

National Gallery of Art, 2003), p. 82, no. 30 (repr.). The Perrette chain was then absorbed by Couche Tard, more in keeping with the times (information communicated by Claudette Hould).

11 *Collection de planches gravées qui composent le fonds des sieurs Basan et Poignant* (Paris: 1799), p. 6 (for the price of one livre and four sols).

12 *Inv. 18e s.*, IV (1940), p. 55, no. 5: BnF Est. Qb¹ 1727 (additional location).

Bibliography

Catalogues Raisonnés and Repertories (Engravers)

Baudicour, Prosper de. *Le Peintre-graveur continué, ou catalogue raisonné des estampes gravées par les peintres et les dessinateurs de l'école française nés dans le XVIIIe siècle. Ouvrage faisant suite au Peintre-graveur français de M. Robert-Dumesnil.* Paris: Mme Bouchard-Huzard, Rapilly, Vignères; Leipzig: Rudolphe Weigel, 1859–61. Reprint, Paris: F. de Nobèle, 1967.

Bocher, Emmanuel. *Les gravures françaises du XVIIIe siècle, I: Nicolas Lavreince.* Paris: Librairie des Bibliophiles / Rapilly, 1875.

– *Les gravures françaises du XVIIIe siècle, II: Pierre Antoine Baudouin.* Paris: Librairie des Bibliophiles / Rapilly, 1875.

– *Les gravures françaises du XVIIIe siècle, III: Jean-Baptiste-Siméon Chardin.* Paris: Librairie des Bibliophiles / Rapilly, 1875.

– *Les gravures françaises du XVIIIe siècle, IV: Nicolas Lancret.* Paris: Librairie des Bibliophiles / Rapilly, 1877.

– *Les gravures françaises du XVIIIe siècle, V: Augustin de Saint-Aubin.* Paris: Librairie des Bibliophiles / Rapilly, 1879.

– *Les gravures françaises du XVIIIe siècle, VI: Moreau le Jeune.* Paris: Damascène Morgand et Charles Fatout, 1882.

Collection De Vinck: Bibliothèque nationale, Département des estampes. *Un siècle d'histoire par les estampes, 1770–1871: Collection De Vinck; Inventaire analytique.* 4 vols. (Ancien Régime through Empire, images accessible online). Paris: Bibliothèque Nationale, 1909–29.

Collection Hennin: Duplessis, Georges. *Inventaire de la collection d'estampes relatives à l'histoire de France léguée en 1863 à la Bibliothèque Nationale par M. Michel Hennin.* 4 vols. (Ancien Régime through Empire, images acessible online). Paris: Henri Menu [Alph. Picard], 1877–82.

Dacier, Émile, and Albert Vuaflart. *Jean de Jullienne et les graveurs de Watteau au XVIIIe siècle*. Vol. 3, *Catalogue*. Paris: Société pour l'étude de la gravure française / Maurice Rousseau, 1922.

Huber, M., and C.C.H. Rost. *Manuel des curieux et des amateurs de l'art contenant une notice abrégée des principaux Graveurs, et un Catalogue raisonné de leurs meilleurs ouvrages; depuis le commencement de la Gravure jusques à nos jours: Les Artistes rangés par ordre chronologique, et divisés par Ecole*, vol. VIII [Ecole de France, 18e s.]. Zurich: Orell, Fusli et Compagnie, 1804.

Inventaire du fonds français: Graveurs du XVIIe siècle. Paris: Bibliothèque nationale, 1939–.

Inventaire du fonds français: Graveurs du XVIIIe siècle. Paris: Bibliothèque nationale, 1930–.

Jean-Richard, Pierrette. *L'Œuvre gravé de François Boucher dans la Collection Edmond de Rothschild* [Musée du Louvre]. Paris: Musées nationaux, 1978.

Portalis, Baron Roger, and Henri Beraldi. *Les graveurs du dix-huitième siècle*. 3 vols. Paris: Damascène Morgand et Charles Fatout, 1880–2.

Catalogues Raisonnés (Painters)

Berckenhagen, Ekhart, et al. *Antoine Pesne*. Berlin: Deutscher Verein für Kunstwissenschaft, 1958.

Garnier, Nicole. *Antoine Coypel (1661–1722)*. Paris: Arthena, 1989.

Hercenberg, Bernard. *Nicolas Vleughels, peintre et directeur de l'Acdemie de France à Rome, 1668–1737*. Paris: Léonce Laget, 1975.

Lefrançois, Thierry. *Charles Coypel, Peintre du roi (1694–1752)*. Paris: Arthena, 1994.

Leribault, Christophe. *Jean-François de Troy, 1679–1752*. Paris: Arthena, 2002.

Maës, Gaëtane. *Les Watteau de Lille: Louis Watteau (1731–1798). François Watteau (1758–1823)*. Paris: Arthena, 1998.

Exhibition Catalogues

Colourful Impressions: The Printmaking Revolution in Eighteenth-Century France. Washington, DC: National Gallery of Art, 26 October 2003–16 February 2004.

Dominique-Vivant Denon: L'œil de Napoléon. Paris: Musée du Louvre, 20 October 1999–17 January 2000.

Gabriel de Saint-Aubin, 1724–1780. Paris: Musée du Louvre, 21 February–26 May 2008.

La Bastille ou 'l'Enfer des vivants.' Paris: Bibliothèque de l'Arsenal, 9 November 2010–11 February 2011.

Regency to Empire: French Printmaking, 1715–1814. Baltimore Museum of Art, Museum of Fine Arts Boston, Minneapolis Institute of Arts, 10 November 1984–23 June 1985.

Voltaire. Un homme, un siècle. Paris: Bibliothèque nationale, 1979.

General Bibliography

Anon. 'LETTRE A M.*** En luy envoyant une nouvelle Estampe de M. le Bas,' March 1751, pp. 143–5.

– 'VERS pour mettre au bas du Portrait de M. l'Abbé GOUJET, gravé par M. [Benoît II] AUDRAN Par un Ch. Reg. D.S.G.' *Mercure de France,* December 1762, p. 20.

Bailey, Colin B. *Patriotic Taste: Collecting Modern Art in Pre-Revolutionary Paris.* New Haven and London: Yale University Press, 2002.

Bellier de la Chavignerie, Emile. 'Actes de naissance d'Etienne Villequin, Pierre Legros, Jean Franç. Hue et Simon Mathurin Lantara.' In *Archives de l'Art français. Documents,* V (1857–8), p. 191.

– *Biographie et catalogue de l'œuvre du graveur Miger.* Paris: J.-B. Dumoulin, 1856.

Bonnardot, Alf. *Histoire artistique et archéologique de la gravure en France. Dissertation sur l'origine, les progrès et les divers produits de la gravure. – Listes de graveurs français rangés par ordre de règnes, de Charles VII à Louis XVI inclusivement. – Notice sur quelques graveurs étrangers qui ont laisse des pièces curieuses pour l'histoire de France. Listes d'anciens marchands d'estampes, à Paris. – Remarques iconographiques et bibliographiques sur le commerce et les ventes d'etampes et de livres anciens; sur les causes de leur rareté; sur les collections privées et publiques; sur les échanges internationaux; sur la Lithographie et les procédés pour reproduire les anciennes impressions; sur les réformes applicables à la Bibliothèque Nationale et aux autres bibliothèques de la ville de Paris, etc.* Paris: Librairie ancienne de Deflorenne Neveu, 1849.

Caix de Saint-Aymour, Comte de. *Une famille d'artistes et de financiers aux XVIIe et XVIIIe siècles. Les Boullongne.* Paris: Henri Laurens, 1919.

Casselle, Jean-Pierre. 'Pierre François Basan, marchand d'estampes à Paris (1723–1797),' *Paris et Ile-de-France. Mémoires* XXXIII, 1982, pp. 99–185.

Castex, Jean-Gérard. 'Graver Le Brun au siècle des Lumières; Le recueil gravé de la Grande galerie de Versailles de Jean-Baptiste Massé.' 2 vols. PhD diss., Université de Paris X-Nanterre, 2008.

Catalogue du cabinet de tableaux de Monsieur le Comte de Vence. Paris: Veuve Quillau, 1759.

Cohen, Henri. *Guide de l'amateur de livres à gravures du XVIIIe siècle.* 6e édition revue, corrigée et considérablement augmentée par Seymour de Ricci. Paris: A. Rouquette, 1912. Reprint, Geneva: Bibliothèque des Érudits, 1951.

Collection de planches gravées qui composent le fonds des sieurs Basan et Poignant. Paris: Basan and Poignant, 1799.

Courboin, François. *L'Estampe française. Graveurs et Marchands.* (Bibliothèque de l'Art du XVIIIe siècle). Brussels and Paris: G. Van Oest, 1914.

– *Gabriel de Saint-Aubin, peintre, dessinateur et graveur (1724–1780).* 2 vols. Paris and Brussels: G. Van Oest, 1929.

[Crayen, Auguste]. *Catalogue raisonné de l'oeuvre de George Fréderic Schmidt, graveur du roi de Prusse, membre des académies royales de peinture de Berlin et de Paris, et de l'académie impériale de St. Petersbourg.* London, 1789.

Cubières, le Comte de. 'Vers à M. le Comte DE BUFFON, pour le remercier du présent qu'il m'a fait d'une. Gravure dédié aux Mânes de J.J. Rousseau.' *Journal de Paris*, no. 95, 5 April 1782, pp. 377–8.

Dacier, Émile. 'La Sedaine du Musée Condé, ou Gabriel de Saint-Aubin poète.' *Revue de l'art ancien et moderne*, XXXVIII, June 1930, pp. 5–18; July–August 1930, pp. 93–104.

– 'Sur deux portraits gravés de Mlle Sallé.' *Revue de l'art ancien et moderne*, XXXIX, 1911, pp. 313–15.

– 'Les trois "Suites d'estampes" de Freudeberg et Moreau le Jeune et le "Monument du Costume." ' *Bulletin du bibliophile et du bibliothécaire*, 1951, pp. 50–63.

Danzel, P.-A. 'LETTRE DE M. DANZEL à M. DE LA PLACE.' *Mercure de France*, January 1766, I, p. 183.

Delignières, Émile. *Catalogue raisonné de l'œuvre de Jean Daullé.* Paris; Rapilly, 1873.

Desnoiresterres, Gustave. *Iconographie voltairienne. Histoire et description de ce qui a été publié sur Voltaire par l'art contemporain.* Paris: Librairie Académie Didier et Cie, 1879.

Diderot: Salons, II (Salon de 1765). Ed. Jean Seznec. 2nd ed Oxford: Clarendon Press, 1979.

Dorbec, Prosper. 'La Peinture française de 1750 à 1820 jugée par le factum, la chanson et la caricature.' *Gazette des Beaux-Arts*, IV/XI, January 1914, pp. 69–85; February 1914, pp. 136–60.

Duplessis, Georges, ed. *Mémoires et Journal de J.-G. Wille, graveur du Roi, publié d'après les manuscrits autographes de la Bibliothèque Impériale.* 2 vols. Paris: Veuve Jules Renouard, 1857.

E***, Marquis D., Chevalier d'Honneur de l'Ordre de Malthe. 'Vers pour mettre au bas d'une Estampe que le sieur LAURENT, Graveur du Roi, propose par Souscription, & dans laquelle il doit représenter la belle action de feu M. D'ASSAS, Cap. Au Rég. D'Auvergne.' *Journal de Paris*, no. 245, 2 September 1778, p. 997.

Fontenai [Fontenay]. Louis-Abel de Bonafous, Abbé de. *Dictionnaire des Artistes ou Notice historique et raisonnée des Architectes, Peintres, Graveurs, Sculpteurs, Musiciens, Acteurs & Danseurs, Imprimeurs, Horloger & Méchaniciens*. 2 vols. Paris: Vincent, 1776.

Gassier, Émile. *Les Cinq Cents Immortels: Histoire de l'Académie Française, 1634–1906*. Paris: Henri Jouven, 1906.

Griffiths, Antony. 'Proofs in Eighteenth-Century French Printmaking.' *Print Quarterly*, XXI, March 2004, pp. 3–17.

Guibert de F., Mme. 'A M. Flipart, sur une marine gravée d'après M. Vernet.' *Mercure de France*, June 1768, p. 88.

Guiffrey, Jules-Joseph. *Eloge de Lancret, peintre du Roi, par Ballot de Sovot, accompagné de diverses notes sur Lancret, de pièces inédites et du catalogue de ses tableaux et de ses estampes*. Paris: J. Baur / Rapilly, 1874.

Hartley, Craig. 'Moreau's "Heloise et Abeilard."' *Print Quarterly*, XII, June 1995, p. 185.

Hecquet, Robert. *Catalogue des estampes gravées d'après Rubens; Auquel on a joint l'œuvre de Jordans, & celle de Visscher*. Paris: Briasson/Jombert, 1751.

Hédou, Jules. *Noël Le Mire et son œuvre, suivi du catalogue de l'œuvre gravé de Louis Le Mire*. Paris: J. Baur, 1875.

Heinecken, Karl-Heinrich von. *Idée générale d'une collection complette d'estampes*. Leipzig and Vienna: Jean Paul Kraus, 1771.

Hérold, Jacques. *Louis-Marin Bonnet (1736–1793). Catalogue de l'œuvre gravé*. Paris; Maurice Rousseau, 1935.

Johann Georg Wille (1715–1808). Briefwechsel. E. Elisabeth Decultot, Michel Espagne, and Michael Werner. Tübingen: Max Niemeyer Verlag, 1999.

Jombert, Charles-Antoine. *Catalogue de l'œuvre de Ch. Nic. Cochin fils; Ecuyer, Chevalier de l'Ordre du Roy, Censeur Royal, Garde des Desseins du Cabinet de Sa Majesté, Secrétaire & Historiographe de l'Académie Royale de peinture & de sculpture*. Paris: Prault, 1770.

Lacombe. Jacques. *Dictionnaire portatif des Beaux-Arts, ou Abrégé de ce qui concerne l'architecture, la sculpture, la peinture, la gravure, la poésie et la musique*. Nouvelle édition. Paris: J.-T. Hérissant / Frères Estienne, 1759.

La Correterie. 'IMPROMPTU à un dame, en lui envoyant l'estampe des Incroyables.' *Journal de Paris*, no. 116, 26 Nivôse an V – 15 Jan. 1797, p. 466.

Le Leyzour, Philippe, and Dominique Cante, eds. *Notes et souvenirs d'un artiste octogénaire, 1778–1798* [Pierre La Cour]. Bordeaux: Musée des Beaux-Arts, 1989.

Lescure, M[atherin] de. *Correspondance complète de la marquise du Deffand avec ses amis le président Henault – Montesquieu – d'Alembert – Voltaire – Horace Walpole*. Paris: Plon, 1865.

Levitine, George. 'Jacques-Louis David and François-Anne David at the Police Station: An Incident of Homonymic Confusion.' *Art Bulletin*, LXIII, December 1981, pp. 346–54.

– 'Les origines du mythe de l'artiste bohème en France: Lantara.' *Gazette des Beaux-Arts*, VI/LXXXVI, September 1975, pp. 49–60.

Lundberg, Gunnar W. 'Le graveur suédois Pierre-Gustave Floding à Paris et sa correspondance.' *Archives de l'Art français*, nouvelle période, XVII, 1932, pp. 249–359.

[Mariette, Pierre-Jean]. *Catalogue historique du cabinet de peinture et sculpture françoise, de M. de Lalive, Introducteur des Ambassadeurs, honoraire de l'Académie Royale de Peinture*. Paris: P.A. Le Prieur, 1764.

McAllister Johnson, W. 'Compositions faites "de mémoire, de souvenir ou de réminiscence."' *Nouvelles de l'estampe*, no. 212, May–June 2007, pp. 38–53.

– 'L'estampe en France au XVIIIe siècle: Titre ou absence de titre.' *Nouvelles de l'estampe*, no. 230, May–June 2010, pp. 16–18.

–, ed. *Hugues-Adrien Joly, Garde des Estampes de la Bibliothèque du Roy: Lettres à Karl-Heinrich von Heinecken, 1772–1789*. Paris: Bibliothèque nationale, 1988.

– 'Petite métiers d'autrefois: Les versificateurs d'estampes en France au XVIIIe siècle.' *Bulletin de la Société archéologique, historique et artistique 'Le Vieux Papier,'* XXX, October 1985, pp. 377–84.

– '"*Serviteur, Elève et Ami*": Some Print Dedications and Printmakers in 18th-Century France.' *Gazette des Beaux-Arts*, VI/CXI, January–February 1988, pp. 49–54.

McAllister Johnson, W., Véronique Meyer, and Stéphane Roy. 'Le Chevalier de Damery (1723–1803) et la gravure de collections privées en France au XVIIIe siècle.' *Nouvelles de l'estampe*, no. 223, March–April 2009, pp. 9–49.

Mémoires secrets pour servir à l'histoire de la république des lettres en France, depuis MDXXLXII jusqu'à nos jours. 36 vols. London: John Adamson, 1780–9. Now selectively available in a modern edition, see Bernadette Fort, ed., *Les Salons des 'Mémoires secrets,' 1767–1787* (Paris: École nationale supérieure des beaux-arts, 1999).

Métra, François. *Correspondance secrète, politique et littéraire; on Mémoires pour servir à l'histoire des cours, des sociétés et de la littérature en France depuis la mort de Louis XV*. 18 vols. Reprint Geneva: Slatkine Reprints, 1967.

Michel, Christian. *Charles-Nicolas Cochin et le livre illustré au XVIIIe siècle. Avec un catalogue raisonné des livres illustrés par Cochin, 1735–1790*. Geneva: Droz, 1987.

Petit, Gilles-Edme. *Catalogue des différens portraits gravées par feu E. Desrochers, graveur du Roy, et qui se vendent à présent chez G.-E. Petit, graveur, demeurant à Paris, rue Saint-Jacques, à la Couronne d'Epine, pres les Mathurins*, 1754.

Ponsonailhe, Charles. 'Le peintre-graveur Joseph-François Le Roy.' *Revue des Sociétés des beaux-arts des départements*, XXIV, 5–9 June 1900, pp. 649–56.

Portalis, Baron Roger. *Les dessinateurs d'illustrations au XVIIIe siècle.* 2 vols. Paris: Damascène Morgand et Charles Fatout, 1877.

Préaud, Maxime, et al. *Dictionnaire des éditeurs d'estampes à Paris sous l'Ancien Régime.* Paris: Promodis, 1987.

Procès-verbaux de l'académie royale de l'Académie royale de peinture et de sculpture, 1648–1793. Ed. Anatole de Montaiglon. 10 vols. Paris: J. Baur [-Charavay frères], 1875–92.

Ratouis de Limay, Paul. *Le Pastel en France au XVIIIème siècle.* 2nd ed. Paris: Baudinière, 1946.

Ravaisson-Mollien, François. *Les Archives de la Bastille. Documents inédits.* 19 vols. Paris: Durand, 1866–1904.

Sanciaud, Anne. ' "L'enfant des dieux": Les représentations d'enfants royaux en France au XVIIIe siècle.' *Nouvelles de l'estampe*, no. 156, December 1997, pp. 5–22.

– 'Images de l'enfance. La Représentation de l'enfant dans l'estampe française du XVIIIe siècle.' 2 vols. Thesis, Ecole nationale des Chartes, 1996.

– 'Le texte au service de l'image dans l'estampe volante du XVIIIe siècle.' *Bibliothèque de l'Ecole des Chartes*, CLVIII, January–June 2000, pp. 129–50.

Schroeder, Anne L. 'Genre Prints in Eighteenth-Century France: Production, Market and Audience.' In *Intimate Encounters: Love and Domesticity in Eighteenth-Century France*, pp. 69–86. Hanover, NH: Hood Museum of Art, Dartmouth College, 1997.

Snoep-Reitsma, Ella. 'Chardin and the Bourgeois Ideals of his Time.' *Nederlands Kunsthistorisch Jaarboek*, XXVI, 1973, pp. 147–273.

Tanevot, Alexandre. 'A M. BARJAC, en lui demandant l'Estampe qu'il a fait graver d'après le Tableau de M. Autreau, dont on a parlé dans le Mercure de Septembre dernier.' *Mercure de France*, March 1739, pp. 536–7.

Tourneux, Maurice, ed. *Correspondance littéraire, philosophique et critique par Grimm, Diderot, Raynal, Maistre, etc.* Vol. 12. Paris: Garnier Frères, 1880.

Watelet, Claude-Henri. *L'Art de Peindre: Poëme; Avec des Réflexions sur les différentes parties de la peinture.* Paris: B.-L. Guérin and L.-F. Delatour, 1760.

Whyte, Ryan, 'Understanding Painting, Print and Verse; Chardin's *Le Négligé ou Toilette du Matin.*' In *Word and Image in the Long Eighteenth Century: An Interdisciplinary Dialogue*, ed. Christina Ionescu and Renata Schellenberg, pp. 44–54. Newcastle, UK: Cambridge Scholars Publishing, 2008.

Index / Glossary

This index is more directive and associative than enumerative. It has been constructed accordingly, the better to see the interrelationship and mutability of concepts. Descriptive terminology relating to print phenomena, technique, gestation, and commerce is indexed when it orients the reader, situates issues, provides context, or concerns research methodology. When a given word or issue appears under several headings, one sees how fluid was its understanding in the print milieu and society at large. Portrait indexing bears figure references, as do prints illustrating stages in their realization or transformation. Painters and sculptors are indicated by *(p.)* and *(s.)* respectively, engravers by *(gr.)*, and print editors by *(ed.)*. Most engravers issued their own works, so *(gr./ed.)* refers to the favoured few who, as entrepreneurs, published numerous prints of their pupils and colleagues, and commissioned or purchased additional copperplates to enrich their stock.

Index to Illustrations by Engraver

Illustrations of the prints on which this study is based are indexed to give a comparative idea of the manner, subject matter, and typology of format and design employed by their engravers and generation. Reference is single or multiple depending upon whether an engraver worked alone or in collaboration. Prints classed as anonymous include unsigned works issued by known editors. Female engravers are indicated by an asterisk.

Index to Illustrations by Painter or Draughtsman

This index references the painters and draughtsmen (and a few print-makers who engraved and signed their own compositions) whose names appear in print letters, who are securely attributed, or whose signed prints led to repetitions. Unsigned compositions usually deemed anonymous are here presumed to be the work of engravers and/or editors and are accordingly termed *undetermined*.